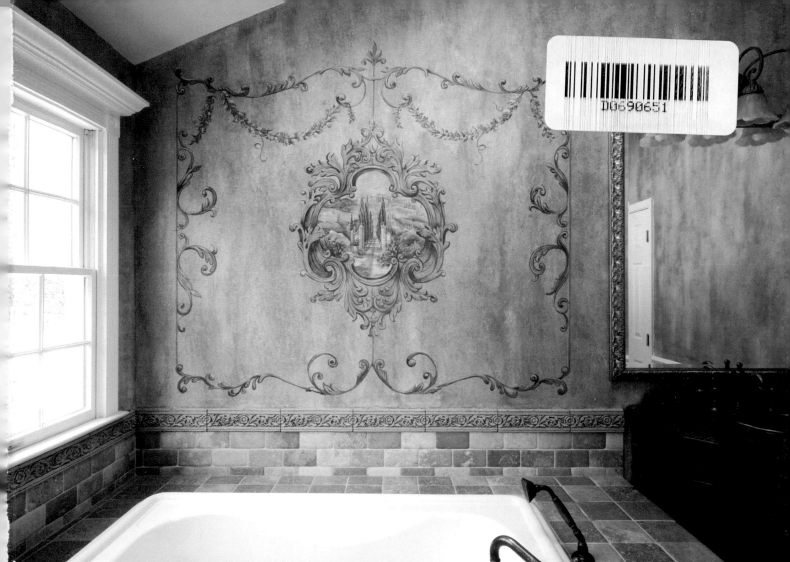

GARY LORD

MURAL PAINTING
secrets for success

Cincinnati, Ohio
www.mycraftivity.com

NORTH LIGHT BOOKS

Mural Painting Secrets for Success. Copyright © 2008 by Gary Lord. Manufactured in Singapore. All rights reserved. No part of this book may be reproduced in any form or by any electronic or mechanical means including information storage and retrieval systems without permission in writing from the publisher, except by a reviewer who may quote brief passages in a review. Published by North Light Books, an imprint of F+W Publications, Inc., 4700 East Galbraith Road, Cincinnati, Ohio, 45236. (800) 289-0963. First Edition.

Other fine North Light Books are available from your local bookstore, art supply store or direct from the publisher at www.fwpublications.com.

12 11 10 09 08 5 4 3 2 1

Distributed in Canada by Fraser Direct
100 Armstrong Avenue
Georgetown, ON, Canada L7G 5S4
Tel: (905) 877-4411

Distributed in the U.K. and Europe by David & Charles
Brunel House, Newton Abbot, Devon, TQ12 4PU, England
Tel: (+44) 1626 323200, Fax: (+44) 1626 323319
Email: postmaster@davidandcharles.co.uk

Distributed in Australia by Capricorn Link
P.O. Box 704, S. Windsor NSW, 2756 Australia
Tel: (02) 4577-3555

Library of Congress Cataloging in Publication Data
Lord, Gary
 Mural painting secrets for success / Gary Lord. -- 1st ed.
 p. cm.
 Includes bibliographical references and index.
 ISBN-13: 978-1-58180-980-0 (pbk. : alk. paper)
 1. Mural painting and decoration--Technique. I. Title.
ND2550.L68 2008
751.7'3--dc22
 2007044367

Edited by Jacqueline Musser
Designed by Clare Finney
Production coordinated by Greg Nock

About the Author

Gary Lord is recognized internationally as an artist, teacher, author and television personality. Gary owns and operates Gary Lord Wall Options and Associates Inc., which executes all of his commercial and residential decorative finishing contracts. Wall Options won first place in two Painting and Decorating Contractors of America national competitions and was named best faux finisher in the nation in 2002, 2003, 2004, 2005 and 2006 by *Painting and Wallcovering Contractor* and in 2007 was awarded the top spot for *Who's Who in Decorative Painting*.

Gary also operates Prismatic Painting Studio, which allows him to teach his extensive faux finishing skills to others, nationally and internationally.

Gary has appeared on HGTV's *Decorating with Style* and *The Carol Duvall Show*, the PBS show *Paint! Paint! Paint!* and The Discovery Channel's *Christopher Lowell Show*. Gary writes numerous articles on decorative painting for *Decorative Artist's Workbook*, *The Artist's Magazine*, *The Faux Finisher*, *The Artistic Stenciler*, *The Decorative Painter*, *Profiles in Faux*, *Paint PRO*, *American Painting Contractor* and *Architectural Living*, among others. This is his fourth North Light book. He has also written *Great Paint Finishes for a Gorgeous Home*, *Marvelous Murals You Can Paint* and *It's Faux Easy*.

METRIC CONVERSION CHART

To convert	to	multiply by
Inches	Centimeters	2.54
Centimeters	Inches	0.4
Feet	Centimeters	30.5
Centimeters	Feet	0.03
Yards	Meters	0.9
Meters	Yards	1.1

Acknowledgments

This book reflects the artistic talents, creative excellence and enduring passion of many wonderful artists. I am humbled to be surrounded by such a wealth of artistic talent, but even more importantly, I'm humbled by the fact that I can call each of the contributors in this book my friend. I feel this is the best book I have ever been involved in, mainly because of the collective involvement of my friends. My talents alone could never come close to reflecting the depth and variety of projects displayed in this book. I am truly blessed to know so many wonderful artists who are willing to share their knowledge and help others grow in their own desires to be the best they can be. Many of the artists in this book have their own schools, books and videos where they share and teach even more of their knowledge. If you see someone's style you like, look in the back of the book for their contact information to learn more about what they offer.

I wish to personally thank each of my friends for the time and effort they put into their projects to help make this book as good as it is. I will thank you each in the order your project appears in the book: Sharon Leichsenring, Joe Taylor, Nicola Vigini, Kris (O'Dub) Hampton, Sheri Hoeger, Zebo, Pascal Amblard, Sean Crosby, Randy Ingram, Brian Townsend, Jeff Raum, Alison Woolley Bukhgalter, Cynthia Davis, Jeannine Dostal, Lori Le Mare, Rebecca Baer, Dave and Pam Schmidt, Shawn Voelker, Marc Potocsky, Melanie Royals, Pierre Finkelstein and William Cochran.

Many of the artists had people help them with the book and I wish to thank one of those people, Craig Walsh. I want to thank my office manager, Sheri Evans, and my wife, Marianne, for all of the assistance they gave me.

I wish to thank F+W Publications for their belief in me to write my fourth book with them. My editor was fantastic, very organized, on time, and helpful in providing information for me and all of the contributors; thank you, Jackie Musser.

I want to give a special thank you to my family Ben, Corrie and Jared for being the wonderful people they are. I am proud of each of you. My wife, Marianne, is my life partner and is my best friend. She allows me to be a better person with her support, guidance and love.

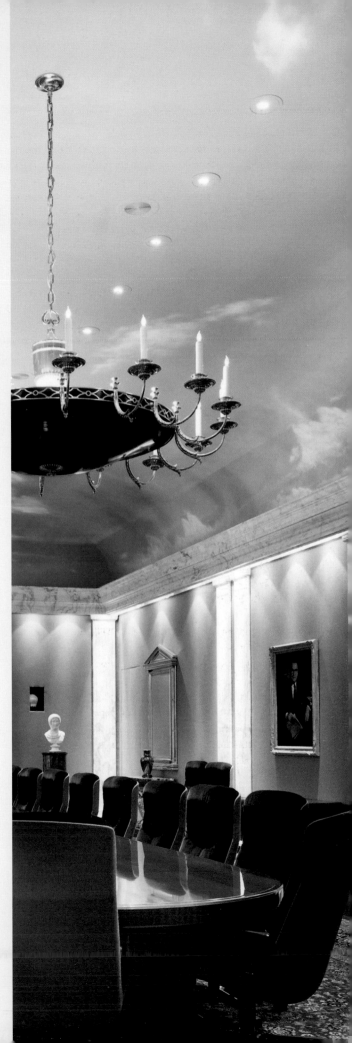

TABLE OF
CONTENTS

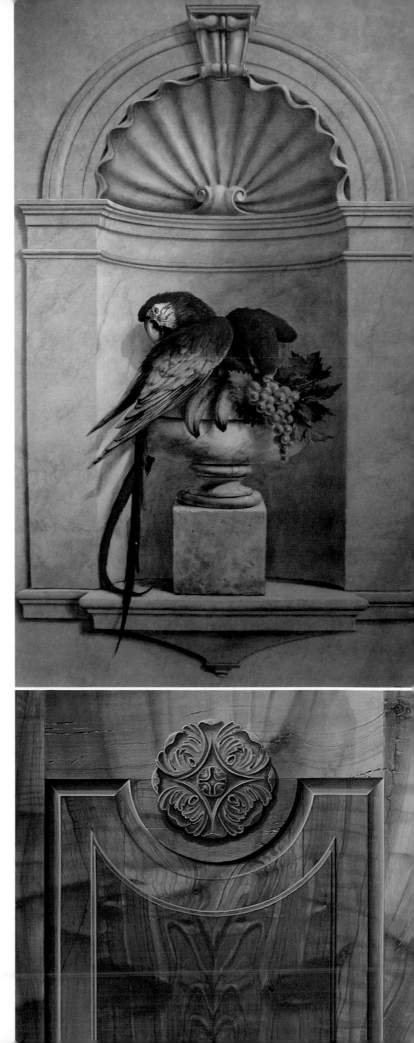

INTRODUCTION

IF YOU ARE READING THIS BOOK, odds are you are passionate about painting. Maybe you're only looking for great instruction on mural painting. If so, you'll find it here. This book contains many different and wonderful mural painting styles from twenty-three professional decorative painters. Each artist depicts one element of a mural to show you how it is created step-by-step. We hope these are inspirational and useful resources for your own work.

But maybe you're so passionate about your painting that you want to make it your occupation. After all, what could be better than being paid for doing something you love! Many very talented artists have tried to run their own decorative painting businesses. Some succeed, but many more fail. It's not an easy process. It takes tremendous dedication, discipline and an understanding of business—something many artists lack.

In this book, the contributors and I share the "secrets" of our successes, in both business and painting. Remember, the skills and practices we share here took us years—even decades—to understand and master, so don't be discouraged if you try a new networking or marketing approach and don't receive a hundred new clients or if you paint one of the demonstrations and it doesn't turn out as great as the pictures in the book on your first attempt. The goal is for you to learn from our experiences as you cultivate your own skills.

I am thankful to the contributing artists for their hard work and dedication to making this book as wonderful as it is. I have been a professional decorative painter since 1975, and I have had the opportunity to meet many talented artists over the years. I am humbled by the wealth of talent reflected by the artists in this book.

While putting this book together, I worried more than once that my own personal work would not hold up well to the talents of the other included artists. But as I spoke directly with each artist, I heard some of them voice this same concern about their own work. They compared their own work to another contributor and felt inferior.

Confidence in your own artistic style is difficult and elusive. I love this quote: "It is hard to see the beauty in a picture when you are inside the frame."

As artists, we are always critiquing our own work: we try to make it better, always striving for that next step that will satisfy us. I rarely complete a mural project without thinking to myself, *Next time I would….* This attitude helps me improve my skills because I keep a positive goal in mind. I focus on my weaknesses to strengthen them, not to berate myself and feel inadequate.

There's always something new to learn, no matter how long you've been painting. Some of my skills may never match those of other artists in this book, but if I focus on my strengths and work on improving my weaknesses, I can make the most of my talent and develop it to its full potential.

No matter what level you are at in your art, I hope you will find something inspirational in these projects and galleries to help you improve and become the best artist you can be.

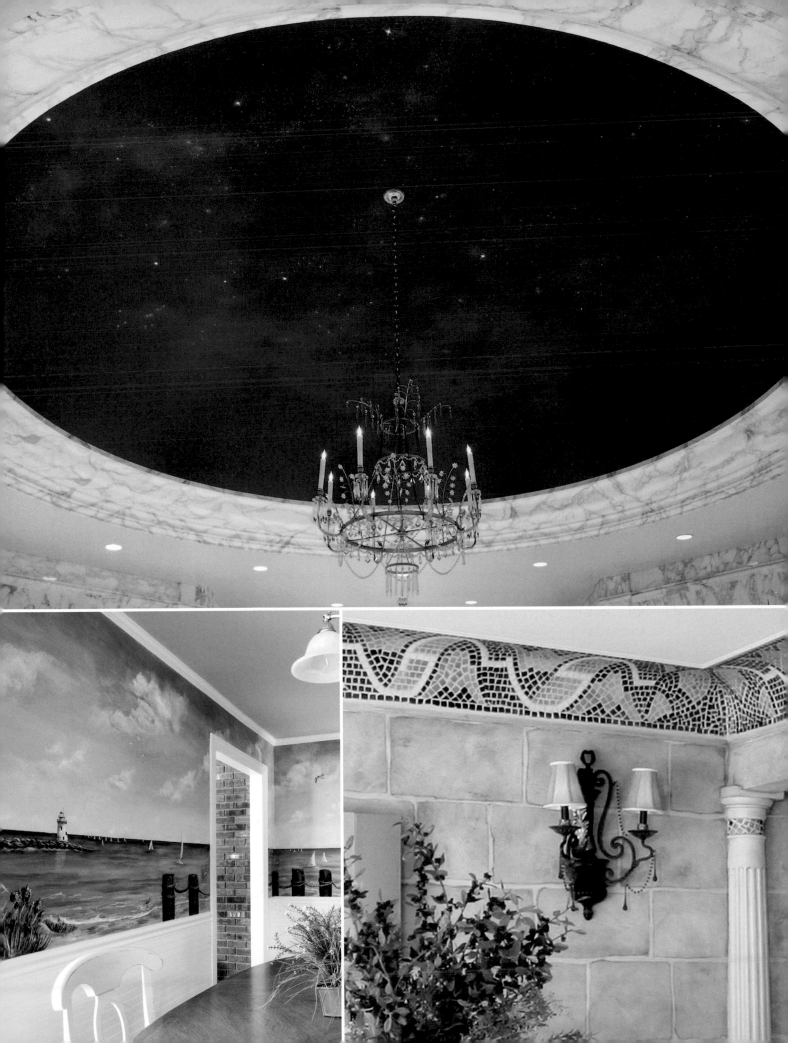

1 THE ART OF RUNNING A BUSINESS

ANYONE CAN PAINT MURALS FOR FREE and enjoy using his or her artistic talents to paint for oneself and friends, or a school or church. This is how many of us started out. Some of us realized sooner than others that we would like to be paid for what we paint.

I started my business on my own without the benefit of the numerous books, videos and schools that are available today to help educate the decorative artist. Many of the things I have learned came from making mistakes, correcting them and trying not to repeat them. I survived because I was young, naïve, inexperienced, not married and needed very little money to live on. I loved painting, had fun doing it, and thought I would give it a try and see what happened.

I do not recommend this approach to others.

Think seriously about what starting your own business means financially and emotionally. The advice I give in this book is not based on any professional business model. It's based on my own experience and what worked and didn't work for me. I also have compiled valuable insights and personal stories from many of the artists who contributed to this book. Each artist in this book enjoys a full-time career working in the decorative painting field, and collectively we will try to tell you how to be successful and make a living at this as well.

Being paid takes you from a hobbyist to a professional. To stay professional, you need to constantly make a profit or you will quickly be out of a business.

Unfortunately, there is no magic formula that allows someone to be *successful* in the arts. Success is different for each person. You may want to work full-time at this profession and aspire to the level of the artists in this book. If it's your passion to be the best, please understand it will take you years to reach that level, just as it did for each of these contributing artists. (Full time at this level often means more than forty hours per week.)

Success for others may mean enough work to keep you busy and provide the income you require. This may be part time on the weekends or at night, or while your children are in school. This field is very flexible in the hours you can work, but just like everything else, you get out of it what you put into it. If you only work a little, you will only earn a little money.

Experience shows that it will take years of working hard at painting to be able to earn a respectable income. I started my business when I was 22 years old, and I had other part-time jobs to help subsidize myself while my business developed. Without that extra income, I never would have been able to sustain myself on the little I earned painting.

In her book *Do What You Love—Love What You Do*, my friend Rebecca Parsons says, "There are many rewards to the decorative painting business. Being your own boss and doing what you love allows you to flourish. You will experience the sheer joy of loving your work, being grateful for each day, each commission, and performing at your best always. Your clients will notice and the commissions will follow."

There is no magic bullet answer that will make your artistic and business dreams come true. You need a strict work ethic, perseverance, passion, a belief in yourself and endless energy. Combine this with the three main ingredients of success in any business—*competitive prices, excellent quality* and *exceptional service*—and you have a good shot at operating a successful business.

HOW I STARTED

Many of my students ask how I got started in professional painting. I am including my own story and those of a few other artists in this book to illustrate the fact that most of us do not have glamorous beginnings. It is only through hard work, perseverance and good fortune that we are able to do what we love and make a living at it.

I have been drawing and painting for as long as I can remember. I grew up watching my mother make arts and crafts at the kitchen table, and I wanted to do what she was doing. I always enjoyed art in school and if a class involved an art project (like making a volcano for geography class) my grade always benefited. I was an

average student, and the only subjects I did well in were history and art.

I graduated from high school in 1970 and my family expected me to go to college. Fortunately, at that time they did not have as difficult requirements to get into college as they do today. I decided to go to The Ohio State University and study art because I really had no other ideas about what I could do. I considered the commercial art program, but learned at freshman orientation that it was no longer offered. So, I enrolled in a general art studies program and ended up majoring in sculpting and minoring in painting. I graduated and looked for a job as an *artist*. I quickly realized my college sculpting and painting portfolio was not what the advertising companies were looking for. (I didn't know this, but throughout my college career, my father had been asking my mother, "What the hell does he think he is going to do with an art degree?")

I ended up working in shipping and receiving at a factory where I was made fun of as the only college-educated person on the factory floor. After being late to work 183 days in a row, I was fired. (Who knows why it took them that long to fire me.)

Soon after being fired, I was riding my motorcycle down a street that was under construction for a HomeArama showcase of homes. It was late in the day, and I entered a home that looked interesting. All of the workers had left for the day. As I was admiring that large, open, contemporary two-story home, a woman walked in and asked "Can I help you? I own this home." I feared I would be arrested for trespassing. Fortunately, the woman was nice and gave me a tour. On the way out, I asked her if she needed any sculpting or painting done. She asked me if I did any "super graphics" and I told her I didn't know what they were. "Large murals," she explained. I said, "Sure, I can do those," with no idea on earth how to do them. She told me to speak with her interior designer, which I did, and I showed him my college portfolio. I got the job and painted two murals for the entire three weeks before the show started. One mural was to incorporate the client's son's Formula One race car bed into a scene on the wall behind it. The other was a woodland scene that accented a swing hanging from a ceiling rafter in the client's daughter's room.

When I was awarded the job, I had no idea how to paint a mural that large. My mother helped me devise a grid system to enlarge the designs the client approved.

Then I painted the murals to match the colors the designer wanted. It went smoothly until the designer asked me to paint the inside of the woodland mural's main tree yellow. I thought, *Yellow, trees are not yellow, and I just went to art school why would you want a tree yellow?* I made excuses why the tree was not painted yellow, and the show came and went with the tree remaining the color I wanted it. The designer never used me again for the next twenty-five years because I wanted it *my way*.

When it came to pricing, I had no idea how much to charge for these two murals, let alone how long it would take. I had been making $4.10 per hour at the factory, so I thought $50.00 for each mural sounded good. Then I painted the two murals and when I finished, I realized I had made way less money per hour than I thought I would. Has anyone else made this kind of error?

I did a lot of things right on this job, but I also made a lot of mistakes. I learned:

- To ask for a job and to promote myself were good things (see *Networking*, page 15).
- If I said I could do something I had never done before, I had better be able to figure it out (see *Working with Clients*, page 23).
- I should do what the client wants, not only what I want (see *Service*, page 30).
- If I wanted to stay in business I had to learn how to price my jobs to make a profit (see *Pricing*, page 27).

All in all, this first job taught me many things that I still use in my business today. The moral of this story for me is to do my very best on each job, to honestly critique myself on the pros and cons of that project, to learn from them both, and on the next project, improve on my weak areas and enhance my strong areas even more.

ARTIST'S INSIGHT

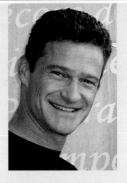

My first mural was at an Italian restaurant/pizzeria owned by a friend from my neighborhood in New York. The mural was a surrealistic Italian landscape, with a bust of the Greek god Hermes. I was painting while the restaurant was open, so all eyes were watching me. Since I was inexperienced at painting large-scale murals, I was very nervous and probably spent the first hour rearranging my drop cloths, paints and tools just so the audience would know that I knew what I was doing! I finally got started, and since I lacked confidence, I started painting very lightly, using a drop of paint and a *lot* of water…almost as light as tea. It was so thin that I'm sure most of my audience thought I was pretending to paint (not unlike the fairy tale of the emperor's new clothes)! Once I painted my first layer, I liked what I did, so I added more paint to the water to increase the values. I gained more confidence with each layer, adding more and more paint. Eventually, after about twenty layers, I finished the job.

Looking back now, with the skills I've built since that time, I probably could have done the same mural in three to four layers. So the technique that I have developed is not unlike watercolor—glazed color on a white ground. This stems from my understanding of the relationship of glazed color to a basecoat and the lessons I learned when my stepfather and I took an evening watercolor class together during my teenage years. Light goes through the glaze, hits the white base, and reflects back through the veil of color. This creates a luminosity that I could not achieve with opaque paint. An example would be painting a flower white first then glazing over the white with red. This would create a vivid pink that would be very difficult to achieve mixing red and white together on my palette, which for me always leaned towards pastels.

Years later I discovered that the nineteenth century Pre-Raphaelites as well as the twentieth century illustrator Maxwell Parish realized the same technique. I like to say that my technique is based on fear—light to dark, getting more courage with each layer. You gain experience with each pass of color.

Each successful experience diminishes fear and creates confidence. Confidence tramples fear underfoot.

—Sean Crosby

Proper organization, bookkeeping and time management skills are the glue that binds all other business principles together. Without these essential ingredients, the other principles will fall apart.

If you feel you are weak in the area of actually running your business, educate yourself or you may go out of business. You can learn at home for free by joining an online forum about operating decorative painting businesses (see page 19) and reading books by successful business leaders in *all* fields. (All effective and profitable businesses maintain similar business principles no matter what product they sell.) Or take night classes at a community college or from professionals in the field. You also can seek counsel from your local Small Business Administration. Never stop learning—it will keep you profitable and allow you to grow to whatever level you are dreaming of.

ARTIST'S INSIGHT

When I first started my business in the mid 1970's, I kept my receipts, check stubs and invoices in a shoebox, but I only placed them in the shoebox when I could find them! I ran my little start-up business by using my own personal checking and credit card accounts to pay my bills. I used my home phone line for my business calls for years. I put what little business profits I had into my personal savings account and blended the profits with my personal savings. As time went on and my business grew, this system became more and more confusing at tax time. I had no idea how much money I had made or lost because I was not consistent in keeping an accurate account of the finances. I did keep client files, but they were in no particular order and were thrown together in a cardboard box. The piles of mismatched information I had to sort through at the end of the year never gave me a correct picture of my business and how healthy it was. I knew I was making more money than I was spending, but I had no idea if that money was from my working at nights as a waiter, my decorative painting work, or my part-time sign work, grass cutting, odds-and-ends sources of income. I was too busy having fun as a young adult, and I did not like doing this "busy work" to keep track of everything. After all, I thought, I was not making any money doing book work. My bookkeeping model was a disaster waiting to happen!

—Gary Lord

Once I decided to make decorative painting my full-time job, I sought advice from other businesspeople and they pointed me in a more organized direction for keeping records.

I bought filing cabinets and organized the files so each client had a separate folder containing contact information, contracts, time of appointments, notes, work sheets, designs, invoice dates, copy of payments, etc. The files are all in alphabetical order in their own drawer. I also created files for each of the vendors I purchased items from and put receipts into these files and also noted vendors in the client files.

I opened up checking accounts and credit cards for my business to keep this information separate from my personal life. I started a relationship with a local bank very early on, and I have stayed with that bank for more than thirty years, establishing excellent credit with them. Excellent credit goes a long way in helping you be profitable. You can get better rates and payment plans on loans and products, and other businesses are more likely to want to do business with someone they feel they can trust.

I installed a separate business telephone line so work calls would sound more professional. (It also became easier to separate work from home, which my wife liked.) As years went by I switched the entire contracts and accounting/payroll system over to computer programs that interface with my bookkeeper and accountant. All of this important financial information now is available to me in daily, weekly, monthly, quarterly and yearly reports.

Early on, I hired an accounting firm to do my year-end taxes. The firm also gave me valuable information on how to keep a ledger sheet for my business so I could keep track of my assets and liabilities. A good accountant will actually save you money because of all the important financial information they will give you. I have been with my accountant for more than twenty-five years, and he has probably saved me as much money as I have paid him in the long run. He has become my financial advisor and someone I rely on when I need counsel for a new strategy to grow and expand my business in a financially prudent way.

As profits increased, I hired my wife to manage the office aspects of my work, which gave me more time to paint. Further down the road (about twenty-six years from the start), the workload was too much and we hired someone to help run the office.

PAINTING TOOLS

Organization is key in the office and when you are on site painting. I am a past Boy Scout and I believe in being prepared for the unexpected. I have a standard stock of supplies that I always carry in my work truck (see the *Essential Equipment* sidebar), and it has saved me from many extra trips to my shop or to a store.

Organization requires you to think ahead. Try to list every possible piece of equipment you will need to do your job by thinking through the entire project from step 1 to completion. If you need to order a tool, paint, medium or equipment, do so weeks in advance so you do not need rush delivery. Don't make the mistake of only thinking of your project the morning you are going to do it. Develop a calendar that schedules your projects in advance so you can complete tasks step by step before you even start.

As your business becomes more successful, your schedule will become even fuller, but don't overlook your organization needs. Schedule time to organize future projects. Do this far enough in advance that you have time to implement your plan and calculate problems into that time frame. Problems will arise and you need to have flexibility in your schedule to properly deal with them. Most people are usually overly optimistic in their time estimates—make sure you plug breathing room into the hours you want to work or you will find yourself working nights and weekends until you hate what you are doing (and your family and friends hate it, too).

You need to build flexibility into your thinking process so you can be fluid and change things at the last moment with the least amount of disruption to your business and to your clients. Over time, you will develop a sixth sense for what and whom you should and should not worry about. It may seem like you are spending a lot of time to be organized, but it will save you time and make you more money in the long run. The best tip is to spend a little time organizing every day so you can stay caught up and don't fall behind.

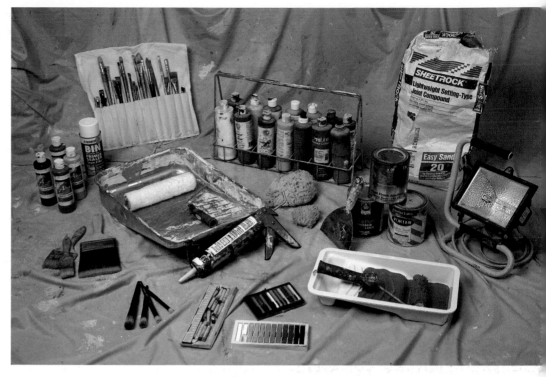

ESSENTIAL EQUIPMENT

This is a list of items that I always carry in my work truck:
Paint can opener, putty knife, screwdrivers, hammer, Allen wrench set, powdered drywall mix, drywall taping blades, pencils, first aid kit, flashlight, plastic sandwich bags, stir sticks, funnel, strainers, tack cloth, batteries, plastic drop cloths, canvas or butyl drop cloths, steel wool, erasers, Spray B-I-N, alcohol, caulk, caulk gun, craft knife and spare blades, hand cleaner, trash bags, misting bottle, mixing containers with lids, universal tints, tape, scissors, ruler, compass, level, yard stick, tape measure, white glue, dust masks, sandpapers, rags, sponges, paint trays, paint rollers, extra paint roller sleeves, blank sample boards, cheesecloth, production brushes, artist brushes, stencil brushes, solvents, string or twine, fine-point permanent markers, spray adhesives, nap line, ladders, camera, halogen light, extension cord, hair dryer.

For mural work, I also carry these items with me at all times:
Tracing paper, masking fluid or masking film material, clear acetate, sketch pad, extra pencils, white chalk, colored chalk, Conté crayons, artist charcoal, transfer paper, specific paints for the job.

If you are still fairly new to the decorative painting industry, you need to design a company logo that can be applied to all parts of your business. My logo appears on all printed media, my Web site, letterhead, mailing envelopes, invoices, business cards, sell sheets and any printed advertisements. Make your logo special so it stands out from others and becomes recognizable. Rebecca Parsons has an excellent chapter about logos, branding and name recognition in her workbook *Do What You Love—Love What You Do.*

Strong branding of your company name and the products it offers is critical to your ultimate success. Creating a "brand" for your company is a process that never stops. Your brand should be continually modified and updated to promote your newest product or project. This reinforces to the general public that your company is still in business and remains a leader in your industry.

GARY·LORD
wall options
INC.

My logo design for Wall Options was created with the thought of having an artist doing something with a brush to reflect craftsmanship. It was actually drawn by Dave Schmidt, whom I had hired as an employee. He had previously worked for an advertising firm in Chicago. Together, we went through three or four design options, and refined the one we liked best. I have been using this logo for more than twenty years.

Q&A

Q: How did you create your logo?

It took me several years to come up with my logo for Zebo Studio. I required a logo that would appeal to a broad range of people, from children's book editors and art directors, to interior designers and potential mural clients. Essentially, I needed it to be appreciated by professionals and "Joe Public" alike.

I knew I wanted an image that would touch people. I knew I wanted an image that people would remember. For years, I studied other artists' business cards, which mainly featured painter's palettes, architectural elements or even their own work. I remembered none of them.

I saved magazine articles that used colors I liked, newspaper ads with a font I liked, and postcards depicting every sort of image and creature known to man. I read books on business cards. But no inspiration came to me. I never sketched anything.

In the meantime, I designed a business card with just my name and address—no logo—to set it apart from the multitude of painter's palettes and columns. I chose a heavy, textured card stock and rounded the edges. I was amazed that people noticed my basic card simply because of those rounded edges. I learned that business cards are

very valuable and important tools, especially for an artist competing in a creative market.

Five years later, my logo arrived at my front door in the form of a four-footed fur child. My husband surprised me with a Jack Russell terrier named "Jack," and he was the whimsy I had been waiting for. Each morning, I walked Jack in my painting outfit—boots, overalls and a hat. Eventually, this image became "me."

One day, after years of trying in vain to create *the perfect logo*, I sat down at my computer and sketched out "me." It took only minutes to sketch, but I had been preparing for years. The logo had everything I wanted to represent Zebo Studio: whimsy, creativity, uniqueness and good design. It was real. (I actually do pull a painter's cart!) I knew the image would translate well to my other marketing materials, such as stationary, envelopes, receipts and thank-you notes. Plus it was sweet, without being cute.

Since 2001, we have acquired another Jack Russell terrier, so I have tweaked the original design to include her. You can't have a Jack without "The Beanstalk!" —Zebo

NETWORKING

Networking is a major element in any successful business, especially in today's global economy. It is a skill that is vital to all points of a career, from the newcomer to the established veteran. You may be the best artist since Leonardo da Vinci, but if no one knows about you, you will not be able to make a living doing what you love.

There is a wealth of knowledge written about networking. I suggest reading as much as you can about the topic and continue to look for new information and advice on networking. You can always learn something new, no matter how long you've been in business.

Speaking About Yourself

Some of us are introverts and some are extroverts. It is certainly easier for people who have the gift of gab to talk about themselves and what they do versus others who are not comfortable speaking about themselves. I have always been blessed with the ability to speak with others about many different topics, including my own work, and I've never struggled with public speaking. But I hone and improve my communication skills each and every time I use them. I believe effective communication is essential to most businesses. Even if you are not comfortable in the beginning, by practicing and perfecting speaking about yourself, you will find it becomes easier and aids in building your business. If you are very uncomfortable speaking in groups, consider taking a communications or public speaking course at a community college.

Networking Groups

A computer network consists of at least two computers connected through phone lines or fiber optic cables to share information. This is basically the same for people; it takes two or more of us to network and share information and knowledge. Networking organizations can be professional clubs, faith-based groups, philanthropic groups or school groups, just to name a few. Where there's a group of people, there is an opportunity to network.

Most networking systems max out at around 150 people or so. Imagine how many contacts you would have if you were in a networking system of 150 people and each person told all of his or her acquaintances about you. Wow! That would be a lot of people, but honestly that is not very realistic.

NETWORKING GUIDELINES

Here are some basic guidelines for networking in any line of work. Once you learn these basic rules, you can apply them to your own market locally and perhaps even nationally.

1. Use your existing network. Start by contacting all extended family members, friends and ex-colleagues. Get the word out that you are a decorative painter and ask if anyone has a contact that might be able to offer you business advice. People are more likely to be generous with their time if you ask them for their consult.

2. Focus on trade groups: Join the organizations that fit you best and don't waste your or other peoples' time on an industry or club that is not in your focus group. To achieve the best results, consider volunteering on one of the group committees as a way to meet members.

3. Cultivate contacts: People will not risk their reputations for someone they do not know. For new contacts to be effective, you need to build solid relationships. Get to know them before asking for a job or help. Business relationships have to be a win-win situation, especially for your contact to want to recommend you or use you again. Try putting your contacts' needs before your own.

4. Be willing to help others: Both parties must be able to receive *and* give information for networking to be truly effective. Don't be self-serving and think only of how others can help you. Make an effort to help those you network with by sharing contacts and information with them. Remember, if you scratch someone else's back, they are more likely to scratch yours.

5. Maintain your network: Even when you are very busy, you need to cultivate new leads for work through your network sources. It can take months to get from an original contact to finally starting a job. Keep the network flowing so there are different clients in different stages of the queue. This will keep your workload steady. It should go from networking, to contact, to appointment, to estimating, to designing, to approval of designs, to contract, to scheduling, to purchasing, to painting (about time, eh!) to final approval of project, to billing, to payment received, to thank you card or gift.

I go to the grocery store after work still dressed in the paint spattered clothes I wear on the job. I got tried of getting looks of disdain from other shoppers because of the way I was dressed, so I took a bad situation and turned it into a networking moment. I had shirts printed with "I am not a slob, I am a professional decorative painter" in large type on the back. Now I get work when I go grocery shopping, or at least people talk about me and what I do, and there are no more disparaging looks!

People tend to think of networking as going to a trade show or business meetings, but what you need to realize is you have the possibility to build your network everywhere, all the time.

—Cynthia Davis

You'll likely start small, with a few of these contacts offering you a chance to bid on a job. Once you do the job and the client is happy, he or she will tell friends about you and that is how your network builds.

You can be involved in more than one networking system, so imagine what that can do for your business—perhaps more work than you could ever do, tons of money, instant success and fame. Your dream comes true. At least that's what I thought. In the early years of my business, I sought advice from a wide variety of sources (especially any free consult) including family, friends and colleagues. They advised me to put together a professional portfolio of my work, create a professional business card and letterhead, and then go out and press the flesh anywhere and everywhere.

Even though I felt comfortable speaking about myself in front of others, I was a little apprehensive when talking about myself in settings where I knew no one. In the early to middle years of my career, I tried to join networking clubs like the Rotary Club, my local home builders association, American Society of Interior Designers, chamber of commerce and various business networking clubs. I usually quit all of these in less than a year.

I went mainly for one reason, to increase my business. Instead of focusing on what the clubs or organization were mainly there for (helping others), I focused on how they could help me. I became discouraged after passing out some cards and talking to a few people and then not receiving any job offers.

When I attended the meetings, I sat in a corner by myself and didn't make any real serious attempts to engage in conversation with anyone. I did not join committees because I did not want to waste my time if I was not getting any work out of this. I thought I would get work by simply attending these meetings. Wrong. Like everything in life, you get out of it what you put into it.

I put very little effort into my attempt to enmesh myself into the professional networking clubs and organizations, and that is what I got out of them—very little.

Now I am only involved in organizations that closely align with my personal, spiritual and professional interest.

Before you join a networking organization, find a group you believe in and want to be actively involved with. It is only by getting to know the people in the organization and helping them that ultimately you can help yourself.

If you are doing it right, networking isn't something that takes a lot of extra time in your life. It will easily blend into your daily activities and relationships. If you see everyone as a potential contact, you can network during any common daily occurrence from waiting in line at the bank, to working out at the gym or going to PTA meetings.

Successful networking is a two-way street. Your company receives help from others by offering to help others.

Local Networking

Local networking is where you will have the greatest impact on your business. This is a process that should start as soon as you conceive the idea for your business and never end. In advertising, it is said that a message must be seen or heard an average of six times or more before it sinks in. Networking is the same. Do not simply mention your business to someone once and expect results. This is work and you have to expose yourself over and over and over to everyone you know to get the message to sink in.

On the local networking level, I am involved with my church, my children's schools, a faux finishers guild and my local Stencil Artisan League, Inc. (SALI)

chapter. It took me awhile to learn what I wanted to be involved in and why. Here are some local networking systems I strongly recommend:

Use your established groups. In the beginning (and throughout the rest of your career), use your already established network of family, friends, coworkers and ex-colleagues to spread the word about your business.

Belong to programs involving your children, like their schools' Parent Teacher Association (PTA) and cross promote your business occasionally as you get to know the other members and become more involved with them.

Be active in your church and its programs and cross promote as you do in your children's school or sports programs. Always have business cards available to pass out on any occasion.

Try a young business leaders networking organization in your city or any charitable organization you believe in. Do some research with your chamber of commerce to find programs that are already set up in your community and pick one that feels comfortable. Be careful not to overextend yourself and then not be able to be involved in any of these organizations because you are spread too thin.

Establish business-to-business relationships. After you establish personal contacts, use your new business contacts to acquire additional, newer business contacts. By business contacts, I mean interior decorators, home builders, general contractors and any other type of business that you may work with or share similar clientele with. Over time (in my case this took years, not months), you build up a solid base of interbusiness relationships that you constantly nurture and deepen. People recommend people who they trust and like and who do what they say they will do when they say they will do it without the least bit of hassle or complaining.

Try your home builders association as a way to meet new contacts who you can benefit and in turn they may be able to help you. They may do some charitable projects; if so, volunteer to be on a committee that may need your skills as a muralist. The more involved you are, the more contacts you make.

Interior designers and architects have many different organizations and functions that either you can belong to or speak at as an expert on decorative painting.

Try a trade group. Join your local Stencil Artisan League, Inc. (SALI), Society of Decorative Painters

TRADE GROUPS FOR MURALISTS

There are many different trade groups available for muralists. These are great places to network on a local, regional and national level. The Professional Decorative Painters Association is a new group forming as I write this book. I am on its board of directors along with contributors Pascal Amblard, Sean Crosby, Pierre Finkelstein and Nicola Vigini. More information is available at www.pdpa.org. Here are some other, long established groups:

• **Stencil Artisans League, Incorporated (SALI)** was organized in 1983 and is an international nonprofit organization dedicated to promoting and preserving the art of stenciling and related decorative painting.

SALI is now focused on the whole field of decorative painting, from stenciling to faux finishes, plasters, concrete products, murals, and any other form of artistic painting. Membership provides opportunities for artistic and professional growth through education, certification, public awareness and networking. I feel it offers the widest degree of knowledge in our field without being influenced by any specific products or manufacturers. Its Web site is www.sali.org.

• **Society of Decorative Painters (SDP)** started in 1972 to foster interest in and create recognition of decorative painting around the world. It's also a great resource center for all aspects of decorative painting. SDP is a very large international organization that has local, regional and national functions. They deal more with the fine art aspects of using a brush and learning many valuable ways to paint in smaller detail. Rebecca Baer, a contributor to this book, is a very well-known leader in this field and her painting style in the book represents part of what SDP teaches. They have many talented teachers who can show you how to paint fur on an animal, feathers on a bird or realistic flowers. I feel muralists can advance their speed and techniques by becoming involved with this organization. Its Web site is www.decorativepainters.org.

• **Painting and Decorating Contractors of America (PDCA)** was established in 1885 to help regulate and improve standards and working conditions in the painting industry. When I first started in this trade, I read the PDCA magazine to get a good general knowledge of how to prep and basecoat my projects. I especially liked the articles on wood graining, marbling and other decorative painting techniques. Its Web site is www.pdca.org.

ARTIST'S INSIGHT

I started my painting career in 1975 and by the mid to late 1980's I had built up my name locally to the point where I was looked upon as a leader in this cottage industry called faux finishing (at this time some people still called it fox finishing). I was always looking for new and different revenue streams, and many people wanted me to teach what I knew. I was reluctant to agree because I feared I would be teaching my own competition, and I did not want to diminish my market share. Susan Theil, a friend of mine, told me about the Stencil Artisan League, Inc. (SALI), a group of stencilers that she had been associating with on a regional and national level. She had decided to open a local chapter in Cincinnati. I decided to teach stenciling for the chapter, but no faux finishes.

I did this for four to five years, and at each class everyone wanted to know how to do my faux finishes. These were the secrets I did not want to share. At the time, faux methods were still relatively unknown to the majority of people. I was not the only person who did not like to share artistic knowledge. There is a steadfast tradition (dating back centuries) of decorative artisans dying without ever sharing their secret formulas or techniques.

Susan spoke so highly of the national SALI organization that I decided to go to my first SALI convention in 1996 and teach painting on glass and basic faux finishes. I was very impressed by the extremely organized event. There was tons of information and techniques being freely shared in a fun, caring atmosphere. I came home changed, and I decided to teach in my own market with that same attitude. Since that time, my reputation has grown locally and nationally, and my market share never diminished. Instead, my volume went up even though I have trained hundreds of people in my own territory. I now feel that with better-educated technicians and a more educated client base, the whole industry benefits.

—Gary Lord

(SDP) or Painting and Decorating Contractors of America (PDCA) chapters, or any other artistic trade-related organization. Each one of these groups deals with the decorative painter in slightly different ways, and like everything else I mentioned, you get out of it what you put in to it.

These organizations will put you in touch with other people who have similar interests in the decorative painting trade. They can share their wealth of knowledge and personal business experiences to assist you in attaining your goals. For any of the organizations to be beneficial, you and the other members need to be open, honest, sharing, truthful and caring.

My city has a Faux Guild that meets monthly to discuss the trade, demonstrate new techniques and products, and basically drink wine and vent or rejoice in an understanding atmosphere with kindred spirits. Sometimes your spouse just doesn't want to hear any more "shop talk," and all of these venues are good places to release that tension to an understanding ear.

National Networking

Regional and national networking helps you in a different way than local networking. Instead of generating clients, it can help you generate creativity and show you how to develop new skills and techniques. It's also a great way to stay tuned in to the latest products and trends.

Nationally, I am involved with the Professional Decorative Painters Association, SALI, the National Society of Decorative Painters, and Murals Plus.

As I mentioned in the Artist's Insight on this page, I was amazed at how freely and honestly information was shared when I went to my first national SALI convention. Let's face it, many of us feel threatened by revealing too much personal information to our direct local competitors. This usually comes through experience from the "school of hard knocks." When you are involved in a less threatening environment, you are more apt to share and receive more valuable information.

Attend conventions. I strongly suggest attending the national convention for SALI, SDP, or PDCA. The networking at the conventions is fantastic, and you can also take classes, listen to seminars or explore an expo for what is new and unique to you in the field of your passion.

Take classes. Take classes around the country from a variety of artists whose work you respect. Many if not all of the artists in this book teach around the country at conventions, schools or in their own studios. If you like what you see of their style, call or e-mail and ask for more details about their classes. Their contact information is in this book (see page 158).

Not only will you learn from these great artists, but you will network with all of the students in the class. At lunch or during the evening, the classroom is charged with the energy of learning and sharing the passion for painting. Often, in these types of settings, you can make lifelong friends who you can confide in and share your worries about work. You can also share your highs and lows with someone who understands where you are coming from. If you have never taken a class, do so. It will re-energize you and motivate you to move to the next level of your chosen career.

Global Networking

I think the largest way to network is online. You can reach people down the street or around the world, all while sitting in the comforts of your own home or office. I am in my 50s and I admit my children know way more about computers than I do. But I do know that computers and the Internet are currently an essential business tool and will become even more dominant in the future. There are thousands of decorative painting Web sites and forums that let you share and receive information from other decorative artists around the world. Do a search as specific as you like and you most likely will find something relevant. But be careful; I choose not to spend a lot of my time searching and reading information on these sites because it can be very addicting and then it takes time away from something else, usually my family.

Online communities. My friend Martin Allen Hirsch asked me to be a moderator on his Web site, MuralsPlus, so I agreed to look into it. The wealth of knowledge and how freely it is shared and the quick (almost instant) responses to any business, faux or mural question asked is staggering to me. The answers are diverse and leave you with many good options to think about. Often, information overlaps and reinforces the correct way to approach something. There are very smart, seasoned artists on this site who share their experiences with no reservation, in a noncondescend-

ONLINE DECORATIVE PAINTING FORUMS

- MuralsPlus, www.MuralsPlus.com

- FauxTalk, www.fauxstuffonline.com/FauxTalk/

- Atrium Online, www.atriumonline.org

- The Faux Finish School, www.faux-painting-finishing-board.com

- The Finishing Source, Inc. www.fauxfinishingsource.com/forum

ing manner. It does not matter if it takes you months to work up the courage to ask a question or if you're just a new member who wants to know everything. Ask a lot of questions. There is an archive of invaluable information that addresses many different topics in very informative ways. Some people are on this site every day, posting many times in one day. I have only been on the site since May 2006, and as of February 2007, I have less than two hundred postings. I often read the questions and have no response because smart answers have already been given and there is no need to reply unless you feel like being chatty. Many of the forum participants have become good friends online and meet each other at conventions or attend classes around the country together.

Contributor Melanie Royals is another moderator on MuralsPlus. She also moderates on the Atrium Online. Contributors Randy Ingram and Brian Townsend are moderators on FauxTalk where they and many other moderators will address all kinds of painting-related questions.

No matter what level you're at in your career, I highly suggest looking into some of these online forums. Find one that fits your personality and become involved. It is one of the most open and sharing networking systems I know of for this industry.

MARKETING

KNOW YOUR MARKET

Before you can effectively market your services to anyone, you need to study your target market to understand its needs and desires. Here are some essential questions to ask while you research:

• **Who is my target market?** My market is mostly high-end residential consumers, churches and businesses such as hair salons, restaurants, doctors' offices, and furniture stores. When I started my career, I heavily marketed to interior designers, architects and builders because I knew they could help me find a constant infusion of new and repeat business through word of mouth. They have contact with the type of clients I need, so I market to the designers and builders so they can market to their clients on my behalf.

• **Is there a large number of potential clients in my area?** Evaluate how large your market is and how many people are currently doing the style of painting you want to do. Then decide how you can fit into the market size. I live in Cincinnati, Ohio, with a greater metro population of about 2 million people—a mid-size market with room for growth.

• **Are customers and their needs fairly homogenous to the services I want to offer?** I decided at the very beginning of my career to offer both mural painting and decorative painting to my client base. It is very difficult to make a full-time career doing nothing but mural painting (at least in my size market). I also believe the skills acquired as a decorative painter enhance your mural painting skills when they are combined together, and I offer more value to my entire client base if I am a one-stop shop for all of their decorative painting needs. What services do you want to offer, and are they needed? How competitive is your market currently?

Artistic talent certainly plays a large part in what we offer our clients, and if your natural talent is better than others in your local or national market, that is to your advantage. If your work ethic is better than the average person in your arena, this too will help. But I feel that being a better marketer is even more advantageous than being the best, hardest-working artist, because people can only buy what they know about. I know many artists who have far greater talents than I can ever hope to possess, but they do not know how to promote

themselves effectively and eventually that is one of the reasons they may go out of business.

Marketing is almost as old as mankind itself. A market was originally a simple gathering place for people to supply products or offer to perform services for others. The sellers and buyers sought to understand each others' needs, all with the goal of exchanging items or services. We basically do the same thing today. All businesses first determine potential customers' needs or desires and then build the product or service to match that desire.

Once you know your market (see the sidebar on this page), you can work on the two major aspects of marketing: recruiting new customers, and maintaining and expanding existing customer relationships.

Recruiting New Customers

I recruit new customers in a multi-pronged approach that is repeated year after year. This process never ends. Early in my career, I decided to use interior designers, architects, builders, general painting contractors and paint stores as a means of getting leads in my target market, and I still work those sources to this day. In the beginning, like everyone else, I paid cold calls to these people and tried to show them my very limited portfolio. Over time, as my networking skills and my reputation in the marketplace increased, I used other, additional contact sources for leads as well. Much of the recruiting process is related to local networking (see page 16).

Selling to new customers. A service business like decorative painting is intangible; it cannot be experienced before it is delivered, which makes it risky in the minds of potential clients. They don't know if they will actually get what they want. To reduce this feeling of risk, and thus improve the chance of winning a job, potential customers need to see many examples of your service and products.

I want my clients to feel as comfortable as possible, so I have a four-color printed sell sheet (see page 21) that has facts and information about my company and photographs of completed murals that I can leave with potential clients after an appointment. The sell sheet includes my contact information and my Web site address, where they can see and learn even more about my company.

In my initial presentation, I show examples of many mural projects completed by my company. I also have personal testimonials from prior clients describing the value they perceived in the work my company did for them.

Maintaining and Expanding Customer Relationships

In my more than thirty years of experience, I have worked for thousands of different clients. Some individual clients are repeat customers, but a higher percentage is not. It is much easier to retain interior decorators and home builders as your repeat customers. Some artists do not like to work with the interior designer or architect. I personally find them invaluable to my business, and they act as my satellite sales force and are only paid a commission when a job they brought to me actually goes through to completion and final payment.

It takes time and effort to establish a profitable, trusting relationship with a decorator or builder. I have made hundreds of thousands of dollars through contacts from designers whom I have been working with for years. I am able to retain these relationships because I treat the designers and builders like the friends they are. I nurture and care about each relationship even if I am not currently working on a project with that person.

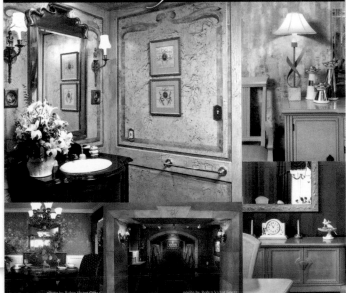
Sell Sheet. My sell sheet is a quick and easy way to introduce my company to potential clients. The sheet includes professional photos of my work, lists my company's awards and accomplishments and includes all of my contact information, including my Web site.

Advertising is getting your information out to the public by using paid or unpaid communication formats. By effectively spending your marketing and advertising dollars repeatedly over months and years, you will create strong brand awareness for your business and its name.

My company does a lot of work for the corporate offices of Proctor & Gamble, the largest advertiser in the world, which spends more than $3 billion a year in advertising. An executive once told me the company spent twice as much money on advertising than it needs to, but they did not know where to cut the extra advertising budget. The decorative painting industry is a cottage industry, dominated by small businesses that often employ only 1 to 4 people. The revenues are comparatively small, with the majority of the businesses grossing less than $250,000 per year. Therefore, the amount of money that can be allotted to paid advertising or marketing must be wisely spent, and unlike huge corporations such as Proctor & Gamble, you cannot afford to incorrectly guess where to spend your advertising money half the time.

In the many years I have been in business, I have tried advertising in all medias: newspapers, magazines, bulk mailings, radio, television, the Internet. Many of these were a waste of money for me, but some proved to be money well spent.

Word of Mouth

The most successful way I've found to spend my advertising/marketing dollar is by word of mouth. There is a very successful national company that you likely know (and may love) that does not pay for any advertising—Krispy Kreme Doughnuts. They have built up their name and brand recognition by word of mouth.

The best way to promote word-of-mouth buzz is to keep in touch with customers, and maintain peer-to-peer (business-to-business) relationships. I do this with follow-up phone calls after a job has been completed for a few months to make sure everything is still OK. I send out thank you flowers to every completed job. I send holiday cards and greetings to these customers and colleagues. I send special VIP offers of discounts on their next project or let them pass this discount on to a friend, and at Christmas time we send out a small gift.

With the computer age, I am now developing a blog site where anyone can check in on my company's newest projects and techniques with full descriptions and photographs of the works in process. Melanie Royals, a contributor to this book, writes two blogs that offer outstanding information on decorative painting. You can find them at www.designamour.com and www.artoflivingonline.com.

Trade Shows

The second best way I use my advertising dollars is on preselected audiences that already want to buy my services. Go to where an established audience wants what you have to offer. Find the consumers when they are in the mind-set to look for, if not buy what you have to offer.

You'll find these potential customers: at local or regional expos such as home and garden, remodel or kitchen and bath; a local builders' home show (either by working in the homes or participating in the trade show booths); and any professional trade association expo where you can be a vendor to offer your company's services to other construction-trade-related businesses.

Listing Online or in Yellow Pages

After word-of-mouth and trade shows, I've found it's useful to make my company name available in reliable resources that consumers search when looking for a decorative painter. These resources can be Internet-based and include general online classified sites (such as Craig's List) or industry-specific Web sites such as The International Directory of Decorative Painters (www.fauxdirectory.com).

You can also list in the yellow pages or business section of your local telephone books. Advertising in these listings is my third choice because I learned over time that the majority of people who found my name this way were shopping for price first, not quality or service, so oftentimes, I was not what they were wanting (because my services did not fall within their budgets).

Mass Media Advertising

Finally, you can throw your name at a ton of people by advertising in the mass media, such as TV, radio, newspapers, bulk mailings and magazines with local, regional or national coverage. This is the most expensive way to advertise, which makes it more challenging to get a return on your investment.

I have tried all of these mass medias at one time or another and have had very limited success.

WORKING WITH CLIENTS

Quality results when you provide products and services that meet or exceed the customer's expectations. Quality is also associated with having a high value for the cost attributed to it. In mural painting, the key to providing clients with superior quality in their finished mural is excellent verbal and visual communication. This process takes place through open, back-and-forth dialogue with the client. This communication begins with the first contact you make with the client.

Consumers seek professional muralists because they cannot create their artistic vision on their own. They may not even be able to verbalize exactly what it is they envision. The professional muralist must be a detective first to find out what the client's vision is—to discover what kind of mood they want the finished mural to project. Perhaps it is a tranquil meditative space, a serene atmosphere, a whimsical theme, something representational, biblical, allegorical, etc. For this awareness to happen, the artist needs to listen effectively.

Take notes while your clients are sharing their visions. Then repeat back to the clients what you just heard them say. This lets the client know you have heard their visions and ensures you fully understand what they are trying to communicate.

If the client has many scattered ideas for a project, ask leading questions to learn more about the client's desires. Often, the artist must clearly organize and sort through the ideas to discern the best option for the client's requested project. Be sure to clearly explain your organizing methods with clients so they know you are working in their best interest.

Find the Style

Once the theme of the mural is decided upon, the artist and the client need to determine the style the client wants the mural painted in. To offer superior quality to your client, you need to truthfully evaluate your own painting and drawing skills.

Art comes in many different styles as you can see by the wide variety of talent in this book alone. I certainly cannot paint in the same style that many of the artists in this book can. I have developed my own style over the years, and I truthfully face my weaknesses and embrace my strengths. There is nothing worse than saying you can do something that is not really in your skill level.

Show your client examples of your past projects and discuss areas of their proposed project that may be

Q&A

Q: What is the best way to understand a client's vision?

"If they do not know exactly what they want, I try to let them tell what they do not want. I also listen very carefully to the 'keywords' that they will use (space, sunlight, baroque, soft, colorful, soothing, dynamic, classical, Italian-like…) as well as their reaction to the keywords I use during our conversations. I look at their home and the style of decoration, of course, and I sometimes propose to bring books to one of the meetings to show them different options and see how they react." —Pascal Amblard

"I like to meet with clients in their environments so I can pick up visual clues about them—not relying just on the verbal ones. I ask them to look through my portfolio and to be vocal about their preferences or anything they have an aversion to. I try to really listen to them and their thoughts about their project and try to determine what it means to them. I make it a point to remember details like their children's names or that they love dogs and often note them in the client file, even if they are not related to the work. The first meeting is usually a brainstorming session. Often they have a better idea of how they want it to feel than how they want it to look. It's my job to translate." —Sheri Hoeger

"Use references, be they books, your portfolio, clippings—any kind of visual that can act as a common reference/starting point/springboard for you and your client. Every project I do started from something I or the client had. If a client starts talking about something they saw and you can't envision the image, tell the client that you cannot get inside their head and see what they are picturing. Try to find things that you can refer to together. One reference can be for technique, another for color, several for subject matter. If you can, use a photo computer program or cut and paste, combining the images to get a facsimile of the concept. Also, you can understand a lot of the clients' vision if they have lived in their house for awhile. Look around. Sometimes whole room schemes have been inspired by a little trinket or painting they had. Look also at the books they own. See what subject matters interest them." —Jeff Raum

After I had been painting professionally for many years, my company was awarded a sizeable contract to work in a new, upscale restaurant in my town. We did the mural designs in a minimal thumbnail pencil sketch. The owners accepted the sketches and we set about doing our work to meet their deadlines for opening.

As the mural was progressing, the clients kept saying how much they loved it. Soon they liked it so much they wanted to add more detail than on the thumbnail sketch. (The sketch was small and did not really show every elevation in full detail.) Because this job had potential for great exposure, we kept adding more elements. We added quite a bit and finally I decided that if we added anything else, we would need to charge an additional fee. This did not make the client happy. We discussed it and I agreed to one more day of extras at no charge. By now, the restaurant was open, and the only time we could paint was on Sunday morning. I had to pay my people time-and-a-half to do what I thought was an extra, but the client felt they had contracted for this work. The client slept in and was three hours late that day so I lost all of that time and money and had no one to charge for it. The mural won rave reviews by the media and the public. Even though this restaurant became very successful, the owners were unhappy with the overall quality of their mural experience, and they did not tell anyone who painted the mural.

For me, the moral of the story is that the more detail in your designs and your contract, the better for everyone and ultimately the better the quality of the overall project. Quality is not just attained by a beautiful end result; it is the whole experience that determines overall superior quality.

—Gary Lord

similar to projects you have done in the past. This is a great time to use your marketing sheet. If the client, or even you, show an example of someone else's work as a concept of what might work in the client's space, make sure the client understands the differences between your style and the other artist. Sell yourself and what you can do for the client.

Verbalize the Painting

After the theme, mood and style of the mural are determined, the artist should create a verbal picture of the completed mural for the client. Describe the mural in the client's own space with enthusiasm and passion. Make sure the clients verbally commit that they love this vision as you have described it. If they don't like what you're describing, ask how they would change the vision and work with them to incorporate their desires into the vision.

Discuss Budget Options

At this point, I ask clients if they have a budget they want to stay within. I feel a general budget needs to be determined before any designing takes place. This way the client receives drawings for a price point they are comfortable with, and no time is wasted. Most of the time, clients will not know or will not commit an answer, so offer preliminary budgets based upon earlier discussions. I usually will give a range of prices that can be hundreds or even thousands of dollars apart, depending on the way the mural is painted.

I switch into a teacher mode and inform the client why certain styles of painting cost more than others. I explain how realistic painting with atmospheric perspective and three-point perspectives with a lot of detail take longer to paint than no perspectives and washy rendered areas. I use examples of other projects I have completed to illustrate the differences in the final products for the client. See the *Pricing* section (page 27) for more information on this topic.

Designing the Mural

Once your verbal communication is completed and the client likes the ideas, it is time to move into the design phase. I ask for a retainer fee for the designs before I do any design work at all. This money goes toward the cost of the total project, and if the job does not go through, I will keep a certain percent for the design time used. At

This is the maquette Cynthia Davis created for her mural demonstrated on page 82.

Q&A

Q: How do you save time on a job?

I take time to prepare the job and take the time to do a good maquette. On the maquette or rendering, I deal with and solve all major technical aspects: research of the best references, composition, drawing, perspective, values and color. Once I have done all these things, I am ready to start, and I waste very little time during the painting process, as pretty much any potential "trap" has been sorted out beforehand. It does not mean the maquette has to be a masterpiece. I only do sophisticated maquettes if required by the client or if I see it will help me in securing the job.

—Pascal Amblard

This is the final sketch for the mural demonstrated by Marc Potocsky on page 118. Include as much detail as possible in your final sketch so both you and the client know what is expected from the project.

first, I offer a pencil sketch of the mural concept, oftentimes with a few varying design options to choose from. Sometimes, these sketches are accepted immediately with no design changes at all. Other times, there may be small, minor variations required, and still other times, I may have to start all over because it was not quite what the client envisioned. Work on this process until the pencil sketches are drawn to scale and approved. Some of the contributing artists in this book will do a full-color rendering of the finished palette of the mural at this point to make sure the clients approve of the colors to be used. This step certainly costs more money on the front end, but often prevents disagreements later. It is also faster for the artist to have the palette worked out ahead of time so you do not have to guess your way through the colors on the job site.

Keys to Communicating With Clients

- Listen effectively. Ask questions and take notes.
- Clearly and realistically explain your painting skills and styles.
- Describe the painting with words before you start the design.
- Consider charging a retainer fee for any design work you perform.
- Make your final sketch as complete as possible.
- Describe the finished mural with great clarity and detail in the contract.

After the design and colored rendering are approved, it's time to draw up the contract. Make sure you have an amply detailed verbal description of the approved design in your contract so both you and the client are clear about what is expected. My general contract is about three pages long. This contract was created after years of experience in the decorative painting field, and I consulted a lawyer while writing it. Here is a basic outline of what each section contains:

General: The first paragraph establishes that the contract is legal and binding and establishes the means for changing or adding to the contract.

Scope of Work: This section fully explains the project in detail and stipulates that any additional work or modification will result in an additional charge. It also includes a line that makes all contracts noncancelable once work has commenced.

Payments: I always establish the method of payment in my contract. I ask for a 50 percent deposit at the client's acceptance of the contract with the balance due at completion of the project. Another option is to ask for one-third of the payment at the signing, another third at the start and the final third at completion.

Project Time: While my company strives to complete projects in a timely manner, we all know unforeseen setbacks can arise, so I always include a paragraph that makes the client acknowledge deadlines are only estimates. I also give myself the option to reschedule or charge the clients a penalty if my company cannot start work on the designated date because the work area is not in the proper condition or the clients are not available.

Work Area: I ask the clients to be responsible for moving, removing, storing, protecting and replacing light fixtures, fans, furniture, appliances, drapery and any other personal property that may be in the work area. Remember, you are a decorative painter, not a mover. You don't have time to move their belongings *and* paint. Plus, you run the risk of breaking or damaging their belongings.

Limits of Liability: This paragraph is very important as it prevents the client from holding my company responsible for delays and damages caused by outside sources.

Artistic Discretion: In this paragraph, the client acknowledges that the designs, colors and samples are merely representational of the finished product. The client is instructed to be available to monitor progress throughout the project to ensure they are satisfied that the final project matches the design. If they're not available, this paragraph allows me to use my own discretion when completing a job.

Finished Results: This paragraph explains how finished results may vary from samples due to: (1) Actual surroundings inclusive of lighting and shadow effect, position, location and the environmental influence of wall colors, draperies, furniture and flooring materials; (2) Paint mix; (3) Wallpaper and fabric dye lot; (4) Product, fixture, wall or ceiling surface type, composition, condition and texture; (5) Irregular transition lines due to structural design, grout or caulk and/or dissimilar texture at walls, ceilings, corners or trim work and (6) Manufacturers' color changes, production inconsistency and variances.

Condition of Merchandise: I only sell merchandise in good condition and my company isn't responsible for damage incurred through or due to transportation, handling, installation, storage, contractor trades, the client or any other source(s).

Modifications & Repairs To Work Completed: This paragraph explains the process for making repairs and establishes an additional fee for any work the repair may require, including additional designs or samples.

Texture Disclaimer: This paragraph is especially important for faux finishes. The client acknowledges the finish is permanent and will damage the surface if it is removed. They also acknowledge that my company isn't responsible for damage caused by removing the finish. I include a line recommending that all textures be applied over a wallpaper liner or other suitable barrier for ease of removal. It's the client's responsibility to apply the liner or barrier before work begins.

Reservations: I always reserve all rights of reproduction and all intellectual property rights for my projects. This paragraph prevents clients from using my samples to get bids from other decorative painters to perform the work. If they do so, I reserve the right to charge a design and consultation fee.

Default: This paragraph makes the client responsible for any costs and expenses incurred by my company while attempting to collect late payments.

Governing Law: This paragraph establishes what laws are used to interpret and govern the contract. For my company (located in Cincinnati), contracts are governed under the laws of the State of Ohio.

PRICING

I love this saying: "Quality is long remembered after price is forgotten." How many people do you think know how much it cost to paint the Sistine Chapel?

Like it or not, though, the quality of what we offer must have a value cost to it that people are willing to pay. You cannot price the work so high that very few people wish to purchase it, but at the same time you need to set a price that is profitable at a fair market value.

"If you undervalue yourself—the world will under value you!" That's the advice on setting prices my friend Rebecca Parsons gives in her workbook, *Do What You Love—Love What You Do*. It is an in-depth, step-by-step guide to operating a faux finishing and mural painting business. I highly recommend it as a companion to this book. It has helped me even after thirty years of working in the field.

The mantra in the business world is *better, cheaper, faster*. When costs go down and productivity goes up, quality improves. But cutting cost without improving quality at the same time is futile. We become more productive as artists after years of trial and error. By watching others, taking classes, reading and studying what others do, and ultimately becoming more confident in our own skills, we become more productive. It is a continual process to be better and to offer superior quality.

All businesses have to establish a price point that allows them to be competitive in the marketplace and still maintain a healthy profit—how to do this is a complex question that everyone wants an easy answer for. So here is the biggest tip of the book: *Spend less than you make*. Sounds like common sense, but it is very difficult to do for a business of any size, and applying this principle is even more complex as your business grows and expands.

There is no magic formula that tells you how to bid the right amount for a job so you both win the job and receive the maximum dollar amount for your work. When many artists are starting out, most of their pricing is incorrect guesswork based upon what they think someone might pay for the work. Their guesses are based upon the artists' own preconceived notions of what they might want to pay for the work. Most artists have done very little research on their marketplace and the going rates for the skill level, experience and reputation that they offer to the consumer. Don't make this

mistake! Do your research. Find out what your market is paying by asking other artists, interior designers, or architects in your area. Markets differ all over the country, just as housing costs differ by region.

Track Your Income and Expenses

The first step to determining pricing is to maintain accurate records of all of your business income and expenses. See page 12 for information on bookkeeping for your business. Without accurate records, you have no idea if you are making or losing money. You won't have any sense of how much money you earn per hour.

You also will have absolutely no idea of what to charge for a job until you know what all of your expenses are. One rule of thumb in business is that you have to spend money to make money. So, do not be afraid to spend money wisely, because in the long run it will make you money.

Every business will have its own set of expenses, and its profit margins will be based upon those expenses. The larger you are, the more expenses you will have, and the lower your profit margins become. Grocery stores gross billions of dollars each year in sales and as a rule only make a 1–3 percent profit because the margins are so low. High volumes of sales (billions of dollars annually) allow them to do this and still make money. To make money in the decorative painting industry, you must have higher profit margins on low sales volume. At the size it is now (three full-time and three part-time employees), my company runs at about 34 percent net profit. Each person's company will vary depending on the company's total financial makeup. When I worked alone and had very little overhead, my net margin was around 60 percent, but I was doing fewer jobs.

Pricing Factors

Pricing is a funny thing in the design industry. Why should a pair of Versace jeans cost so much more than Levis? Why do Gucci purses or watches from Tiffany's cost what they do? Certainly, some of the expense is attributed to the quality of the manufactured product. Perhaps the raw materials that make the product are very expensive, or the craftsmanship is unbeatable. Perhaps it is the designer's established record of creativity that influences the whole industry.

REMAIN CREATIVE TO REMAIN PROFITABLE

The old saying, "twenty percent of the companies do eighty percent of the work in their field," is true for every business, including decorative painting. If you want to survive in today's market, you need to position yourself in that twenty percent. How do you do that?

The answer is very complex and multifaceted but really boils down to three things: offer the best in quality, service and price. If you do that consistently for years, then you will rise to the top of your field.

Because this industry has been around for centuries, and in its current form for at least thirty years, the consumer looks for unique and creative techniques to determine quality. Dave Schmidt, a contributor to this book, heard that the Do-It-Yourself and faux finishing market is beginning to slow. I can believe this is true if all a faux finisher offers is basic finishes taught at the paint store or home improvement store. Even though these finishes may be painted with excellent craftsmanship, they still have become a commodity item because they are commonly found and relatively easy to do.

Once a business' main line of goods becomes a commodity, price often determines who will be awarded the job when all else is equal. For a business to win the price war and be profitable, it would have to be the Wal-Mart of decorative painting. You can only make money with low prices if you do extremely high volume, which is not usually possible in our trade.

So where does that leave us? Quality and originality are the skills that will help drive your profit and keep you alive in today's market. You cannot simply offer your clients the sample boards you learned in a class or from another faux finisher. You need to make them your own by experimenting—changing the ingredients, using other colors and patterns, etc. Strive to make yourself unique at a price point that is fair to the client and allows you to make a profit.

Similar issues affect the pricing for the decorative painting industry. How long have you been in business? What kind of service do you offer? What is your reputation? What is your skill level? What kind of quality do you offer the consumer? In our competitive marketplace, more experience and a better reputation for service, quality and skills allows you to charge a higher rate.

Supply and demand also is a factor in pricing. If I am swamped with work, my prices go up and vice versa. If I am slow, my prices come down. Your goal is to build the reputation of your business so that it becomes the "go-to" business for the service you offer. Make the consumer think or say your name when they want your product. This takes years of building up your network, marketing and promoting yourself, and exceeding industry standards year after year. Do not be afraid to charge the maximum dollar amount you can along each step of the path until you reach the top.

Bidding a Job

I bid all of my decorative painting work in two ways: a *square-footage price* compared to my *per-day rate.* My day rate is based upon the expenses of my company, its total overhead including taxes and then adding in my profit margin. For mural painting, I try to get between $600 to $800 dollars per day, depending on supply and demand. My prices are based upon my reputation in the market I work in and the level of competition in my market.

My square-footage rate is based upon past experience and knowing how long it should take to execute the level of difficulty of the mural being considered. I can spray paint large sky murals very quickly, so my square-footage rate will be less for that project because of the speed with which I can complete it. A detailed mural with perspective and a lot of realism takes longer to execute, so the square-footage price increases.

I compare these two ways of looking at a project and come up with a balanced number to bid for the work. Then I keep notes and when the project is done, I compare the actual cost of the materials and labor used to the price I was paid. This shows me just how much money I actually made and helps me make a more accurate bid the next time a similar project comes up.

Q: How do you set your rates?

"Nicola Vigini and I came up with a system based on the difficulty of the project and then charge by the square foot. The easiest (and lowest priced) is faux and patina, then skies (depending on the colors—sunset/sunrise), then landscape and architecture, then fabric and marble in perspective (tile). Figure portraits are the most complex and have the highest cost per square foot. We also consider the promotional value for works we would do in nice restaurants or some other public work. Using that base, we also consider marouflage versus onsite work. As I build a reputation for good work, I can pick and choose work that I am interested in doing and refuse work that I'm not excited about. I can also charge more because the client recognizes my abilities based upon other works I have completed."

—Sean Crosby

"I decide what I want to make per hour and multiply that by a seven-hour day. That is how I came up with a day rate. I also have a day rate for my assistant who is always on the job. After twelve years in business, I am usually fairly accurate with estimating days for the job. Then I add material cost. I also charge for sample boards because it is additional time when a customer wants something that isn't in my portfolio. Ninety percent of the time, I do new samples. This keeps my ideas fresh and my portfolio exciting. When I present a job price, it is not broken down by days or hours to the client. They pay that price whether I am on the job for an extra day(s) or if I finish early. The client has no surprises this way. If I lose money on one job I always seem to make it up somewhere."

—Cynthia Davis

"I bid the whole job, but figure it by multiplying my day rate by my best estimate of time plus materials. If it is something really difficult or unknown, I sometimes factor in twenty percent additional or give the client a ballpark estimate. If I'm not sure whether I'm on target with the daily rate, I'll sometimes figure it by the square foot to double check."

—Sheri Hoeger

"Time!! (basically how long it will take you to do a job) and materials. Then decide how much you want to make per hour or per day. You have to make sure you add in supplies, drive time, prep time, setup time and tear down time and also the extra if-something-should-go-wrong."

—Marc Potocsky

"Since I have been in business for eighteen years, I'm pretty good at figuring how many days it will take to complete a project, and I give a bid according to my day rate. I figure day rate for murals and some-times square-foot rate for faux. If I get an intuition that the client may be difficult, I tack on extra to cover myself. If I don't get the job, maybe it was for the best."

—Jeff Raum

"When I first started out painting, I would take any job, at any price… and on a lot of jobs I was happy to break even. My goal was to learn the business, inside and out, and to develop a satisfied client base that would support me in the long run. How I charge now is based on overall painting and design expertise developed over the past twenty years. I calculate in the tight work and professional demeanor that my team brings to the project. Giving clients exactly what they want has a price! The cost is primarily derived by calculating man-days needed, materials and the scope of the project, and of course, factoring in overhead cost. I believe in always being fair in price, delivering the best possible finished project to my clients. Everyone on the project works hard for the referral and the repeat job."

—Randy Ingram

"I was working for a studio (in Italy), and they paid me the basic rate for beginners. When I started to price jobs, I learned how to charge from the studio owner. Their method is based on the time involved to execute the project and the rate your competitors would charge in the local market for an equivalent finish. If your competitors cannot produce something that is equivalent, you have a bit of an edge and can charge more. My pricing is still based on the same factors. I charge more than some of my competitors, but only if I am offering more in terms of quality."

—Alison Woolley Bukhgalter

SERVICE

ARTIST'S INSIGHT

As I was writing this book, I painted a mural that has a special meaning to me. Even though these clients attended my church, I did not know them very well. A year or so ago, they asked me to paint a mural in their daughter's room. I of course said I would be happy to and tried to set up a time for a meeting. The wife had just been diagnosed with pancreatic cancer, and the meetings were delayed. After several attempts to reschedule with no immediate results, I became busy with other work and only heard about her status through church. Less than a year had passed when I received another phone call from the husband, wishing to try to reconnect to create the mural.

His wife's health was failing and she was in the care of hospice at home. She had requested to have her vision painted in her daughter's room so her daughter could always have her with her. Prior to her illness, the wife had designed the mural concept herself using stencils available on the Internet. Her vision was a little princess's room with floor-to-ceiling arched gazebos around the entire room. In between the arches were castles, fairies, flowers, unicorns and rolling hillside. She had purchased many of these items in pre-cut stencils because of her limited drawing skills. She had even used a computer to create an elevation drawing of the main focal wall behind the bed in the colors she wanted. The couple asked me to come in and execute this vision for their seven-year-old daughter. I consulted with them about minor details, then scheduled the work for the next week because time mattered. I had two women help me paint the project and we added extra touches to the project by putting beads on the fairies and glitter on the unicorns. Other than that, it was pretty much the wife's vision. While we were painting, the wife took ill once again and was admitted to the hospital. She returned home the night we completed the mural. The husband later told me his wife willed herself up the stairs and walked into the room to see her project completed. She died two weeks later.

I know I am blessed to do what I do for others, but I have never felt more honored than when I was requested to do this project. This mural will have a far-reaching effect in that household and allows the daughter to be surrounded by her mother's love in her room created for a princess.

—Gary Lord

Once you have been awarded a job, you need to keep your client happy in order to win possible referrals and repeat business. You can satisfy your clients through quality and service.

When it comes to customer service, I use a philosophy I learned many years ago in Boy Scouts. This philosophy seems simple and should be common sense, but in my career I have observed many businesspeople avoid some or even many of these concepts. Just think of how you like to be treated by others in business transactions. Follow these principles to offer the best in customer service.

Trustworthy. Tell the truth, always. Keep your promises. Honesty is a code of conduct. Allow people to depend on you each and every time. This sounds like it should be easy, but we all want to please our clients so much that we say yes too often. Then we have difficulties meeting our obligations. Learn to say no at the right time. People will respect you more for honestly saying no to a request than if you promise what you cannot deliver. Contributor Jeannine Dostal once told me, "When I learned to say the word *no* I became even busier because people were willing to wait." And because she could say no, she also could set a comfortable pace to deal with the larger workload.

Loyal. Be loyal to your interior designers, associates, clients and employees or business partners. If you stick with people and honor your business relationships, your associates are more likely to stay with you in your difficult times, which are bound to happen.

Helpful. Be concerned about other people. Do things willingly for others, sometimes without expecting pay or additional rewards. Contributor Cynthia Davis says, "You have to like people and be service-oriented to be successful in this field."

Friendly. Be a friend to all. Respect those with ideas other than your own. By being a friend to the general painter, the carpenter, the drywaller, or the builder on the job site, they may be able to help you move ladders, have a tool you need, know where the touch-up paints are and save you time in hundreds of other ways. Learn their names. Also be willing to share and help them with any of their needs. It is a two-way street.

Courteous. Be polite to everyone regardless of age or position. I heard a great story while working on a project at a manor estate in northern England in 2002. The estate owner shared his family's noble heritage, which

dated back to the 1100s. He was quite proud when he spoke of his great-great-grandmother. "Ah, there was a lady," he said. "She knew how to speak to a duchess or a dust man just the same, and they all loved her." If only everyone had that skill and humility.

Kind. There is strength in being kind. Treat others as you want to be treated. Follow the golden rule. We are asked to work in the most personal spaces of peoples' lives—their homes or offices. Think of how you would want your belongings protected, your privacy not gossiped about, and your project to be completed on time and above your expectations.

Obedient. Be ethical and follow the law. If you break or damage something, fix it. (Now, I must say I will try to fix it before the client finds out about it.)

Cheerful. Look on the bright side of life. Cynthia Davis says, "Do not bring in your personal problems. Love what you do and show your passion. It sells. People buy from those they feel comfortable with, no matter the price."

Thrifty. Save for unseen needs. Try to buy your products in bulk. Take care of tools and materials so you do not have to replace them unnecessarily. It is amazing how much everything adds up. Do not rob Peter to pay Paul. A good friend of mine lost his business because he was spending the draw money from one account to pay his bills and salary instead of buying the materials for that job. It finally caught up to him during a slowdown in work where the draw money could not keep up with his spending. Keeping accurate accounting records for each job is critical to success in the long run.

Brave. Face your fears and educate yourself on how to deal with them in a positive manner. Contributor Rebecca Baer says, "I do not like to read directions on products because I do not want to be bound only by what it says I can do. Breaking rules to be original is important, but by doing that, we have to be willing to fail. The reason we are successful is because we are willing to fail, and when we do fail it does not devastate us but makes us ask the question 'why?' and then seek the answer."

Clean. Physically, this is very important to do at the end of each day on the construction site. Studies show people are more effective and productive in a clean environment. This may take a little time, but it adds to your pride in the workplace and your finished job. Once again, think about how you would want people to

treat your home. At the end of the job, make the job site cleaner than it was when you got there.

Reverent. I believe in God, and my life benefits from that. I believe those I come into contact with also benefit from my belief. I believe in humility, and I try to approach every aspect of my life with the Ten Commandments in mind. I could be better, but I continue to try.

I believe the businesses that are the most successful incorporate some of the aforementioned morals and ethics into their corporate philosophies.

THE COST OF COMMITMENT

I am not a business expert by any means nor would I say are the majority of the other artists in this book. We may not have the perfect business models, but my approach and those of the contributors have allowed us to be successful enough to stay in business, often with great personal, artistic and financial success.

It is very easy to get addicted to saying the word *yes* when you are a business owner. All work comes through you in a small business, and if you say *no*, you fear you may lose that job and possibly any future prospect of a job from that designer or client. But when you say *yes*, you have to follow through, even if you do not know how to do something and it requires hours you did not anticipate. This all affects how well you can *service* your client, your family and yourself.

Long Hours

Saying *yes* all of the time comes at a price, mainly time spent away from family and friends. In the beginning, this may not be much and in all likelihood is necessary to build your business. Some sacrifices are essential but can eventually grow out of control. Almost none of the artists featured in this book work less than forty hours per week. Most averaged about fifty-five hours per week. Some people work seventy or more hours per week, especially in the years spent building up their business. I personally worked more than sixty hours a week for more than twenty-five years while building my businesses. There was a point when I did not want to count the hours, because it was too depressing to compare the hours I worked with the money I brought in. When contributor Dave Schmidt worked for me, he made fun of all the hours I worked while he put in his forty hours or less and "played" at night and on the weekends. Once he started his own business, those carefree nights and weekends became work-filled, and he probably works more hours a week now than I do. Certainly, there is a strange payoff when you say, "I am so busy I can work 24/7 and not get caught up." I have been there. You get there by not turning away any work, overcommitting yourself, taking on projects you don't know how to do, and letting deadlines and scheduling spin out of control, even through no fault of your own. Stress can become overwhelming at times. Ah, the joy of owning your own business, there is nothing quite like it. If you have never owned or been a part of a family-run business, you need to talk to people who

have before starting up your own. You need to go in clear-eyed with the support of your whole family, especially a spouse. Many artists in this book have spouses, children, parents or other loved ones working with them. Let's face it, family can be cheaper labor than anyone else, and we get to keep the money in the family. But if you do this, you also need to beware that daytime work blurs into nighttime life, and that is not always easy. Whether your family works directly with you or not, they will become enmeshed to some degree or another in your business.

Overcommitted and Out of Control

I used to say *yes* all of the time in my work. I did it for a variety of reasons. It was fun and stroked my ego to be in such demand. It generated more income, and I loved to watch the numbers grow. I was afraid if I said *no*, clients would become upset and go elsewhere and maybe find someone they liked better than me, and then I would not only lose that job but many future jobs. I am also very competitive, mostly with myself, and I always wanted to do better, which I equated with doing more. I could always add just one more thing.

This philosophy helped make me successful enough that I needed to hire on help. More help increased overhead costs, which reduced profits, which necessitated price increases, which reduced client contracts, which made me increase advertising and marketing, which increased business, but reduced profits and so the cycle of success began.

I made many mistakes because I mostly learned on my own through trial and error. Eventually, I had eleven people working for me. I could not go out in the field and paint because I was too busy selling jobs to keep everyone else working. Scheduling became a nightmare with this many employees. Keeping clients happy and my own employees busy was difficult. I overstaffed jobs just to have somewhere for employees to go, but this ate away most, if not all of my profit. I was also not able to manage all of my jobs, but there was not enough money to pay a field supervisor.

At this point, I had built my business to a very dangerous place. My jobs were not being run as efficiently as they would have been if I were on site. I did not even have time to check on quality as much as I should have. I had more complaints in this two-year period than the twenty prior years combined.

But boy was I successful; I was working seventy plus hours a week and was grossing more income than ever (forget the fact my profit margin was going down the drain). Even when I was not at work, I was thinking about it. I burned my way through one marriage because of this. I missed events with my children because of my *success*.

I realized I did not like what I had made and cut down my staff to five people, which helped but certainly did not eliminate these problems.

I remarried and found myself falling back into the exact same habits again. I was more aware of it, and my wife and I even discussed it (many times) but I helplessly felt that I could not turn down my clients and turn off the crazy pace I set for myself.

Work, deliberately or not, took first place in my life; my family was a distant second and friends were basically nonexistent. Work and my life were out of control and I did not know what to do.

When to Say No

In 1999, I took my first teaching trip abroad to France and had an epiphany that has changed my life for the better. I fell in love with the French culture and food. In Europe, people do not work at the crazy, rapid pace of Americans. Money is not as big of a motivator for Europeans as it is for the highly consumer-based society in the United States.

Europeans value family more and spend hours together preparing and then eating fantastic meals. They take an hour or two during the midday for lunch and social time. They have a mandatory six weeks of vacation or more by law. All of this was unheard of in my life. *I loved it.* I came home realizing success can mean many different things and that I wanted to change my view of what success meant.

I told my wife I was no longer going to work weekends and only have appointments two nights per week. She laughed! I started using the word *no* right away, but it took me six months to wean myself off the *yes* schedule I was on because of all of the prior commitments I had set.

I felt guilty saying no and I had to remind myself it was OK to want to be with my family. My clients are mostly women, and when I refused a request and explained that I was putting my family first, they were mostly understanding. Sure, sometimes I would lose

opportunities, but I was building far more important relationships with my family and friends. I also found that my workload in the long run did not suffer but actually grew. My profits increased and my family and I became happier. I learned to delegate more and work less. I now work about fifty to fifty-five hours per week. One day, when I grow up, I hope to work just forty hours per week!

To me, service now means to serve myself and my family first and then my business and its employees and finally my clients. My clients are still extremely important and they know it, but they also know I value myself and my family now.

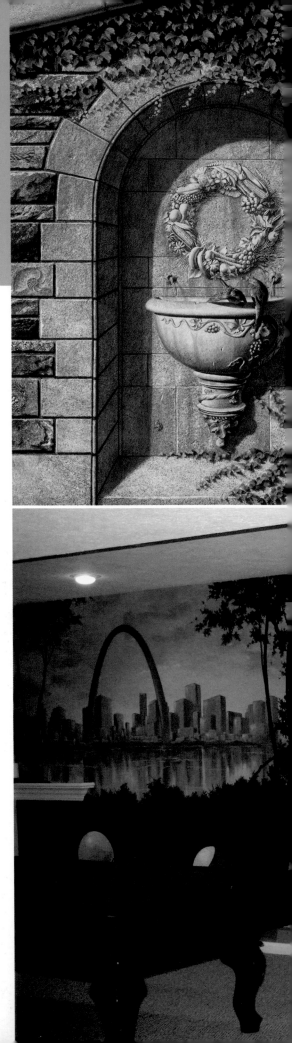

2 MURAL PAINTING SECRETS

THE ARTISTIC TALENT IN THE FOLLOWING DEMON-STRATIONS AMAZES ME. Many of these art-ists are leaders in the decorative painting industry. The tips and techniques you learn here can be applied to the future murals you paint. Select something that fits your style or takes you in a new direction in your art. And remember, you are the artist. Feel free to alter the designs and color choices to suit your own style. This is the perfect opportunity to expand your own composition skills.

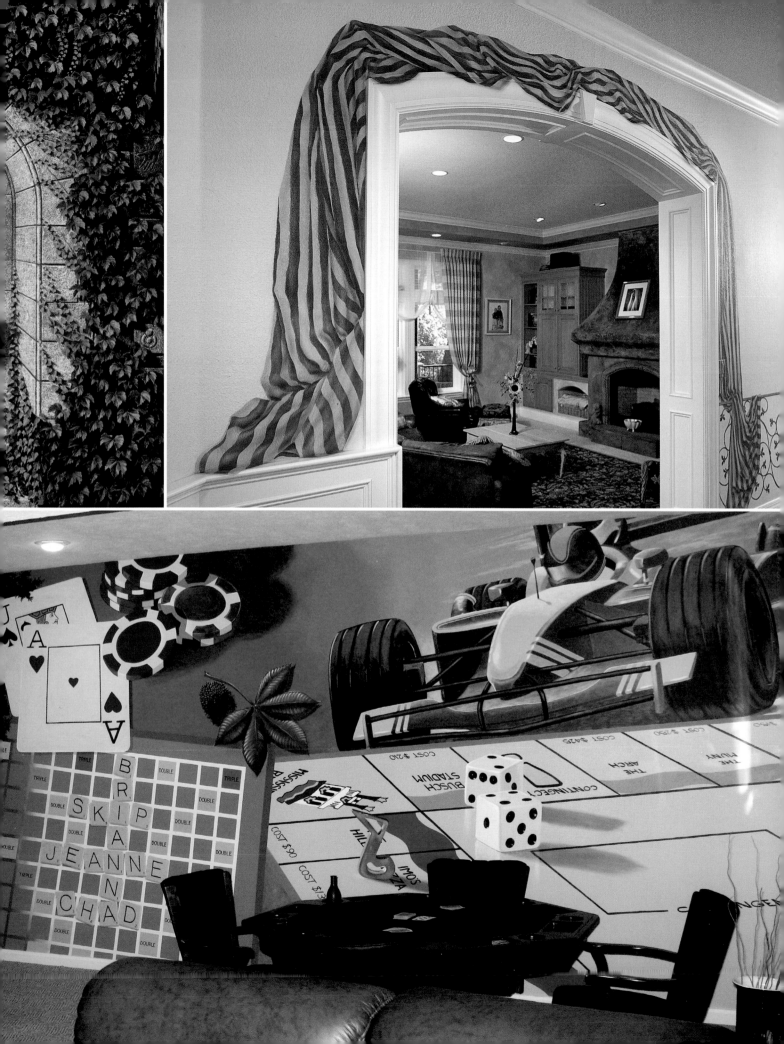

SEPIA-TONED ROADHOUSE MURAL

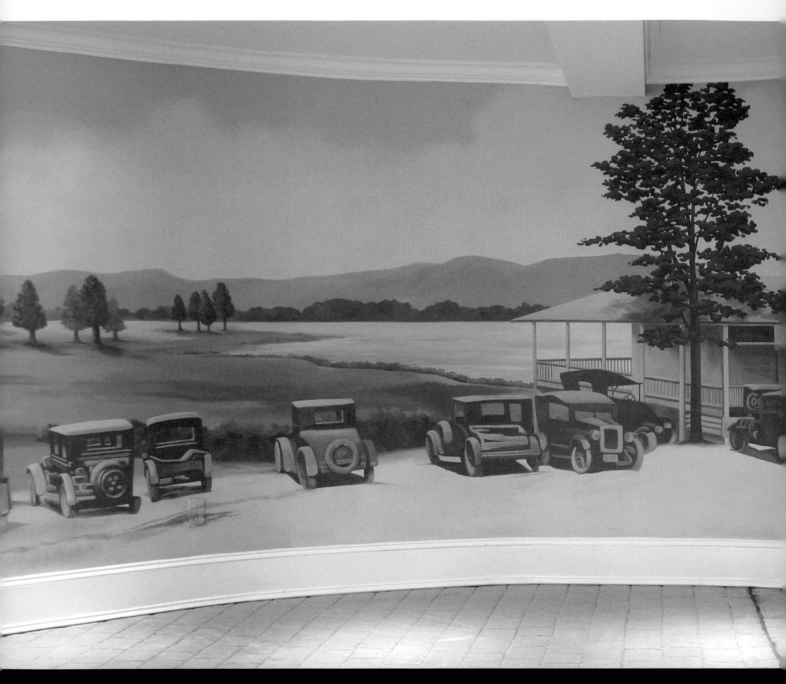

BEFORE SHE PAINTED

Sharon Leichsenring attended the Paier College of Art, formerly known as the Whitney School of Art in New Haven, Connecticut. "My textbooks have stood me in good stand for a solid understanding in perspective, composition and trompe l'oeil," she said.

Her previous life was as a commercial sign painter where a large percentage of her client base was boat owners. During the transition from that career to becoming a decorative artist, she marketed herself

to that established client base, which had developed over a twenty-five year span.

"My reputation gave me a solid source of referrals," Sharon said. She believes passion and commitment to excellence are two of the essential ingredients that separate the good from the best.

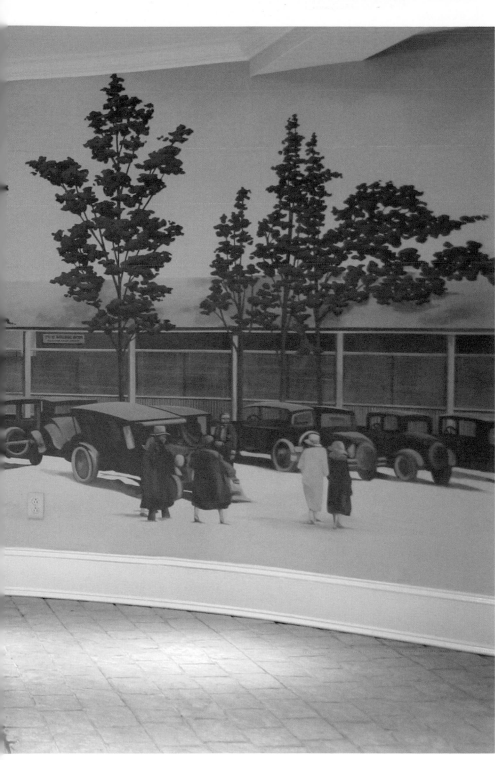

SHARON LEICHSENRING

This sepia-toned mural captures The Music Box, a beachside roadhouse located on Bantam Lake in Morris, Connecticut, as it appeared during the 1920s. Measuring 21' × 7'9" (6.4m × 2.4m) on a gently curved wall, the monochromatic palette lends itself to a nostalgic feel. The only reference photo was faded and quite small. I found myself reconstructing the automobiles by painting the light and dark values as I saw them, recognizing them only as shapes to be painted, not as car parts.

I chose to paint this mural using Benjamin Moore AquaVelvet paint. Because of the large areas I would need to cover, I would be able to keep the values clean. The key to replicating this look is to mix a color with another color that is only one step lighter or darker. This keeps the values and color consistent across the entire mural.

MATERIALS

Brushes
¼-inch (6mm) and ¾-inch (19mm) filberts
½-inch (13mm) flat
Ultimate Stippler

Benjamin Moore AquaVelvet paint
Brandon Beige, Chantilly Lace, Tapestry Beige, Woodcliff Lake

Additional Materials
AquaGlaze by Faux Effects

Photographs on pages 36–39 by Thomas Cain

1. BASECOAT AND CLOUDS. Paint the background with two coats of Tapestry Beige. The cloud formation is created using a glaze of Chantilly Lace + Aqua-Glaze (1:4) and applied with an Ultimate Stippler in a soft, pouncing motion. Additional pounces to the very top edges of the clouds create the more opaque highlights. Keep all edges soft.

2. SHRUBBERY. Block in the shrubbery using a mixture of Woodcliff Lake + Brandon Beige (3:1). Use a ¾-inch (19mm) filbert to apply two coats.

3. SHRUBBERY HIGHLIGHTS. Establish the imaginary light source from the left. Use a ¼-inch (6mm) filbert to apply impressionistic leaf highlights to the shrubbery color. Create the highlight color by gradually adding more and more Brandon Beige to the base shrubbery color. This is background detail—keep it light, airy and undefined.

4. AUTOMOBILE. Transfer the drawing of the automobile (I find pounce patterns easiest to use). Block in the auto's darker areas with a dark mixture of the shrubbery color, Woodcliff Lake + Brandon Beige (4:1). Use a ½-inch (13mm) flat to apply two coats for opacity.

5. AUTOMOBILE. Block in the automobile's lighter areas with Brandon Beige, using a ½-inch (13mm) flat. Again, two coats achieve opacity.

6. AUTOMOBILE. Drybrush the darker areas with additions of Brandon Beige to the mixture used in step 4 to show gradations.

Show contours in the light areas by adding small additions of Woodcliff Lake to the Brandon Beige used in step 5. The sepia look is most effective when the additions of a new value are kept very subtle.

EXPERT ADVICE

Tip 1: To make it easier to see your values, make a copy of your reference photos on a color copier using the black-and-white setting. You will be able to see more of the "in-between tones" that very often get dropped out if you're using a black-and-white copier.

Tip 2: For large projects such as this, be sure to mix plenty of every paint mixture right from the beginning. You may end up using a little more paint, but it will save you endless time in trying to get back to the original mixtures.

7. AUTOMOBILE HIGHLIGHTS. Complete the rendering using a highlight mixture of Tapestry Beige added to Brandon Beige. The highlight accent is created by adding a small amount of Chantilly Lace to Tapestry Beige. This accent should be used sparingly. Too much of it makes the painting look cartoon like, having too much "pop." The shadow accent (the darkest part of the composition) is Woodcliff Lake.

BEFORE HE PAINTED

Joseph Taylor attended the Art Academy of Cincinnati and received additional schooling in Cleveland. Immediately following school, he worked as a commercial illustrator and photography touch-up artist. He worked for a half dozen different studios before striking out on his own for thirteen years as an airbrush photography touch-up artist, but the rise of computer touch-ups forced him into another career choice. Joseph's grandfather had been a well respected wood grainer and marblier, and this side of the arts had always interested Joseph. Joseph first met Gary Lord in 1983, in a wood graining/marble class at Rocky Mountain Studios in Columbus, Ohio. The two became friends and Gary offered Joseph a job as a muralist for his company. Gary's business has won seven national awards since Joseph and contributor

JOSEPH TAYLOR

This trompe l'oeil drapery mural is created with underpainting. There are many ways to approach this method. In this demonstration, I used one color to create the underpainting, which establishes almost all of the form of the drapery. Because all of the subsequent color will be transparent, the underpainting shows through in the final painting.

MATERIALS

Brushes
1-inch (25mm) and 2-inch (51mm) synthetic or nylon or acrylic flat
No. 6 round

Faux Effects AquaColors
Autumn Brown, Dark Brown, Earth Brown, Earth Green, Red, Royal Blue, Violet, Yellow

Additional Materials
Chalk
Liquitex Matte Medium

Photographs on pages 40–43 by Joseph Taylor

Kris Hampton have been with the company. Joseph believes that drawing daily and furthering your education will help your artistic ability advance to the next level.

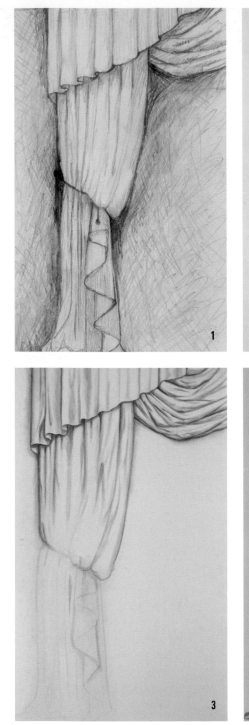

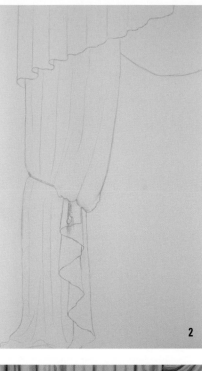

1

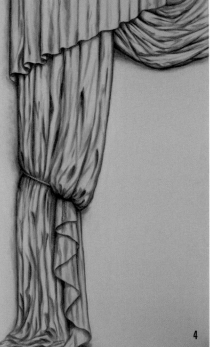

2

3

4

1. THE SKETCH. Make a preliminary drawing to establish the proper proportions and composition. You will also use the sketch to obtain client approval.

2. THE CHALK DRAWING. Transfer the sketch to the working surface using chalk. You can use an opaque projector or a grid system to help transfer the image. Here, I've used a dark chalk color that shows up better for the photography of this demonstration, but the dark chalk can interfere with the painting. Ordinarily, I would use a white chalk with light pressure so there is only enough chalk to guide my painting.

3. THE UNDERPAINTING. The underpainting color is a mixture of Dark Brown + Earth Brown + Violet. This creates a cool brown color that will work well with the drapery color to create the desired shadow color.

After the colors are mixed, add Liquitex Matte Medium to the mixture to create a semitransparent glaze. The proportion of Liquitex Matte Medium to color will vary according to how transparent you want the glaze. Start out very sheer, using about equal amounts of color and medium.

4. THE UNDERPAINTING. With a loaded brush, begin painting the shapes of the drapery. The working time of the medium is not very long. You'll feel the glaze begin to get tacky as you blend your color. At this point, move on to another area, allowing the tacky area to dry. It won't be long before you can come back to that area and apply another layer. Don't overwork it. Move around the painting, coming back and building up areas one layer at a time. The glaze dries fairly quickly, so once you've painted through about a 3' (91cm) section of drape, you can already start back through that section with another layer of glaze.

It will take many layers to create the darkest shadows. I've gone over the shadow areas at least six times, gradually building up form.

This photo shows the finished underpainting. You can see that almost all of the shape and form of the drape has been established. All that remains is to color it!

5. ADDING COLOR. The next steps mostly add color to the underpainting. Some form and depth are created, but most of the shape and shadows are made with the underpaint.

The color is a mixture of Autumn Brown + Red + Yellow + a small amount of Earth Green. Add Liquitex Matte Medium to create a glaze as in step 3. The first layer of color is very sheer and covers all of the drapery. Don't go too dark with this first step. More color can always be added.

When this layer dries begin coming back through with a darker glaze and paint in sections, allowing tacky areas to dry before you add more paint, as you did with the underpainting. Build up depth of color layer upon layer. Emphasize the forms in the underpainting but also allow your brushstrokes to create some new wrinkles and creases in the fabric.

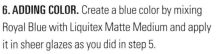

6. ADDING COLOR. Create a blue color by mixing Royal Blue with Liquitex Matte Medium and apply it in sheer glazes as you did in step 5.

7. DETAILS. Using a no. 6 round brush and the base color (in this case the wall color), paint tassels on the ends of the cords. Once the tassels dry, add glazes of yellow and then blue to them and to the cord.

In some areas of the drapes, you may want to go back in and add more of the underpainting color to deepen the shadow colors.

WOOD-GRAINING MURAL

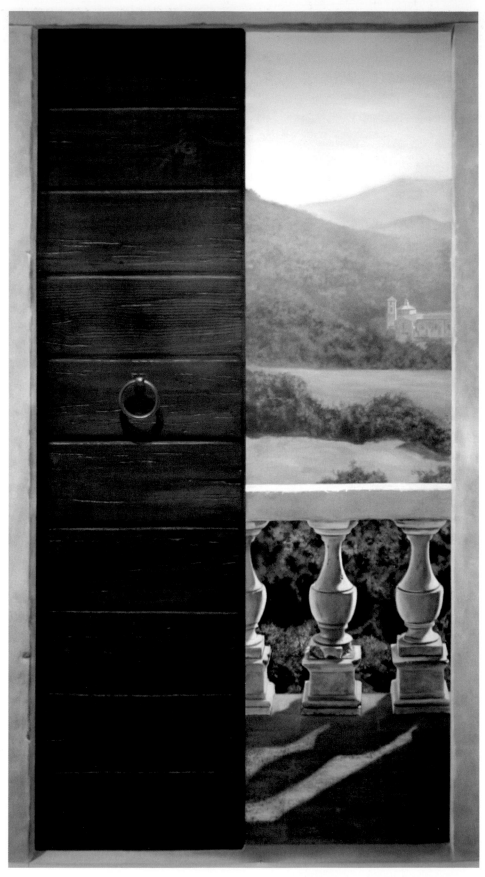

NICOLA VIGINI

Wood graining adds a tremendous amount of realism to any mural and works well with trompe l'oeil scenes. In this demonstration, I use the moiré effect to help create texture in the "wood."

MATERIALS

Pierre Finkelstein Brushes
Beveled edge brush or a liner
Large badger
Size 6 domed
Size 80 or 100 spalter
A variety of stencil brushes from small to large
A variety of straight or flat brushes

FauxCrème Colors by Faux Effects
Burnt Sienna, Raw Sienna, Raw Umber, Red Oxide, Titanium White, Ultramarine Blue

Golden Heavy Body Acrylics
Yellow Ochre

Additional Materials
AquaCreme by Faux Effects
FauxCrème by Faux Effects
High quality blue painter's tape
Metal faux finishing comb
Rag
Straightedge/ruler
Toothbrush

Photographs on pages 45–47 by Patrick Ganino

BEFORE HE PAINTED

Born and raised in Rome, Italy, in 1959, Nicola Vigini has become a very well known decorative artist all across the U.S.A. where he now lives and works. "From about the age of five I was always drawing and painting things and I was good at it. My father was an architect and he encouraged me at every opportunity," he said. His early schooling placed a strong emphasis on art. He went on to attended the prestigious Liceo Artistico in Rome and the Institute Superieure de Peintre Decorative in Paris. After finishing his education he took up a few jobs with decorative painters and broadened his skills.

Nicola moved to Seattle in 1987 and began doing work for a furniture manufacturer. After a short time, people started to regularly ask him to do work for them and by 1988 he was working for himself.

"One of my first major jobs was in a 35,000 square-foot home which kept me going for about a year and a half. That job got me on my feet and it entailed a lot of wood graining. This job allowed me to create one of my icons I call *The Cellar*, a trompe-l'oeil piece done on a wall of an actual cellar which gave the illusion of another cellar leading away from the one you were actually standing in," he said.

1. BASECOAT AND GLAZE. Apply a light-toned basecoat of latex paint or Faux Effects Set Coat in a Titanium White + Yellow Ochre color over the entire surface, except on the door knocker, in horizontal strokes following the direction of the wood grain pattern. Once this is dry, basecoat the door knocker with the basecoat mixture + Raw Umber.

Add Ultramarine Blue and Raw Umber to the original basecoat color and block in the shadow for the door knocker.

Apply a glaze of Burnt Sienna + Raw Umber + AquaCreme horizontally with a size 6 domed. The photo shows this in progress, starting at the top with the glaze.

2. WOOD GRAINING. When the glaze is applied, spread it evenly with a size 80 or 100 spalter. Drag a metal faux finishing comb through the wet glaze following the wood grain pattern to create the grain. Create knotholes in the grain by twirling various sizes of stencil brushes in the wet glaze.

Go back over the glaze with a spalter, this time making parallel strokes that are at a very small angle (about 30 degrees) to the wood grain pattern to create a slightly rippled appearance. This is the moiré effect.

45

3. TONING LAYER. Add another layer of glaze made with Raw Umber + AquaCreme, again using a spalter to create a moiré effect as in step 2. This softens highlights and adds aging marks around the knots. Go over the entire area with a badger and let dry. The photo shows the toning layer in progress. In the photo, the area above the tape has received the toning glaze, while the area below has not.

4. AGING. Dip a toothbrush into a mixture of Raw Umber diluted with water and spatter the mixture onto the surface by running your finger or a palette knife over the bristles of the toothbrush. Badger the surface in the direction of the grain. This gives the appearance of aging.

Next, to create the appearance of cracks in the wood, add horizontal lines of Raw Umber with a domed brush, rolling it in your fingers and varying pressure to create a thin-thick-thin line.

EXPERT ADVICE

Tip 1: The basecoat needs to be opaque, and quick-drying so use a latex house paint or set coat by Faux Effects or a slow drying acrylic such as FauxCrème Colors by Faux Effects. The rest of the mural can be painted with slow-drying acrylics (such as Faux-Crème by Faux Effects) or oil paints, which give you more "open time" with the glazes. Work in the medium in which you feel most comfortable.

Tip 2: When painting the door knocker, use painter's tape to create a clean, crisp square where the knocker is attached to the door. You can freehand the circle.

5. HIGHLIGHTS AND DOOR KNOCKER. With a beveled edge brush or a liner, apply highlights to the lower portion of the wood "cracks" with the basecoat mixture + Raw Umber. Place breaks in the highlights to add interest. (Be sure not to have highlights overlap the cast shadow of the knocker.)

Basecoat the door knocker with the basecoat mixture from step 1 + Raw Umber. Be sure to leave a little background showing around the shape of the upper middle portion where the knocker meets its base or hinge. Reestablish the cast shadow. Let dry and apply a second coat.

6. DOOR KNOCKER. Add highlights to the door knocker starting in the upper left corner and fading downward in a 45-degree angle. I generally use the woody yellow basecoat + Titanium White and a beveled edge brush or liner to create these highlights.

Add shadow to the bottom right with Ultramarine Blue and Burnt Umber. Be sure to let midtone (the basecoat from step 5) show between highlight and shadow. Try to leave texture when applying the paint.

7. CAST SHADOW. Use a glaze of Raw Umber, Ultramarine Blue, Red Oxide and FauxCrème to fill in the cast shadow of the door knocker. While the paint is still wet, blur the edge of the shadow and then badger the area to remove brushstrokes.

8. PLANKS. Using the same color as the doorknocker's cast shadow, create horizontal lines for the planks. Drybrush the edge and then fade it by lifting pressure on the brush.

9. FINAL SHADOWS AND HIGHLIGHTS. Add darker lines on top of the plank lines you established in step 8, leaving some breaks to create interest. Use a beveled edge brush with Raw Umber and Ultramarine Blue. Then dress your brush with alcohol (turpentine or paint thinner if working with oils) and remove the glaze below the plank's shadow. Hold a straightedge against the plank's shadow as you remove the glaze to keep your line sharp and straight. The straightedge will keep the alcohol from bleeding onto the rest of the shadow. This creates a highlight. For the highlight accent, add a thin stroke with a mixture of Titanium White + Raw Sienna + Burnt Sienna.

DOG MURAL

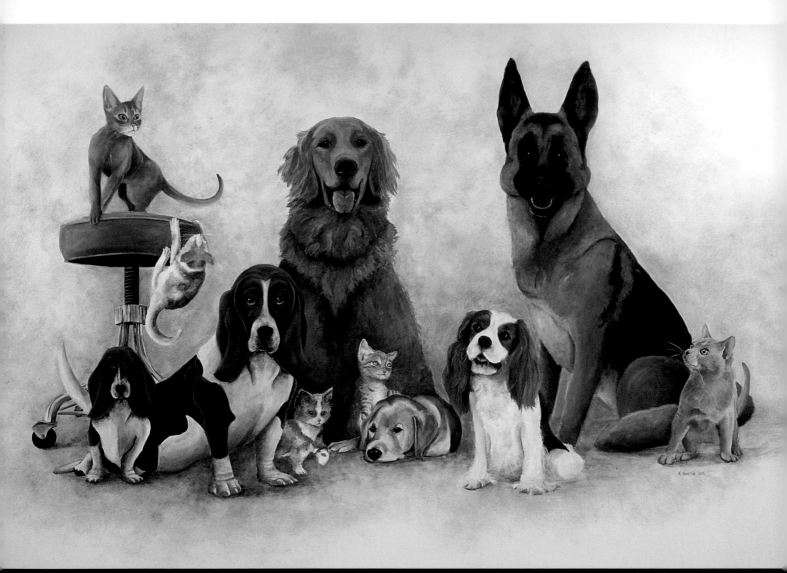

BEFORE HE PAINTED

A look in Kris' high school yearbook gives an indication of his future. Under the title "Where You'll Be In Ten Years," Kris wrote "Doing something with art, though I'm not sure what." After high school, Kris attended Wilmington College in Ohio, studying to be an art teacher. Soon realizing that creating was more fun than teaching, he left school to pursue other avenues. Managing a pizza parlor kept him from becoming a "starving" artist, while completing murals for friends and the occasional commissioned portrait. When painting a mural for a friend, the friend's decorator asked if he could do any decorative finishes. Curious, he took a class from Dave Schmidt of Prismatic Painting Studio, which led Kris to work with Dave on actual jobs. After working on his own for a few years, and subcontracting

with Dave and Gary Lord, Kris decided to take a full-time position with Gary Lord Wall Options in Cincinnati, Ohio, so he could focus on creating. Kris' murals have helped Wall Options to win multiple national awards. He feels the business side of decorative painting is mostly about marketing and networking, while the creative side relies on being able to stay open to new ideas. He's still not sure entirely what he'll do with art, and that's the beauty of murals and decorative finishes: they are constantly evolving into something new and exciting.

Photographs on pages 48–51 by Kris Hampton

KRIS HAMPTON

This dog is part of a mural I painted for an animal hospital. I worked with the hospital's staff to select examples of dogs and cats that represented the hospital's patient population. The client wanted the mural to capture the spirit of happy and healthy pets and brand the hospital as a very special place for pet health care. The mural is an enjoyable conversation piece for both the hospital's clients and its staff.

Using an overhead project saved countless hours on this project. With projectors, I save myself time, save my client money, and increase profits, all in one small step. While some call it cheating, in 1490, Leonardo da Vinci wrote of using a projector (at the time called a "camera obscura") for his paintings. If it's good enough for him, it's good enough for me.

MATERIALS

Brushes

A selection of small to medium round and square brushes

Faux Effects AquaColors

Autumn Brown, Black, Dark Brown, Eggplant, French Red, Ochre Yellow, Violet, White

Additional Materials

Chalk

Fine point, felt-tip marker

Overhead projector and transparencies (or opaque projector)

Photograph or drawing to work from

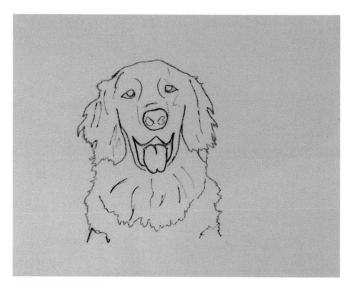

1. TRANSPARENCY. Once you've gathered your photo or drawing and any references you'll use, it's time to create a transparency. Using a fine point, felt-tip marker, trace your image onto a transparency sheet. Include any important information such as strong shadows and highlights. Small details are unnecessary. Your goal is to get the basic shape of the lights and darks within the dog.

(Note: If you choose to use an opaque projector instead of an overhead, you do not need to make a transparency. Go directly to step 2, still making a drawing with the same information as covered in step 1.)

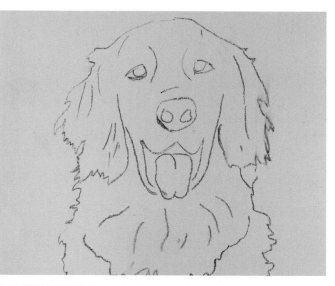

2. TRANSFER IMAGE. Project the image onto the mural surface using your overhead projector. Move the image around until you and the client are happy with the position. Using chalk that is a color similar to the completed painting, transfer the image onto the surface. Before moving the projector, unplug it and turn the lights back on to ensure you've transferred the entire image. Unplugging, rather than turning off, ensures that you won't move the projector slightly, and end up with an out-of-proportion dog.

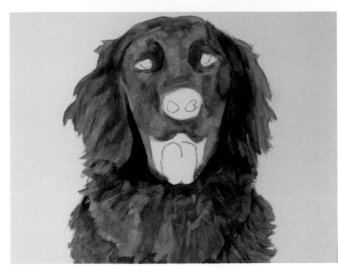

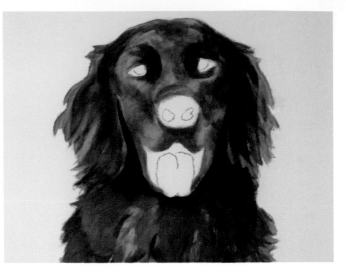

3. FUR. Pick two or three of the dominant colors you'll be using. Here, I used Autumn Brown and Dark Brown. With a medium-sized square brush, make a loose, washy color and do a value study as an underpainting. The purpose here is to give some shape and dimension to your dog. Be sure to make your brushstrokes in the direction of the fur, rather than just "coloring in." Focus on the shape and suggesting the fur and save the facial features for later. Let this step dry before continuing.

4. SHADOWS. Refine the shadows with medium-sized square brushes. Don't make the common mistake of being afraid to go really dark; darks add depth to the subject. I rarely use black for my shadows; instead, I use darker or complimentary colors. In this case, I use Dark Brown + Eggplant, mixed with a small amount of Autumn Brown and a tiny amount of Black only in the darkest darks. Again, make brushstrokes in the direction of the fur. Let dry.

EXPERT ADVICE

Tip 1: I like to mix my colors on a palette, in small amounts so my mural doesn't have the exact same six or seven colors throughout. This looks more natural.

Tip 2: Instead of turning off the projector to see your drawing, unplug it. This will keep it from shifting and throwing your drawing off.

Tip 3: Use chalk that is close to the color of the image. The chalk will mix with the paint, and if you're not careful, will still be visible in the end.

Tip 4: Forget what you're painting. It's not an "eye," it's a combination of shapes and shadows. Paint what you see and not what you know.

Tip 5: Opaque projectors require a dark room, but allow for more detail. Overhead projectors can work in light areas, but need a transparency, and small details are easy to lose.

Tip 6: Don't be afraid to go dark. An all-midtone mural looks very flat.

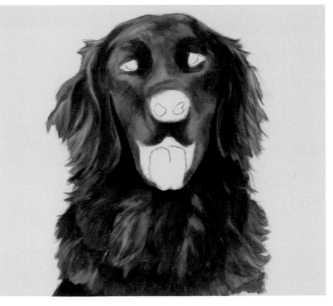

5. HIGHLIGHTS. With medium-sized square brushes, add in the lighter tones using a combination of Autumn Brown + Ochre Yellow + a very small amount of White. Use White sparingly here, as it's easy to go too "chalky." During this step, you may have to use some of your midtones to blend out the edges of your highlights. In the thicker fur, use very definite strokes, with little blending.

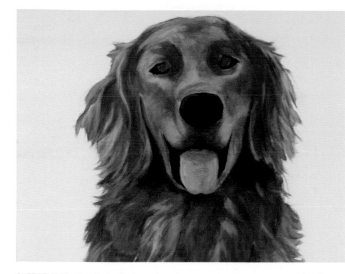

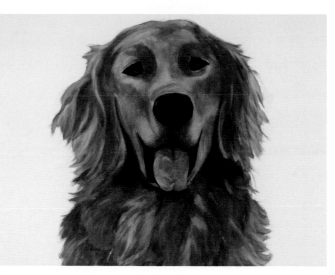

6. FEATURES. Rough the features in using a smaller square or round brush, whichever you prefer to get better control of your brushstrokes. Do not simply "block in" color. Instead, show some indication of the shape, using darks and lights. Here, I use Black, White and Dark Brown for the eyes, nose and mouth, and French Red, White and Violet for the tongue. Let dry.

7. FEATURE DETAILS. With the same small brush and colors, build up the shadows and highlights of the nose, eyes and mouth. Try to forget that you're painting a nose or mouth or eyes; instead concentrate on the shapes of the darks and lights. Let dry.

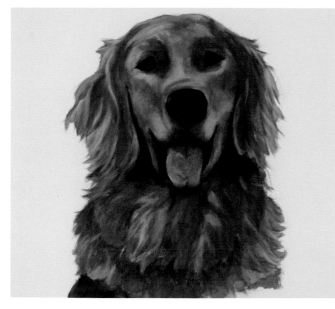

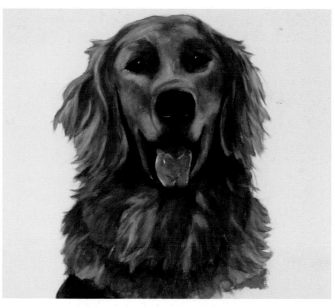

8. EDGES. At this point, the facial features may appear to "jump" off of the dog's fur. Go back and soften any edges that may need it with the brush used to paint the features. Using the two adjoining colors (Black for the nose, Autumn Brown for the fur), slightly blend the harshest lines. Be selective of which edges to soften. At the same time, add in any extra shadows that may be around, or caused by, the nose, eyes and mouth. Once you're more familiar with this step, you can eliminate it, instead doing it wet-into-wet while you're painting in the features.

9. BRIGHTEST HIGHLIGHTS. Add in the brightest highlights with a combination of White + Ochre Yellow and a very small round brush. The "wet" areas of the dog (eyes, nose and tongue) will reflect light, and the brighter lights help to make these areas read as "wet" to the viewer, while breathing a little excitement and life into the subject.

AIRBRUSHED UNDERWATER SCENE

SHERI HOEGER

Airbrushing gives this mural the soft, diffused feeling of being underwater, while stencils create clean edges and shapes for the various sea creatures.

I painted this mural using only three colors, plus white where the fish were blocked out for contrast. Fine sprays of color are layered in various intensities to create the full spectrum of color in the mural. The colors are generally layered from light to dark, almost always starting with the yellow. I chose the colors partially for their transparency so that the order could be successfully interchanged. (If the yellow were opaque, spraying it back over a saturated red or turquoise would cause a pasty appearance.) The red and turquoise layers were interchanged to get different tones—the order of layering will always affect the final color.

MATERIALS

Golden Fluid Acrylics

Hansa Yellow Medium,
 Pyrrole Red, Titanium White,
 Turquoise

Additional Materials

Blue tape
Cambric cloth
Cheesecloth
Golden Airbrush Medium
Iwata Eclipse airbrushes, hoses and
 holder
Mad Stencilist Stencils: Clowns and
 Damsels, Hippo Tang, Saddle-
 back Butterfly, Sea Turtles, Willow
 Boughs (available at
 www.madstencilist.com)
Masking film

No. 11 craft knife
Scotch repositional clear tape by 3M
Sea sponge
SilentAire compressor
Spray bottle

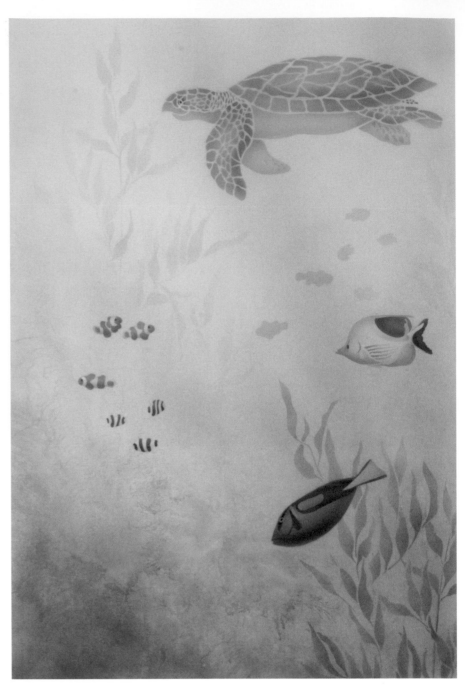

Photographs on pages 52–55 by Sheri Hoeger

BEFORE SHE PAINTED

Some of us just fall into our careers and this is Sheri's story: "My career started by a happy accident. I was introduced to the airbrush when I worked as a manicurist in the early 1980s. I had become known for painting little scenes on my clients' nails, and airbrushed designs were just coming into vogue when I left that profession to stay home to raise my children. My husband gave me a beginner airbrush set for Christmas in 1983. I 'played' with it by painting an outer space mural for our son's room.

"Later, a friend showed me the traditional drybrush method of stenciling. I stenciled my bathroom, and I was hooked. When I attempted to stencil my kitchen with geese, my stencil brushes were too small for the windows so I brought out that little airbrush, thinking it might work for those large spaces. I loved the soft look of the airbrushing combined with the crisp edge of the stencil, and it fascinates me to this day. In 1988, I started stenciling for friends and acquaintances who had seen my home, and in a very few months, word had spread and I was as busy as I wanted to be."

1. BACKGROUND. Spray Hansa Yellow Medium in diagonal bands from top to bottom, increasing the width of the band as you move toward the bottom. Reapply a fine spray to increase the color intensity.

Then spray some Turquoise lightly over the yellow, repeatedly applying a fine spray to build intensity near the bottom.

To suggest a coral bed, on only a small area at a time, spritz water onto the surface and quickly spray Turquoise lightly into the droplets, using a broad spray pattern. If the surface is too wet and drippy, blot with cheesecloth or a dampened sponge, but leave some small droplets.

Using only air, push the droplets of water in an upward and/or sideways motion. The droplets will carry the turquoise color along. Keep checking for drips and either blow into them or blot them off before they make a permanent mark.

Now apply Pyrrole Red in the same manner as the Turquoise, but cover less area. Allow the fine spray of red to create some orange tones when falling onto the yellow, and some slightly purple tones when falling onto the turquoise. Too much red will muddy the green combination created with the yellow and turquoise. A little goes a long way.

2. TURTLE. Position the turtle stencil and spray with Hansa Yellow Medium. Shade so that there is a highlight area at the upper part of the shell and a darker area at the junction of the shell plates.

3

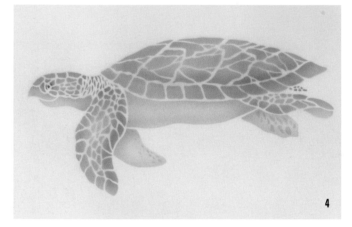

4

5

6

3. TURTLE. Insert masks over the far flippers and abdomen to preserve the yellow. Spray with Turquoise, shading as described in step 1, to create a green color. Lightly spray details of far flippers.

4. TURTLE. Remove the masks and lightly shade with Turquoise, going slightly darker on the upper side of the far flippers and the abdomen. Repeat very lightly with Pyrrole Red. The red tones down the green and helps the yellow abdomen stand out against the background. Very lightly spray Turquoise over the bridges (the areas that were masked by stencil material) so the appearance is not so stark.

5. DISTANT SEAWEED. Position, spray and reposition Willow stencil. Use the same color order: yellow, turquoise, and red. Spray very lightly to suggest diffused seaweed. Allow the weeds to fade as they run into the coral bed.

Add more soft color streaks to the water, spraying right through the turtle. It's OK for there to be this small amount of color added to the turtle, since it's already in the mix.

6. FISH. Arrange a variety of fish and mark the alignment registrations onto pieces of blue tape affixed to the painting surface. You really only need to stencil two alignment registrations, usually across the top of the design. This is the most accurate way to assure exact alignment. Spray with Titanium White to lighten against the water background. These don't have to be totally blocked out white. In fact, if a little of the water colors show through, it will help everything to relate. However, these fish do need to be distinctly lighter. I have blocked out only the tail of the Hippo Tang.

EXPERT ADVICE

Tip: When airbrushing water, pull back away from the surface to maintain a wide, soft spray pattern. You want to suggest bands of light streaming down, but if the spray pattern is too narrow, it will look like stripes. Track with your eyes slightly ahead of where you are actually spraying for a smooth movement. If you get off track, just lift off by pulling backwards and start again. Practice spraying evenly and smoothly in any direction.

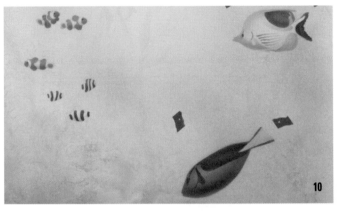

7. FISH. Spray the yellow details of the fish.

8. FISH. Lightly spray red over the yellow. Repeat on the Clown Fish and the Damsel Fish to create bright orange.

9. FISH. Spray Turquoise over the Damsel Fish details and Hippo Tang body, shading darker at underside. Shade lightly with red.

10. FISH. Proceed through the details in this manner, layering the three colors to create the full spectrum. Shade very lightly with Turquoise, then red on the bodies of Clown and Zebra fish, just enough to suggest volume and keep enough contrast so they show up against the background. This will be the same for the light area of the Butterfly Fish.

Spray some White first for the light details of the Hippo Tang. Add color if needed to the Butterfly Fish.

11. DISTANT FISH AND SEAWEED. Using just the body shapes of the Clown and Damsel fish, position and spray just a light silhouette with Turquoise, then red to suggest distant fish. They should get lighter and cooler the farther away they are.

Arrange, spray and rearrange weeds, shading darker than previously so they will look more substantial. Use masking film to mask off the leafy area that falls across the Hippo Tang. This preserves the weeds behind the fish.

To finish, spray in final layer of light color overall, following the established band pattern, increasing intensity where needed. This will also serve to unite the fish with the water.

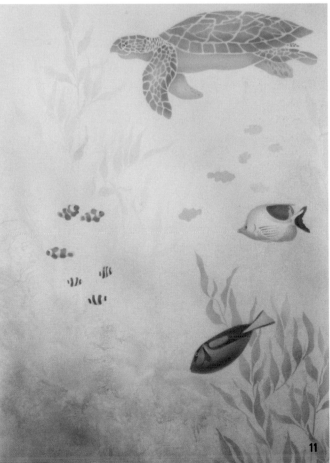

MONKEY MURAL WITH CRACKLE FINISH

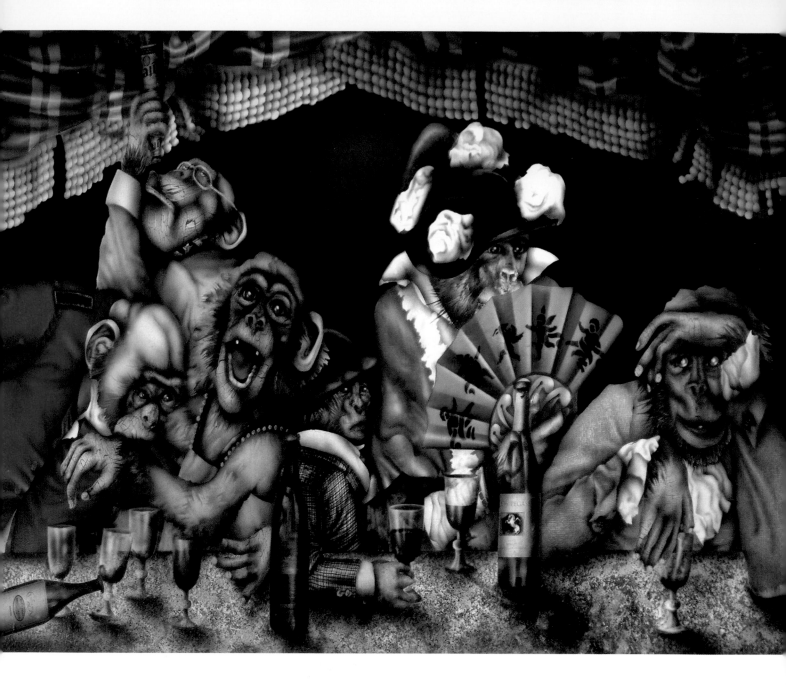

ZEBO

This mural incorporates a number of methods to create a textured finish. The monkey's skin is textured using a crackle technique to create wrinkles, while the hair is created by striaying glaze with a linen weave brush or leon neon. Airbrushing adds soft highlights and dynamic shadows. The labels on the wine bottles are actual labels that were polyurethaned onto the

mural and then shaded and highlighted with an airbrush. The bar counter is sponged with four colors of glaze and flecked with a splatter brush.

Photograph of finished mural by Tina Parkes, Portraits by Tina. Step-by-step photographs on pages 57–61 by Al Parrish. Photo of artist by Zebo Studios.

MATERIALS

Loew-Cornell Brushes

No. 12 chisel blender, 7450

No. 18/0 liner, 7350

No. 3/0 spotter, 7650

No. 6 ultra round, 7020

¾-inch (19mm) wash, 7550

Faux Effects AquaColors

Autumn Brown, Black, Burnt Sienna, Orange, VanDyke Brown

Golden Acrylic

Titanium White

Golden Airbrush

Burnt Sienna Hue, Carbon Black, Titanium White, Transparent Raw Umber Hue, Transparent Shading Gray, Yellow Ochre

Porter Acrylic Latex Flat

Black Onyx, Warm Taupe

Porter Flat Latex

Mauve Pink

Additional Materials

AquaSize, AquaCreme and CrackleMate by Faux Effects

Badger compressor

Badger hose with Iwata converter

Chalk or charcoal pencil

Isopropyl alcohol

Iwata Eclipse HP-BCS Airbrush

No. 2 pencil

Plastic templates

Potter's needle tool

Ralph Lauren linen weaver brush or a Leon Neon

Tombow Dual Brush-Pens pens #N79 and #969

Tracing paper

BEFORE SHE PAINTED

Gayl "Zebo" Ludvicek started her artistic career young, painting her first mural (of the Flintstones) in her own room at age 4. At age 11, she was hired to paint a beach house scene with Mickey and Minnie in it.

Zebo has a Bachelor of Fine Arts from the University of Maryland, where she specialized in lithography. After college, she worked as an illustrator for a Christian-based publishing house in Chicago, where she did coloring books, novels and book covers for four years. She married and moved to Iowa where she continued illustrating on a freelance basis for two years. She and her husband then moved to Florida, where she did her first mural job as an adult—a painting of dogs and cats in an up-scale pet boutique. This job immediately introduced Zebo to a top local realtor, who hired her to paint a mural in the realtor's office. The mural in the realtor's office soon led to a private mural-painting job for the publisher of a west coast of Florida magazine. Since then, she has not looked back.

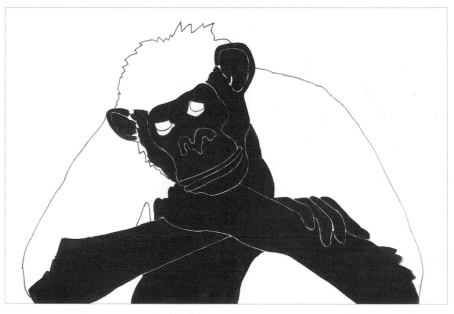

1. SKETCH AND UNDERCOAT. Sketch the monkey on tracing paper. On the back of the paper, go over the sketch lines with chalk or charcoal pencil. Position the tracing right side up on the board and, with a no. 2 pencil, redraw your monkey, pressing firmly to transfer the design.

Mix equal parts Warm Taupe and Black Onyx. This color will be the color of the cracks (wrinkles). With a no. 6 ultra round, paint the areas of skin to be cracked: the forearms, face, ears, fingers and belly. Do not paint over the pencil lines. Paint up to the right and left of each line, leaving a thin hairline as a guide for future steps. Allow to dry.

For a more subtle wrinkle effect, use only Warm Taupe and do not mix with Black Onyx.

2. AQUASIZE BASE. Mix AquaSize + water + isopropyl alcohol (4:1:1) and apply a normal coat of this mixture over the painted skin areas with the no. 6 ultra round. Be careful to avoid painting sizing on the eyes. Do not overbrush. This coat appears milky blue as it is applied, but cures to a clear, transparent, tacky film. Allow to dry to a firm tack, at least thirty minutes to four hours.

If you would like larger crack widths with larger spaces between the cracks, apply a second layer of the AquaSize mixture after the base layer has cured for at least thirty minutes and has become tacky.

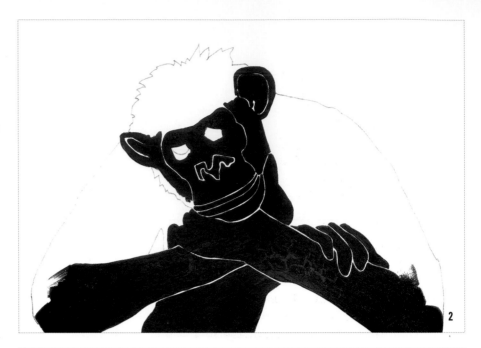

3. CRACKLING TECHNIQUE. Thin Mauve Pink with 20 percent tap water then add 30 percent Crackle-Mate to the thinned paint. This makes the paint crackle. Apply a thin- to medium-thick layer of the CrackleMate-paint mixture over the sizing layer with a no. 12 chisel blender. For smaller areas, like the lips, nose, and outer ears, use a no. 3/0 spotter. When applying the crackle paint, follow the white guidelines.

The direction of the brush strokes determines the shape and direction of the cracks. Lay the paint down according to the contours of the forearms, fingers, nose, face and ears. Paint each feature and appendage separately. Vary not only the direction of the paint but also the thickness. The thicker the paint is applied, the wider the cracks.

For more delicate crackling, brush a thin layer of crackle paint on the fingers, lips, outer ears and chin. A thicker layer of paint creates bigger cracks on the forearms, forehead and inner ears. Do not overbrush. Allow to crack and dry to the touch (about 2 hours depending on paint thickness and environment).

If you are unable to brush the CrackleMate-paint mixture over the size layer within the four-hour time frame, reapply another layer of sizing.

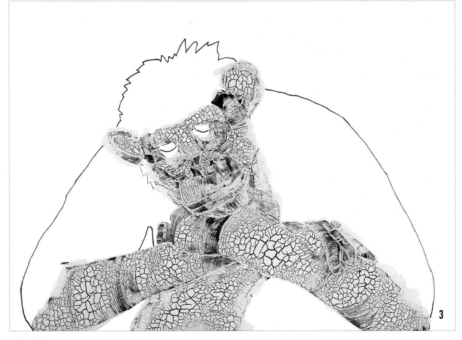

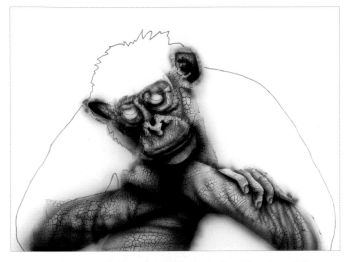

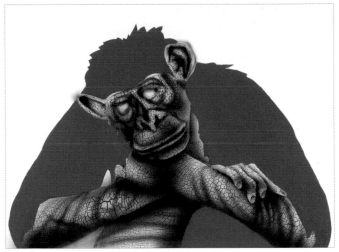

4. SHADING. Airbrush shading onto the crackled skin with an Iwata Eclipse HP-BCS Airbrush, using the fine needle. The direction and varied thickness of the cracks should show the contours of the face and body. If not, reposition the monkey tracing on the surface, and retrace the lines you need onto the crackled finish.

First, airbrush a fine base and create light shadows with Burnt Sienna Hue. Spray creases in the arms and belly and around the eyes. With a curved, plastic template, create a distinct line between the lips, under the lower lip, and under the chin and forearms. Spray a fine line over the upper lip. Shade under the chin and forearms and behind the knee on the belly.

Now deepen these shadows by spraying over them with Transparent Raw Umber Hue. Use your original tracing to make cardboard templates of the fingers and nose. Shade around the template on each feature. Use the negative shape, or nostril, that remains after cutting out the nose as a template for creating the inner ear canal. The negative shape of the finger template is used as a template for creating the fingernails. Use a curved template to shade the outer ear ridge and eyelids.

Spray Transparent Shading Gray for the darkest shadows: under the chin, the lower part of the forearms, under the fingers, on top and behind the knee and the left side of the face. Use the cut templates to spray the nostrils and ear canal again. Spray a fine line between the lips.

Do not be concerned about airbrushing overspray on the background and hair areas. These areas will be painted over in later steps.

5. HAIR. The monkey's hair is created in two steps through a negative process. You first paint the color of the hair.

Mix (AquaColor) Burnt Sienna + (AquaColor) Orange (1:3) and with a ¾-inch (19mm) wash, paint the hairy areas: the head, shoulders, upper arms and knee. This will be the color of each individual hair on the monkey. Cut in carefully with the paint to define the edges of the crackled and shaded skin. Follow the lines and contours of the arms, forehead, knee and ears. Apply two layers for solid coverage. Allow to dry.

In the next step you will apply a glaze of shadow over the hairy areas and remove some of the glaze with a brush and potter's needle tool to create the individual hairs.

EXPERT ADVICE

Tip 1: Always save your tracings. If you are airbrushing, you may need the tracing to cut a template. And you never know if you will require that same image again in future material.

Tip 2: If the mural surface is extremely rough or porous, paint a primer seal coat of Faux Effects AquaSeal on the area to be crackled before brushing on the sizing. Sealing the porous wall aids in creating the crackling effect you desire.

Tip 3: When airbrushing, layer your shading with color from light to dark. This adds depth to your mural and prevents you from painting too dark initially. You can always go darker, but it is very difficult to go lighter once the paint is down. When painting with an airbrush, less is definitely more. Keep it light and layer, layer, layer!

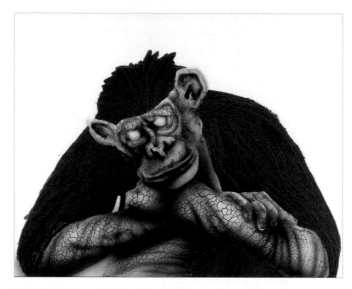

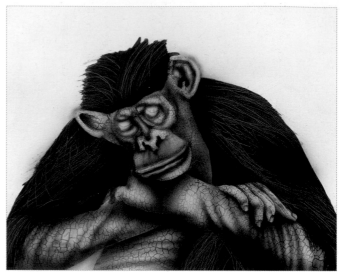

6. HAIR. Mix (AquaColor) VanDyke Brown + AquaCreme (4:1) to create the color of the hair shadows. This creme glazing method allows longer working time for creating a negative striated pattern with either a Ralph Lauren Linen Weaver brush or a Leon Neon.

With a no. 6 ultra round, paint a medium-thick layer of glaze over the hair area painted in step 5. Paint one section of the monkey at a time so the glaze does not become too dry before the negative pattern can be created. Start with the monkey's arms.

After painting the glaze on the arms, place the Leon Neon or Ralph Lauren Linen Weaver brush at the top of the shoulders and pull down and out towards the elbows, creating a striated pattern.

Follow the contours of the body and the natural wave of the hair. To add more depth and realism, apply more glaze over the striated pattern with a no. 6 ultra round. Paint only a few brushstrokes of glaze in random areas. Do not cover up too much of the stria. While the glaze is still wet, take a potter's needle tool and draw hair lines into the glaze. Vary the direction and length of the hair.

Work quickly to prevent blobs. If glaze gets onto the monkey's skin, wipe it off immediately with a slightly damp cloth. Wipe your brush off with a rag in between each brushstroke to prevent blobs and smudging. The random strokes of glaze can be applied over the striated pattern immediately while the glaze is still wet. No dry time is needed between layers.

Now paint the glaze on the head. Place the Leon Neon or Ralph Lauren Linen Weaver brush at the right side of the monkey's forehead and pull up and to the right. Wipe the brush off and then place the brush on the left side of the forehead and pull up and to the left. This creates a natural part. With a potter's needle tool, draw lines into the glaze, creating individual hairs of varying length and direction.

Finally, paint the glaze over the knee area, and with the Leon Neon brush or Ralph Lauren Linen Weaver brush, pull down from the top to create the striated pattern. Draw hair, removing the glaze with varied lines, using a potter's needle tool. Let dry.

7. SHADING AND HIGHLIGHTS. To create dimension in the monkey's hair, airbrush the hair with Transparent Raw Umber Hue.

Airbrush the contours of the upper arms and shoulders. Also shade above the forehead, behind the ears and head, and on top of the knee. Use a template to protect the crackled skin from overspray. Do not be concerned about overspray on the background area, as this area will be painted in a later step. Shade slightly darker on the knee, directly under the forearm.

To finish off the monkey's skin, highlight the skin areas with Golden Airbrush color Titanium White, mixed with a few drops of Yellow Ochre. Use your fine Iwata needle to spray a fine line along the top and bottom lip, around the outer ear, and in the fingernails. Spray highlights on the tops of the creases on the arms, belly and face. Use a template to prevent overspray on the hair.

Take care when spraying highlights. The purpose of adding highlights is twofold. The first is to create the illusion of light reflecting off the skin surface, giving the skin a more realistic appearance. The second is to blend the elements of crackling and shading into one solid, cohesive unit. Too heavy a highlight line will look fake. Too much blending will give the image a cloudy appearance and you will lose the wonderful transparency of your work. Start light, layer on highlight color as needed, and use transparent airbrush paint when possible.

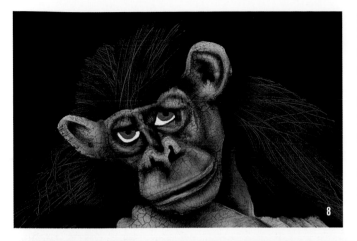

8. BACKGROUND AND EYES. Paint the background layer with AquaColor Black. Use the sides of a ¾-inch (19mm) wash to cut into the edge of the monkey, using the direction the hair flows in as a guide. Paint around the top of the ears and under the right arm along the belly. Apply two layers of paint.

Paint the monkey's iris with Autumn Brown, and the pupils with AquaColor Black, using a no. 18/0 liner. Because the head is angled down and the monkey is looking straight ahead, paint only half of the iris and pupil directly under the upper eyelid. Paint the whites of the eyes with Golden Acrylic Titanium White.

The eye is the window to the soul. No time is truly wasted in working on them to detailed perfection. Of all the elements in a mural that will draw people into it, the eyes have it. Spend the time. Work on the eyes until they look back at you. Work on the eyes until you see life in them. Work on them until they blink.

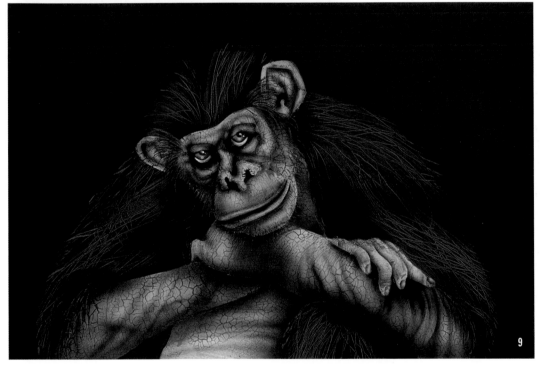

9. FINAL DETAILS. With your airbrush, lightly spray around the edges of the eyeball, using Transparent Shading Gray. Use the fine needle to shade and layer slightly darker towards the nose. Place a circular template on top of the eye and spray a fine line of Golden Airbrush Carbon Black around the inside bottom edge of the template. Be sure the circular template is the same size as the eye. Also, spray a fine line along the bottom eyelash area.

Airbrush a shadow behind the monkey with Golden Airbrush Carbon Black. Use a template to protect your monkey from overspray. With Golden Airbrush Titanium White, spray a fine layer above the black shadow, extending the spray to the top and outer edges of the board.

Highlight the eye by covering the pupil with a pencil eraser and spraying Golden Airbrush Titanium White from the pupil down to the outside edge of the iris. Airbrush a small dot on the pupil and iris, and highlight the upper eyelid. Use a no. 18/0 liner to paint a dab of Golden Acrylic Titanium White in the center of the airbrushed dots.

Add additional hair in front of the ears, on the chin, and along the jaw line. First paint the hairs using Autumn Brown with the no. 18/0 liner. Then, to create depth, use Tombow Dual Brush-Pens #79 and #969, the fine tip side, to draw hair over the painted lines. The potter's needle tool can also be used to create fine lines on the chin and jaw by lightly drawing onto the surface to remove glaze and color.

Finally, extend the hairs along the outside of the monkey, over the airbrushed background shading, using the no. 18/0 liner with Autumn Brown.

FARNESE GARDEN MURAL

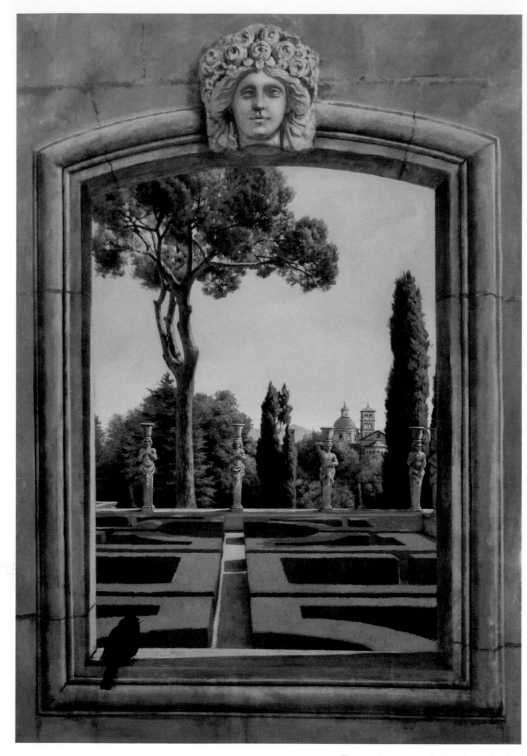

Photographs on pages 62–65 by Pascal Amblard

PASCAL AMBLARD

The original composition for this mural is based on some personal pictures I took in Italy. The garden is from the Villa Farnese in Caprarola. The buildings in the back are close to the Antique Forum in Rome. The window frame, as well as the classical statue head, comes from a villa garden in Aix en Provence. I started with some free-hand thumbnail sketches, and once the composition came together, I made the final adjustments in Photoshop Elements.

MATERIALS

Canvas
Linen primed with gesso

Brushes
2-inch (51mm) chip brush
Nos. 2, 4, and 6 bristle filberts
Nos. 2, 4, and 6 bristle flats
Nos. 1 and 2 pointed nylon

Golden Proceed Paints
Cerulean Blue, Dark Brown,
Earth Green, Raw Sienna,
Raw Umber, Titanium White,
Ultramarine Blue, VanDyke
Brown Hue, Yellow Ochre

Additional Materials
Artist's palette
Digital projector
Erasers (Pink Pearl)
1-inch (25mm) masking tape
No. 2 graphite pencils
Regular rag
Water bucket

▶ To read about how Pascal Amblard started his decorative painting career, see page 10.

1. BACKGROUND WASH. Use a video projector to transfer the drawing onto your canvas (linen primed with clear latex and white gesso). Once the drawing is finished, wash the whole canvas with a mixture of Raw Sienna + Raw Umber. This provides a nice and warm background that enhances the contrasts between the sky and the landscape. It also helps mute down the greens of this setting and creates color harmony.

2. FOLIAGE. Block in the vegetation using mixtures of VanDyke Brown Hue + Ultramarine Blue + Yellow Ochre. These greens should be relatively dark but never opaque. The brushwork on the trees is essential and helps recreate the specific anatomy and texture of each type of tree. Use nos. 2, 4 and 6 flat bristles and nos. 2, 4, and 6 filberts to create the foliage.

Start with the cypresses, making vertical brush marks. Next, block in the bushes by making randomly organized brush marks. Use fan-patterned brush marks for the pine, and finally, block in the boxwood hedges with solid greens. The brushwork for the boxwoods is based on small strokes that recreate the very dense texture of this type of bush.

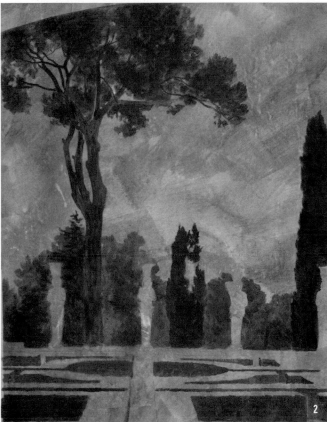

EXPERT ADVICE

Tip: Once you have finished your mural, walk away from it for a few days to let your eye rest and refresh in order to have a better vision of the overall contrasts of the setting. I usually avoid adding details that add nothing to the quality of the whole painting, but I try to enhance the general feel of light and shadow or the contrast between inside vs. outside in the case of classical murals of this type. On this one, I added cast shadows over the boxwood and darkened up the whole window frame. I put one statue in the cast shadow of a tree to break the monotony of the row of statues.

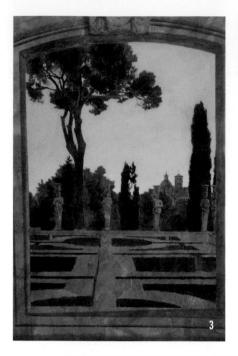

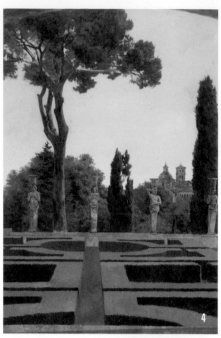

3. SKY, STATUES AND BUILDINGS. Paint in the sky with a mix of Cerulean Blue + Titanium White, making sure the bottom of the sky is lighter than the top.

Establish the basic shapes of the statues and distant buildings by adding some basic shading and blocking in the darkest areas. These shaded parts will help later as you begin building the volume and depth. Indicate the shadows on the buildings with transparent washes of VanDyke Brown Hue and Raw Sienna. The shadows on the statue and molding framing the scene follow the same rules: quite dark but still transparent. The mix is based on VanDyke Brown Hue and Ultramarine Blue.

4. VOLUME AND DEPTH. This is probably the most important step. The goal is to create the feeling of the volume, depth and texture of each type of tree and foliage.

Create lighter greens by adding more Yellow Ochre and a little Titanium White to the dark green mixtures from step 2. Use the same specific brushwork described in step 2, but with much more accuracy and a greater focus on the realism of the textures.

As you paint this step, frequently refer to references photos to help you see the true texture and structure of the trees. Be very careful not to cover up too much of the greens from step 2. Use the dark values of the "block in" mixtures to help the lighter greens stand out.

5. STATUES AND BUILDINGS. The light on the statues is Titanium White + Ultramarine Blue + Raw Sienna. This mixture fills up all the spaces left untouched in step 2. The process is pretty much the same on the buildings; differentiate the light sides from the shaded ones.

On the moldings framing the scene, slightly intensify the shadows with a mix of VanDyke Brown Hue + Raw Sienna and add some light with the same mixture + Titanium White. Now, using a mixture of Dark Brown + VanDyke Brown Hue, and either a no. 12 or ¾-inch (19mm) flat, punch up the value of the architectural details, as well as increase the deepest, darkest shadows on the folds of the fabric on both the cloaks and the headdresses. Use Earth Green to block in fabric on the foreground figure as depicted. Let dry.

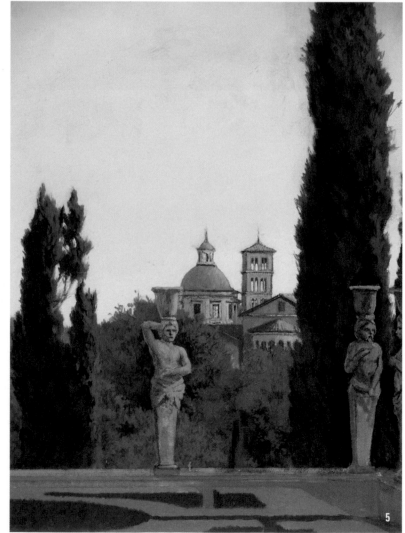

6. LIGHT. This stage is the continuation of volume; however, the focus shifts to creating the direction, quality and intensity of the light. Start by brightening the sky at its base. Add some brighter tones on the buildings to indicate the direction of the light as well as the light's strength.

On the trees, continue to add Yellow Ochre and Titanium White to the green mixtures, gradually making them more opaque. Continue to be careful about not covering up the previous steps. The focus on the texture is still essential, but concentrate your attention on all the subtle variations in the intensity of the light. As you enhance the sense of lighting, you will also have to enhance some graphic details, such as the branching system of the pine trees or the anatomy of the statues.

7. SHADOWS. Since light and shadows are intimately connected, work on some of the darkest values anywhere you feel it will make the light stand out. Cover the dark greens of the boxwood with a slightly lighter and more opaque green mixture. (When the sunlight is intense, even the dark shadows are sometimes indirectly lit by bouncing or reflected light.)

8. DETAILS AND MOLDING. Paint the alley with a mixture of Titanium White, Van-Dyke Brown Hue and Raw Sienna. (The proportion of Raw Sienna is much greater in the darker areas.) The moldings and statue head that compose the windowsill surrounding the scene are enhanced the same way: more intensity in the lights, the shadows and focus on the shapes and subtle midtones.

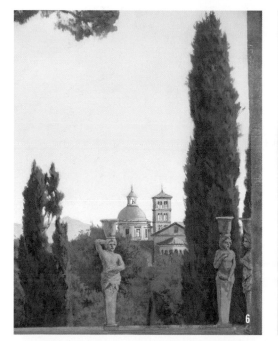

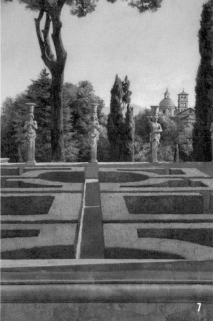

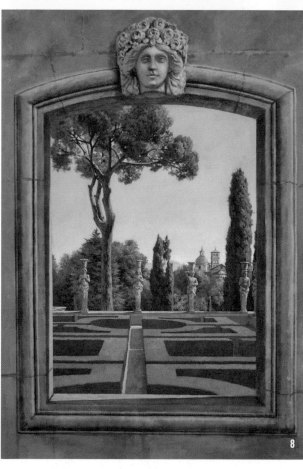

9. BIRD. I decided to add a black bird on the windowsill to add some life to this composition. Draw the bird in place then follow the same steps as in the rest of the composition. Block in the bird with a mixture of VanDyke Brown Hue and Ultramarine Blue. Add some lighter tones to create the volume of the body and the feel of the feathers. Finally, add the most intense lights and shadows and graphic details such as the eye, the beak and the foot.

SEAN CROSBY

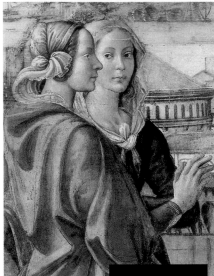

(Above) Original 15th century fresco by Domenico Ghirlandaio, and photo of model for the painting (right).

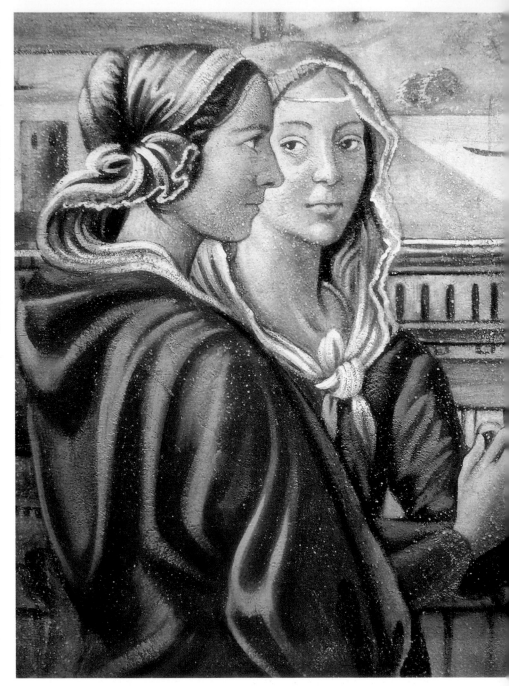

Photographs on pages 66–69 by Craig Walsh

Faux frescoes are always popular with clients and designers. I have completed dozens of faux frescoes for private clients as well as some for large churches over the course of my career. I enjoy working on faux fresco murals, as I can convincingly replicate frescoes as primitive as the ones in Pompeii or as elaborate as the Sistine Chapel ceiling frescoes by Michelangelo. You will notice that when I paint faux frescoes, I render the details first, such as the face, hands and the basic lines of the background elements, and then apply translucent washes of glazes over the details to bring the painting to life. In contrast to an oil painter, who typically works from dark to light, I work like a watercolor artist, working from light to dark, which enhances the brilliance and luminosity in my faux frescoes.

For this project I incorporated a model's face into a portion of a fifteenth-century fresco entitled *The Visitation*, originally rendered by Florentine Renaissance Master Domenico Ghirlandaio. Several of my clients have requested that their family members or their own portraits be incorporated into an old master's fresco, which is quite fun to do. It's also very similar to how many of the Renaissance frescoes were commissioned; members of royalty or influential families commissioned works that depicted family members as important figures in scenes from the Bible or other significant historical settings.

▶ To read about how Sean Crosby started his decorative painting career, see page 11.

MATERIALS

Surface
Fredrix Polyflax/Polymural canvas

Textured Base
PlasterTex by Faux Effects

Brushes
2-inch (51mm) chip brush
No. 12 or ¾-inch (19mm) Golden
 Taklon flats
Nos. 1, 2, 4, 8 Golden Taklon rounds

Faux Effects AquaColors
Dark Brown, Earth Green, Eggplant,
 Red Oxide, Ultramarine Blue,
 VanDyke Brown

Faux Effects Dutch Metal
Gold

Additional Materials
Artist's palette
Artograph MC-250 professional
 projector
Cheesecloth
Eraser (Pink Pearl)
Faux Effects Super Crème (White)
1-inch (25mm) masking tape
No. 2 graphite pencils
Reactive solvent: Activator II by
 Faux Effects
220-grit sandpaper
Saral Wax-Free transfer paper in
 graphite
Spray bottle/mister
4-inch (10cm) and 9½-inch (24cm)
 stainless-steel tapered plaster trowel
Water bucket

1. BACKGROUND TEXTURE. Stretch your canvas tightly to the surface you will be working on. Ensure that there are no wrinkles or creases. Then apply a thin layer of PlasterTex to the entire surface of your canvas, using a 4-inch (10cm) or 9½-inch (24cm) tapered plaster trowel. The goal is to completely cover the weave of the canvas. Let dry.

Transfer the image to your surface with an overhead projector. Use a high resolution printed or original copy of the image sized to fit on the glass projection panel of your projector.

2. FACIAL FEATURES. Print the image of your model or client's face, scaled to fit the dimensions of the original image's foreground figure's face. (Note: You may need to re-size your original image using a photo-editing program to properly scale the image.) Trim the image so you can align it on your canvas to properly fit the space. Secure the image to the canvas with masking tape and use Saral Wax-Free Transfer Paper to transfer the image. Trace the geometry and shadow reference lines and check your work as you go.

3. INITIAL LINES. Begin painting the initial lines of your painting using a no. 2 round and Red Oxide, thinned with a little bit of water, so it flows well off of your brush. Let dry.

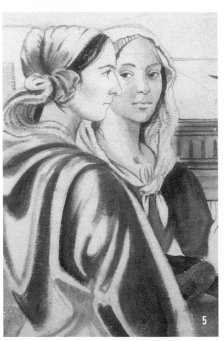

4. FABRIC AND ARCHITECTURE. Begin blocking in the geometry of the fabric folds as well as some of the background architecture with Red Oxide, thinned with water. My theory is "Big Space, Big Brush; Little Space, Little Brush." If you are painting in a little space, use the no. 2 round; for larger spaces, use either the no. 4 or no. 8 round. To eliminate any "hard edges," reduce the paint using a wad of cheesecloth, applying firm pressure initially, and gradually reducing pressure to ensure the hard edges disappear in a gradient manner. Let dry.

5. FIGURES AND ARCHITECTURE. Add Dark Brown to your Red Oxide and begin to confirm and deepen the value of the geometry on the foreground figure's fabric. You will note that the deepest tones are near the fabric folds. In addition, use the same mixture to enhance the shadows on both figures' faces and necks.

Now, using Dark Brown thinned with water, apply a thin wash of color to the background architecture as well as the sleeve of the background figure. Allow this wash to set up for a minute or two, and then gently reduce with cheesecloth. Also use Dark Brown to paint the boats in the background with your no. 1 or no. 2 round. Let dry.

6. FIGURES AND BACKGROUND. Using a mixture of Red Oxide + Dark Brown (2:1) with a little bit of water, apply a wash of color over the entire surface of the foreground figure's cloak and sleeve fabric. Let dry. Now block in the background rooftops, mountains, sky and water with a mixture of Ultramarine Blue and Dark Brown thinned with water. Vary the mixture of the two colors as well as the amount of water depending on the area of the panel you are rendering (for example: use more water and less color in the mixture for the sky and water; and use less water and more color for the rooftop and mountain mixtures).

Now, using a mixture of Dark Brown + VanDyke Brown, and either a no. 12 or ¾-inch (19mm) flat, punch up the value of the architectural details, as well as increase the deepest, darkest shadows on the folds of the fabric on both the cloaks and the headdresses. Use Earth Green to block in fabric on the foreground figure as depicted. Let dry.

7. HIGHLIGHTS. Begin rendering the background shrubs and trees with a mixture of Ultramarine Blue and Dark Brown, and allow drying.

Up to this point, you've been using transparent washes of color for the panel. Now, begin to introduce opaque highlights into the painting. Opaque highlights give the painting some "punch" and let you clean up the shapes. On your palette, mix a drop or two of Red Oxide with an opaque acrylic white paint to "warm up" the highlights (for this panel, I used Faux Effects Super Crème White). Using a round brush, add the brightest highlights on the headdresses, the background architecture, and the foreground figure's hair braids.

Mix a drop or two of Dark Brown with the opaque white to render the highlights on the background shrubs and trees. Let dry.

8. DISTRESSING. With a sheet of 220-grit sandpaper, gently sand the surface of the entire canvas, being careful not to apply too much pressure near the figure's faces. After sanding, apply a thin wash of Dark Brown + water (1:10) to the entire surface using a 2-inch (51mm) chip. Immediately after applying this wash, "spritz" the surface with a fine mist of Activator II, using the spray bottle. Control any undesirable volume of the Activator II material (especially around the faces) by gently blotting with a wad of cheesecloth. The Activator II will react with the glazes, opening them up to create the illusion of "watermarks" which enhances the distressed and aged appearance of the panel. Let dry.

9. ADDITIONAL HIGHLIGHTS. I often add some additional opaque highlights to refine or "bring out" some of the brilliant colors of my faux frescoes following the distressing and aging process.

Mix a drop or two of Eggplant with the opaque white and add to the brightest highlights on the background figure's torso and sleeve.

Then mix a drop or two of Red Oxide with the opaque white to paint the brightest highlights on the foreground figure's fabric.

Now take your no. 1 or no. 2 round and paint the delicate decoration on the foreground figure's right sleeve using Master Dutch Metal Gold (see photo inset). Let dry.

RANDY INGRAM AND J. BRIAN TOWNSEND

The trompe l'oeil stone architecture painted in this 360-degree wrap mural encompassed approximately fifty percent of the design in this beautiful Staten Island, New York, mansion. All walls and existing architecture in this massive, three-story, dual sweeping staircase foyer were painted in a yellow-orange color mood to compliment the client's taste in both color schemes and theatrics. The elements designed for this mural include a 2½-story life-size waterfall; two seven-feet (2.1m) tall warrior stone statues; one five-feet (1.5m) stone female figure holding the reins of four horses; stone block walls; four lion corbels; a lakeside view scene; and two waterfalls in distant mountain ranges.

This demo depicts the female figure in the stone relief carving above the front door. She is the center of the carving and represents classical beauty and power. When Randy and Brian first conceived the idea for the relief, their study contained the client's family crest. Upon closer review, it was decided to change the family crest to the female figure to help balance the two stone warrior's masculine presence. The relief in the mural was inspired by a freeze in Palazzo Montecitorio, Italy, by Aristide Sartorio.

MATERIALS

Utrecht Brushes
Nos. 2, 4, 6, 8, 10, and 12 bristle filberts, Series 209F (6 of each)

Winsor & Newton Artists' Oil Colours
Burnt Sienna, Cadmium Orange, Ivory Black, Raw Umber, Titanium White, Yellow Ochre

Additional Materials
HB pencil
Heavy tracing paper
Palette knife for mixing paint
Small jar of odorless turpentine
Transfer pen (stylist)
White carbon transfer paper
Wooden palette

Photographs on pages 70–73 by Randy Ingram and Brian Townsend

Randy Ingram started out working in the paper industry designing and selling business forms to Fortune 500 companies. He then worked for a company that did new product development for the cosmetic and fragrance industry. "My job was to create, market, and have the new idea manufactured and brought to the marketplace." Randy has been in the decorative painting and mural painting field since 1988.

Brian Townsend studied at the duCret School of Art (1979-1982) and then went on to The National Academy of Design (1984-1987). He has been making his living as a fine artist for twenty years, and has been represented by Swain Galleries since 1987. He worked in commercial art for two years very early in his career. Since then, he has made his living doing portrait and still life commissions and having one-man and group shows. He taught classes on figure painting in oils and still life painting in oils from 1989-2001 at duCret School of Art and at the Visual Arts Center of New Jersey from 1992-1994.

Using a Model

For centuries, professional artists have used live models to accurately portray proportion, detail and anatomy. Choose a person who closely relates in height and proportions to the figure you are trying to paint. Think of the basic form of dress to create the correct theme. Next, choose a place for the model to pose that best depicts the correct height—whether you are looking up or down at the figure. One very important thing to remember is to light the model in the way you choose to paint her. In our painting, the figure was to be lit from above so we used outside sunlight as our light source.

Using the photo reference, we drew the figure on heavy-duty tracing paper in our studio. We work on tracing paper first because it allows us to erase and move things multiple times. We changed the cloth to have a more classical theme and modified the hair to have a feeling of carved stone. We wanted the features of the face to have the ideal form of a perfectly carved statue: an indifferent, non-expressive look. Be careful when trying to paint figures in stone that they do not become too lifelike.

Another important consideration is the perfect proportions of the human form. By stretching the body and making her almost an entire head taller than she really is, the figure becomes much more elegant. The hands were drawn slightly smaller to give a beautiful delicate feel. Never just copy a photo! The camera lens almost always distorts the image. It does not see perspective the same way the human eye sees.

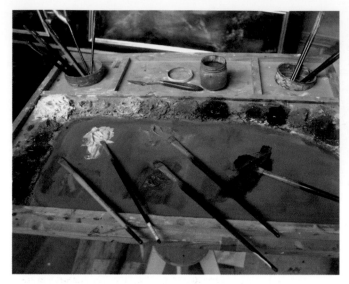

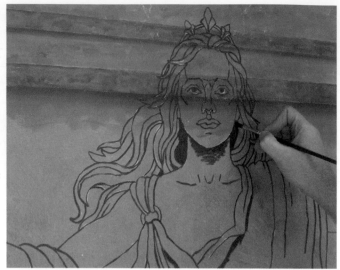

PALETTE. Note the five basic values we used in modeling the stone. These colors were made by mixing Yellow Ochre and Burnt Sienna together. We darkened the mix with Raw Umber and we lightened it with Titanium White and Cadmium Orange. We remixed the colors periodically, letting them vary slightly; a little more yellow or orange to gain variations in the stone. We used two colors to paint in the grout lines: Titanium White with a little Yellow Ochre added for the light, and Raw Umber mixed with Ivory Black for the dark.

1. DRAWING THE FIGURE ON THE WALL. Transfer the tracing paper drawing onto the wall using transfer paper. We used white carbon transfer paper because the wall is a medium-dark tone. Begin the painting by drawing out the figure with a mixture of Raw Umber and odorless mineral spirits, keeping the consistency a little thicker than ink. At this stage you are just trying to find the larger shapes and plane breaks.

EXPERT ADVICE

Tip 1: When designing a large-scale mural, it is important to remember the distance from which the viewer will see your artwork. You do not need to render something that no one will see!

Tip 2: Both Randy and Brian use a handheld laser pointer to critique each area that is being painted. This method allows them to quickly adjust or correct any painted areas that need improvement.

Tip 3: When painting cracks in stone, remember there is not just a dark line but also a highlight on the other side.

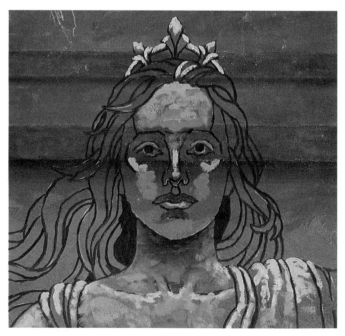

2. BLOCKING IN THE PAINTING. "Blocking in a painting" is the term artists use for breaking down intricately shaped objects into simple planes. Using five simple values (light, halftone, dark, reflected light, and highlight) place value next to value to create form, not by blending. Wash in the darks as large, simple shapes using thinner paint. Then apply the halftones and light with thicker paint. Apply the highlights exactly where you want them.

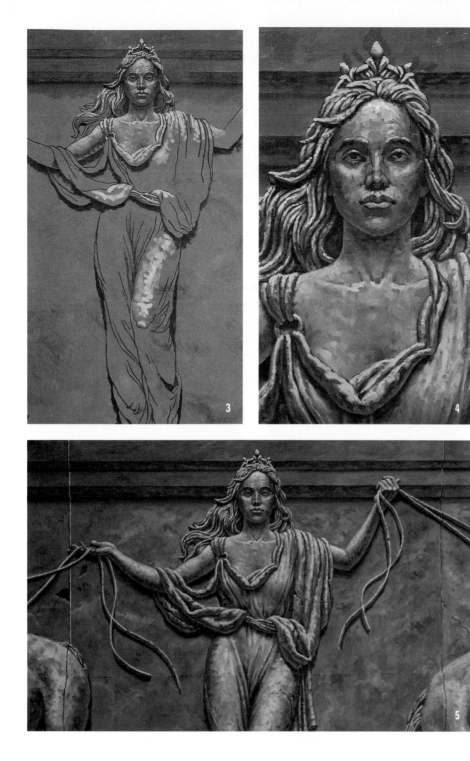

3. BODY. Next, develop the painting as a whole, moving around the painting until all the elements are blocked in with simple shapes so you can see the head (the focal point) in relation to the rest of the painting. Remember, you do not want to render each individual body part to completion one at a time because you cannot relate it to the entire painting.

4. HEAD. As the body comes into focus, begin completing the head. Use smaller brushes to muzzle the individual shapes of each feature. Render from the center of the face out, bringing the eyes, nose and center of the mouth into focus. Also, by using the existing brush imperfections, we began to develop cracks, chips, nicks, and grooves that are the characteristic of stone. Since real stone is not always polished, be careful not to blend the wet oil paint until it looks smooth.

5. COMPLETION. We can best describe the completion process as one of constant tightening up of the painting. At this point, begin to work in smaller areas, still moving around the entire painting, but using smaller brushes, sometimes leaving the happy mistakes alone. Do not repaint the entire painting. Stand back every so often to see the big picture. Once you feel the painting is rendered completely, start the detail process using even smaller brushes if needed. (Always save the details until the end.) Soften hard edges and sharpen some soft edges. As we completed the mural, we noticed incorrect design elements such as the way the dress folds were drawn. We are never afraid to make major drawing changes to create a better painting.

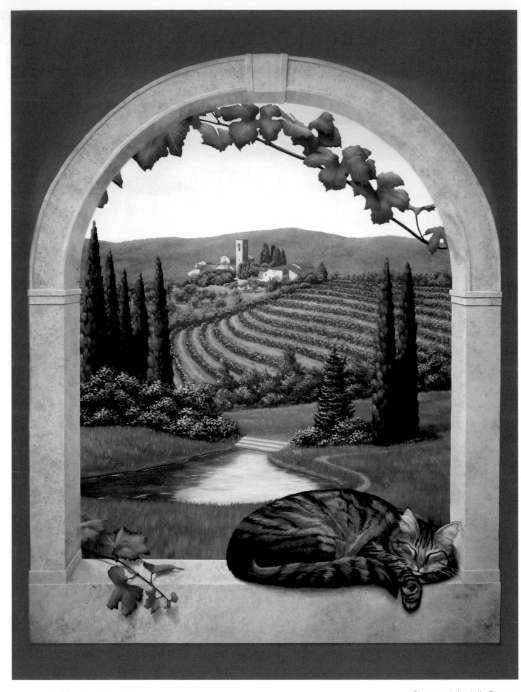

Photograph by Julie Damore

JEFF RAUM

This demo is showing only the middle ground of the completed piece. Keep this in mind as you are painting. The middle ground offers a good example of atmospheric perspective. In atmospheric perspective, objects are cooler, have less contrast, and the intensity, or chroma, of the color is less when the objects are far away. As the objects get closer to the viewer, they get warmer, have more contrast and the colors intensify.

Do not get too detailed in this part of your mural. Remember, the more detailed you make the midground, the more detailed your foreground will need to be. Give yourself some room to grow and prioritize. Keep your work sedate, and then "pull out all the stops" and wow the viewer with the foreground elements.

MATERIALS

Brushes
³/₈-inch (10mm) and 1-inch (25mm) flats
A collection of "ratty" used brushes
Detail brush

Delta Ceramcoat Paints
Blue Mist, Blue Spruce, Burnt Umber, Cloudberry Tan, Coastline Blue, Cricket, Dark Flesh, Gamal Green, Hammered Iron, Light Timberline Green, Medium Foliage Green, Norsk Blue, Raw Linen, Rainforest Green, Spice Tan, Territorial Beige, Wedgwood Green

BEFORE HE PAINTED

Jeff attended college and received his BFA in commercial design in 1983. Jeff's original desire was to become a book illustrator, but he landed his first job in a Washington, DC, commercial art studio. After eight months, he quit and moved to New York to work with a 3D animation studio creating story boards and backdrops for television commercials. Eventually he was promoted to an art director and worked on the first season of the children's show, *Pee Wee's Playhouse*. This led to Jeff becoming a make-up artist on Broadway for the plays, *I'm Not Rappaport* and *Into the Woods*.

After Broadway, Jeff moved to Los Angeles with the intent of working in the movie industry, but he was told he would have to start at the bottom because he wasn't in the union. So Jeff created his own decorative painting business, Muracles, in 1989. He started by calling interior designers listed in the phone book to

set up an appointment to show his portfolio. If no appointment was possible, he mailed a flyer. More recently, he has had a booth at local home shows and designer expos. Also, Jeff uses a marketing firm to obtain targeted mailing lists of home owners. He also has participated in showcase homes which put him in touch with numerous designers.

Jeff, unfortunately, has moved around a lot, and each move meant starting his business over to gain recognition in a new market. Now, with the Internet, Jeff recommends having a Web site for continuity and keeping your phone number the same if possible to keep the referral process going strong.

1. BACKGROUND AND LAYOUT.

The background hills are blocked in with Norsk Blue. Scumble in treetops using a ratty brush with Rainforest Green. Let dry. Now cover the hills with a wash of watered-down Blue Mist to "knock them back." The more opaque your wash, the farther away the hills will appear. Working with references, outline the major shapes of your village. You may want to work out the layout on scrap paper and then, when satisfied, transfer to your wall using graphite or transfer paper.

2. BUILDINGS. Using a ³⁄₈-inch (10mm) flat, block in the light side of the buildings with Raw Linen. Add Hammered Iron with some Norsk Blue to paint the shadowed sides. Use Dark Flesh to paint the roofs. With the 1-inch (25mm) flat brush use Cloudberry Tan and mass in the ground with more Blue Mist added in the distance.

Tip 1: If the village still looks too bold or if you want to create more of an early morning feeling, put a wash of Blue Mist over the entire town. Use a large brush and water down the Blue Mist to "dirty water" consistency. Apply in broad, horizontal strokes. Keep a rag handy to wipe off excess.

Tip 2: When painting the grapevines, keep in mind the vines should get larger as they get nearer. Also, as the vines go up the hill closer to eye level, the view of them will change from looking down on top of them to seeing them from the side.

3. DETAILS ON BUILDINGS. Add darker shadows with Hammered Iron. Windows and doors are Hammered Iron or Norsk Blue. Vary the visual texture of the light walls by mixing in some Blue Mist. Using a detail brush, add some texture to the roofs with Hammered Iron and Raw Linen watered down. Remember to keep it simple. At this distance, you want to imply detail.

Use Cloudberry Tan, Spice Tan, and Territorial Beige to add texture to the ground and create the rows of grapevines. Finally, use a Raw Linen + Cloudberry Tan mixture and rough up the ground between the rows.

4. FOLIAGE. Block in the foliage around the village using Blue Spruce. Using a darker color around the village makes the light buildings "pop" and helps focus the viewer's attention on the focal point. Use a "ratty" used brush and scumble in the distant trees in the orchard and the grapevines using Medium Foliage Green. Continue using Medium Foliage Green and block in the rows of trees separating the two orchards. To add more contrast to the trees that are closest, add Gamal Green.

5. FOLIAGE. Highlight the distant trees with Wedgwood Green, keeping the color focused on the left side of the trees. As the trees get closer to the viewer, add more Light Timberline Green to warm up the greens. Add Cricket to the foliage that is closest to create more contrast. Add grapevine posts with Burnt Umber and use water-downed Burnt Umber to darken shadows in the foreground. Use Blue Mist here and there to highlight posts.

BEFORE SHE PAINTED

Alison Woolley Bukhgalter describes her personal journey: "People often ask me how a Canadian girl got to be running a decorative painting workshop and school in Florence, Italy. The practical answer is that I was born in Scotland, so with my European passport, I can live and work legally in Italy. The long answer, however, starts with graduating from the Ontario College of Art and Design in 1987. Afterwards, I experienced a sense of disappointment as to what kind of career I could have as a 'painter' in Toronto and so decided to go for the OCAD's off-campus program in Florence for a year of post graduate study.

"I fell in love with Florence, especially the artisan district on the south side of the Arno River. Every day I walked down the narrow streets, I gazed through the open bottega doors where I could see painters, gilders, and wood carvers at work and dreamed of working in one of those shops. After awhile, I thought *What do I have to lose?* So I gathered up enough courage and started asking around, showing painted samples I had worked up in my student lodgings. After some

refusals, I was directed to a small decorator's bottega in a tiny street running alongside of the Church of Santo Spirito. At this workshop they didn't say 'no,' but they didn't exactly say 'sì' either (my Italian was pretty bad at the time). But from what I understood, I could come back the next day and they would put me to work. I came back the next day, and the next and they kept saying 'domani' at the end of each day's work, so I kept coming back. I was delighted to be painting all day. By the end of the first week, I had come up with a phrase (and the courage) to ask if I was going to be paid. I was really unsure of what this working relationship was going to be. When I sputtered out my prepared phrase, Carlo (the boss) laughed and said 'sì.' I figured this was the start of something good."

ALISON WOOLLEY BUKHGALTER

I created the flowing decorative brush-strokes on this painted instrument with Casein paint over a crackle gesso basecoat. The patina is created with a wash of tea followed by several layers of antiquing wax. The surface can be further distressed by hitting it with a chain.

MATERIALS

Brushes

A variety of appropriately sized synthetic bristle artist's brushes

Ready-Made Casein Paints

Black, Bone White (or Off White), Brick Red, Burnt Umber, Cadmium Yellow, Primary Red, Raw Umber, Ultramarine Blue, Yellow Ochre, White

Additional Materials

Albumin: 9 oz. (250g)

Charcoal

Earth pigments in powder form: (raw umber, burnt umber, raw sienna)

Graphite paper

Paste wax (a wax that combines beeswax and carnauba wax is good)

Pencil

Permanent Marker

Rottenstone

Shellac: traditional amber colored shellac

Small sponge or scrubbing pad

Stylus

Tea: a strong pot made with three or four tea bags

Tracing paper

Turpentine

Wool rag

Whiting

1. GESSO. Coat the wooden piece with a special 'crackle' gesso made following this recipe: combine albumin powder with cold water, approximately 9 ounces (250g) of albumin to 2.5 cups (600ml) of water to make your glue base.

Add whiting to this glue base until you reach a thick, soupy consistency. Brush it on to untreated wood. When it dries, the gesso basecoat will have a delicate crackle running through it. Sand and basecoat with Bone White (or Off White) casein paint.

2. SKETCH. Work out the design on tracing paper. Use as much pictorial reference as you can find for your project. First, I sketch with a soft pencil, then when I'm sure of the design, I go over it in permanent marker. To transfer the design, apply charcoal sparingly to the back of the tracing paper, or use graphite paper, then trace through from the front with a stylus.

Instrument property of Nicholas Michael

Photographs on pages 78–81 by P. Dunand Filloil – atelier/rc

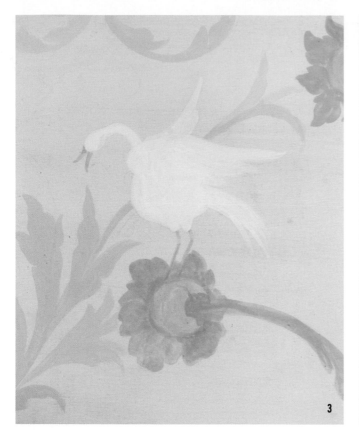

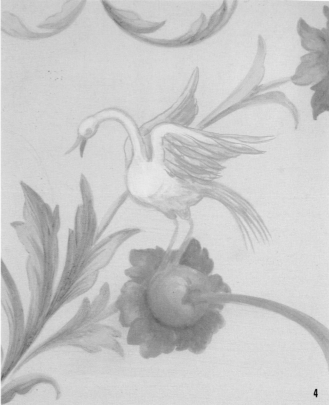

Tip 1: Using tracing paper during the design process allows you to see the elements of decoration before you paint, to see if they work together. It also allows you to trace symmetrical elements of the decoration from one side to the other. You can make all the adjustments (size, proportion, flow of line) at this point. I use reference books of historical ornament and photographic material from palaces and villas around Italy.

Tip 2: When making decorative brushstrokes, your brush should be held perpendicular to the surface you are painting. You may want to use your free hand to support your brush hand to help get more distance from the surface.

Tip 3: Casein paint is particularly suitable for creating flowing brushstrokes because it is an opaque paint that does not dry out quickly on your palette or in the brush. It also wears back very nicely if you want to create an antique effect.

3. BASECOAT. Using commercially available casein colors, mix the shades of color that you want. Generally, for basecoats these are pastel colors dulled down with a little black or brown. The basecoats are a flat, opaque coverage of the forms.

4. SHADOWS. Apply washes of a darker color over the base colors in shadow areas to create form. The casein paint is watered down so that it is slightly transparent. You can choose a light source and follow the basic rules of chiaroscuro. Good shadow work creates the illusion of depth in ornament. It is important to study the basics of shading form to acquire confidence working with the elements of light and shadow in decorative painting. If you are having trouble with where to put the shadows, it helps to have good reference material to draw from, but it might be a good idea to do a quick study specifically on light and shading at your local art school.

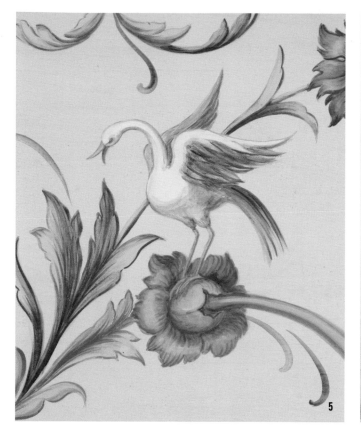

5. DECORATIVE BRUSHSTROKES. After the forms are created, define them further with decorative brushstrokes that add the darkest accents and some highlights. This stroke work follows the flow of the curves and adds vivacity. It can be compared to calligraphy or Chinese brush painting.

6. WEARING BACK. Rewet your painted surface with tea. Once it is wet, you can wear back the casein paint very easily. Use a small sponge or a scrubbing pad to imitate the effects of time. You can also create small dents in the surface by hitting it with a chain.

7. ANTIQUING WAX. Once the surface has dried, you can apply an antiquing wax. This is simply a tinted wax. Here is one recipe:

 Combine paste wax + turpentine (1:2)
 Add $1/8$ part earth pigments to color the wax
 Blend well

 Apply this mixture directly to your painted surface, spreading it out well. Alternatively, before you wax, you can apply a thin coat of shellac or varnish as extra protection. Let the wax dry, then buff it with a wool rag and some rottenstone to polish. You can repeat the wax step as many times as you want to create the right amount of patina.

ORNAMENTAL MURAL DESIGN

Photographs on pages 82–85 by Joshua Pestka

CYNTHIA DAVIS

Designs for ornamental murals are limitless. Inspiration can be found almost anywhere—furniture, architecture, fabrics. Once you have selected your basic elements, some tracing paper and charcoal are all you need to complete the entire design—anything from panels to borders to medallions and more.

MATERIALS

Brushes

½-inch (13mm) stencil
Nos. 4, 6, and 10 Robert Simmons pointed rounds (larger brush for a bigger mural)

Golden Fluid Acrylic Paints

Burnt Umber, Burnt Umber Light, Burnt Umber Medium, Burnt Sienna, Iridescent Gold Deep, Jenkins Green, Red Oxide, Yellow Oxide, Ultramarine Blue; Benjamin Moore acrylic paint #504 (as an alternative to mixing Golden's Jenkins Green and Yellow Oxide)

Additional Materials

Ballpoint pen
Level
Liberon Black Bison Fine Paste Wax in Walnut
1-inch (25mm) painters' tape
Paper towel
PlasterTex by Faux Effects
Plastic card
Small steel trowel
Soft vine charcoal
Tape measure
Tissue paper
Tracing paper
Wandering Ivy stencil by Wallovers

BEFORE SHE PAINTED

Cynthia Davis graduated with a Bachelor of Arts degree from the University of Vermont in 1984 and went on to work in broadcast advertising, advertising account management and retail customer relations until 1994. While taking classes at Boston's School of the Museum of Fine Arts as a part-time student, she began pursuing her career as a decorative artist. Her company originated in 1993 as The Finish Line, where she sold decorative mirrors and other hand-painted accessories in galleries and Ben and Jerry's gift shops. In 2001, The Finish Line became Cynthia Designs, a decorative design and painting company. Cynthia continued her study of art locally in Connecticut at Silvermine Guild Art Center and the Brookfield Craft Center and has attended decorative art classes at Pratt Institute, New York. She has studied abroad in Italy and France, and participated on design teams and in a church restoration. She attends the Stencil Artisans League, Inc. convention annually and now teaches design classes to professionals. Cynthia has recently developed a stencil line called Wallovers that she runs with her associate Rena Paris.

PLAN THE WALL SPACE. Before you begin your design work, map out the space for your mural on a piece of paper. The wall(s) dimensions and area will dictate the mural size. Here, I enlarged my original design to 7 feet (2.2m) and repeated the panel on either side, adding a border around it. The center design was inspired from a piece of Toile fabric for a more Pompeian feel. By doing this, I was able to complete an entire wall space. You could choose to paint the panel only, framing a doorway, or turn it horizontally for a border shape. The maquette for this project is on page 25.

1. THE ORNAMENT QUADRANT. By using a few historical design elements like these scrolls and flourishes, you can create thousands of designs for panels, medallions, borders and more. Resources for ornament design can be found in architectural elements, books, antique furniture, tiles and more. It's always a good idea to carry a camera with you when traveling to record designs of interest.

2. DRAWING. You only need to draw one quarter of the panel as you will create a mirror image from left to right and from top to bottom. Start by folding your tissue paper in half. After each design element is added, fold and trace the design onto the other side.

Have a good supply of tracing paper so you can try out many design possibilities. Add or remove elements as you go along until you end up with the desired result.

Retrace the quarter panel so you have a clean image. Then fold your tracing paper over and trace the image you created. When you open it, you will have half of your completed panel. You only need this completed half to begin your project since you will simply turn it upside down to create the other half.

3. BASE TEXTURE. Using a small steel trowel, apply a skimcoat of PlasterTex by Faux Effects to all the wall space where the mural will be painted. By creating peaks of plaster and pulling the product down you will create grooves and texture that will give your mural a "fresco feel" while leaving the surface smooth enough for hand painting.

4. PANEL BORDERS. Using a laser level or level tool and tape measure, map out the borders around the panels. Use 1-inch (25mm) painters' tape to mask off the border around all the panels. Burnish the tape down with a plastic card so the edges are flush with the wall surface and no paint will seep underneath. Mark off the outer border at 3 inches (76mm) and paint it in with Ultramarine Blue.

5. DESIGN TRANSFER. Rub the back of the tissue paper with soft vine charcoal. Then shake or blow off the excess charcoal. Make sure you apply enough on all areas of the design. Losing images when you transfer will cause you to miss important information and will make the painting job more difficult.

Place your tissue template on the wall where you want to place the design. Using a ballpoint pen (I prefer red so I can see what I've transferred) trace over the entire design to transfer the charcoal onto the wall. Lift up the tissue to make sure the charcoal has transferred dark enough but never remove the tissue once it is in place. Once finished, take a dry paper towel and gently rub back the charcoal so the design is visible but not dusty.

MATERIALS

Surface
Unstretched canvas

Modern Masters Artist's Acrylics
Black, Burnt Sienna, Burnt Umber, Magenta, Raw Sienna, White, Raw Umber, Thalo Blue, Ultramarine Blue, Violet

Additional Materials
Charcoal
Measuring tape
Modern Masters Acrylic Venetian Plaster
Modern Masters Crackle for Latex Paint
Modern Masters Dead Flat Acrylic Varnish
Modern Masters Tintable Glaze
4-inch (10cm) paint brush, roller and tray
Pencil
Overhead projector
Rags
220-grit sandpaper
Set square
Spirit level
Straightedge
Tape
Transparencies
Trowel or putty knife
Various artist brushes

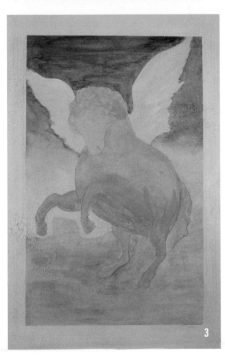

CANVAS PREPARATION. Stretch your canvas onto a wall or plywood by stapling the edges. First staple in the middle of each side of canvas, crossing over to the opposite side after every two or three staples and working your way out to the corners.

Prime canvas with a latex primer thinned down with water (2:1) to the consistency of cream. When the canvas is dry, remove the staples, flip the canvas over, re-staple and prime the other side. When dry, sand the canvas lightly with 220-grit sandpaper. The water in the primer will raise the fibers of the canvas. Apply crackle medium to select areas in a drift pattern. Let dry.

1. TEXTURE. Roll out the surface with Acrylic Venetian Plaster (for the benefit of the photographs, I tinted the plaster with Benjamin Moore HC32). Do not back roll. Let dry. The surface will crack.

Build up texture in select areas by applying more plaster with a trowel or putty knife. Let dry.

2. SEAL AND TRANSFER IMAGE. Seal the surface by rolling on an appropriate basecoat color using an acrylic satin-sheened paint. Or, if you used a colored Venetian Plaster, seal the plaster with Dead Flat Acrylic Varnish. Let dry.

With charcoal or water soluble pencils, draw the reference image onto a transparency and project the image onto the canvas using an overhead projector. (You also can transfer your image using a grid system.) Use a spirit level, a set square and measuring tape to draw out the trompe l'oeil moldings.

3. INITIAL COLOR WASHES. Water down the acrylic paint in the appropriate colors and apply washes of light color to block out each element. I used Thalo Blue for the sky, Burnt Sienna for the body of the horse, Ultramarine Blue, Violet and Raw Sienna for the background and White for the wings.

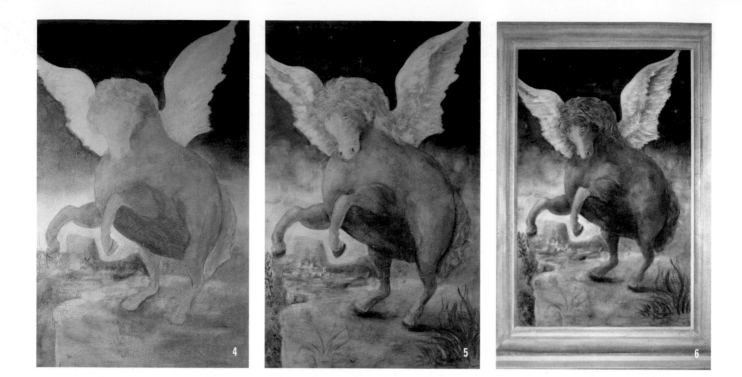

EXPERT ADVICE

Tip 1: When drawing out trompe l'oeil moldings make sure your measurements are exact. If you are off in the measurements, the illusion will not work. However, don't go crazy measuring and remeasuring, trust your eye. If it looks correct, it probably is.

Tip 2: If your aim is to age the fresco by sanding back, make sure your image has a high contrast between shadows and highlights. If you don't have enough contrast, then the detail will disappear when you sand it back.

Tip 3: Choose a light source. When using a reference, locate where the light source is coming from, and when highlighting the image, make sure you follow the areas where the light would naturally touch.

An easy way to shade images is to start off blocking in the image with the lightest color visible in the reference. Then, shade the image with a glaze color that is deeper than your base color. While the glaze is wet, wipe back the areas where there would naturally be highlights (the highest points in the image or the areas that are closest to your light source).

4. COLOR GLAZES. Deepen the colors of each element by using tintable glaze mixed with the acrylic paints. The ratio depends on how intense you want the color. I used roughly 3 parts glaze to 1 part paint. Shade the horse's belly with Burnt Umber and Burnt Sienna. Add more Violet, Ultramarine Blue and Raw Umber to the background. Deepen the sky with Ultramarine Blue and Thalo Blue.

5. SHADING. Using tintable glaze and Raw Umber, add shadows to appropriate areas. Shade the wings and add shadows to the body of the horse and add cast shadows beside hooves. Add grass and plants with Ultramarine Blue and Raw Sienna. Highlight with White. Begin shading the trompe l'oeil moldings with tintable glaze and Raw Sienna.

6. ADDING DEPTH. Deepen areas of the trompe l'oeil moldings by applying a glaze of Raw Umber, Black and Tintable Glaze. The illusion works well with very deep shadows and very bright highlights, so make sure there is enough contrast between tones of shadows. Also, glaze areas in the horse to add depth. Add a little detail to the background using Ultramarine Blue and White.

BEFORE SHE PAINTED

After high school, Lori Le Mare wanted to attend art school but did not have the confidence to go into a program that would require having her artwork juried for acceptance into the school. She met a fellow Canadian who was a general painter, and they decided to travel to England to take a five-day introduction to decorative painting class. After the class, they returned to Canada and started up their own decorative painting business. "At the beginning, we kind of flew by the seat of our pants. We just did all the jobs we were asked to do, even if we didn't know how to do them. After saying yes, we would go back to the studio and work on figuring out how to do the finish. We learned a lot this way. We also learned how to problem solve," she said. In the beginning, they approached designers and architects through cold-calling and then scheduled appointments to find clients. These contacts led to repeat business, and positive word-of-mouth from happy clients helped expand their client base.

7. HIGHLIGHTS AND STARS. Highlight areas of the trompe l'oeil moldings by applying a glaze of White tint and acrylic glaze. Add stars to the sky using White thinned with water. Let dry. Seal with Dead Flat Acrylic Varnish.

8. DISTRESSING. Distress the image by sanding back using 220-grit sandpaper.

Paint the background around the molding with Magenta. Let dry.

9. ANTIQUING. Antique the image by rolling on a glaze made up of Raw Umber and tintable glaze over entire surface. Then rag off the glaze and let dry.

Clear coat the image with Dead Flat Acrylic Varnish. A surface that is supposed to look very old would not have any sheen to it.

ROSE BORDER

REBECCA BAER

MATERIALS

Loew-Cornell Brushes

½-inch (13mm) and ¾-inch
(19mm) Mixtique angular
8400
No. 0 script liner (optional) 7050
1-inch (25mm) stencil brush

DecoArt Americana Acrylic Paints

Cool White, Country Red,
French Vanilla, Tangerine,
Traditional Raw Sienna, Tradi-
tional Raw Umber, Wisteria

Additional Materials

Rebecca Baer Diamond-Plaid
Masquerade stencil item
No. ST-110
Soapstone or chalk pencil
Tape measure and level

Photograph by Al Parish

When developing a composition, I always paint the roses (freehand) first in order to establish placement. The leaves are then added to fill out and balance the arrangement. Compare the finished project photo to the step-by-step images and you can see that each rose is unique. The loose nature of the roses means that each one will vary slightly. Because these roses are more impressionistic than realistic, each painter will create a unique look. The key to creating the roses is value change; don't lose the darker values in the bowl of the rose, nor completely cover the mid-value body of the flower when adding lighter outer petals.

The roses and surrounding foliage are completed entirely with a side-loaded angular brush. The size depends on the desired rose size. When working on walls, a ¾-inch (19mm) angle works best for the largest flowers while a ½-inch (13mm) angle is suitable for smaller roses and buds.

Here's Rebecca Baer's story: "After studying art and completing an internship in sign painting in high school, I accepted a job as a technical illustrator. Next came a job doing architectural renderings for a pipe organ manufacturer. I continued the renderings out of my home office after our second child was born, and after the organ company went out of business, I began taking classes in decorative painting. My talent was quickly recognized, and I was asked to teach classes. Being naturally creative, I soon sought to design my own projects. Before long, what began as a way to support my hobby had expanded into a full-time business, which I was able to launch thanks to the support of my husband and his willingness to be the sole income provider during these times. As my design business increased, my husband joined the business to help with the bookkeeping and then to assist with booths at conferences and trade shows. Our business grew to the extent that it was competing with my husband's full-time job, which prompted his eventual resignation. We incorporated and now work together. The entire evolutionary process, from the taking of my first painting class to today, has been a fourteen-year adventure. I always encourage my students not to be an imitation of someone else. To do so limits your personal potential. Only when you push the creative boundaries to be original will you grow to be a leader rather than a follower."

Roses

1. ESTABLISHING PETALS. Establish the roses with a medium value. I am using French Vanilla for soft yellow roses. Side load the angular with the paint on the toe (long side) of the brush, and then blend on the palette so the paint makes a smooth transition to water on the heel of the brush. Apply the color with short, choppy strokes with the toe of the brush toward the base of the flower.

2. SHADING. Side load your next darker value, in this case Tangerine, and apply the shading in the bowl and at the base of the rose. Let dry.

3

4

5

3. BOWL. Deepen the color in the bowl with a more narrow application of Country Red.

4. OUTER PETALS. With the light value, Cool White + French Vanilla (1:1), sweep the outer petals onto each rose allowing some to flare out beyond the body of the flower.

5. DETAILS. Detail select petals with highlights of Cool White in varying amounts.

Take a moment to study each flower. You can add depth and create dimension with additional layers. To avoid losing the existing values, make sure additional layers are either sheer or contained within a specific area that is of similar value.

LATTICE BACKGROUND

Step 1. Use stencil "C" from the Diamond-Plaid Masquerade stencil set (ST-110) to create shadowy lattice in the background. To do this, begin at one of the lines for the horizontal bands so that the stencil is straight. The stenciling should be in small groupings that are irregular in size and shape with edges that fade away.

Step 2. Pick up Traditional Raw Sienna on a 1-inch (25mm) stencil brush. Wipe the brush on a clean, dry paper towel to remove excess paint.

Step 3. Holding the brush perpendicular to the surface, gently swirl over the stencil so that the lattice is not fully stenciled. Allow the color to fade in and out at random.

Step 4. Reposition the stencil as needed to complete the patchy lattice as shown on page 94, working around the flowers and leaves and over top of the bands so that the stenciling flows. When continuing adjacent areas, use overlap to maintain consistent spacing.

Step 5. Following the angle established by the stenciled lattice, wash the horizontal bands with Traditional Raw Sienna, thinned with water so that it is transparent, on a ¾-inch (19mm) angular. Allow this to dry before continuing.

Step 6. In the same manner, apply thinned Traditional Raw Sienna + a hint of Country Red to create a rusty hue.

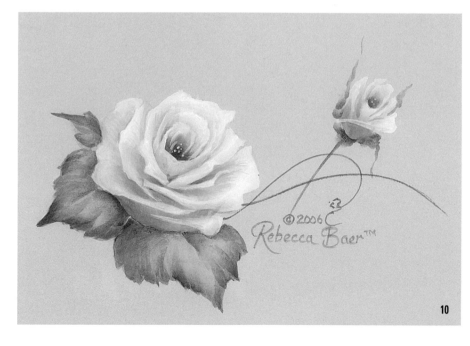

Leaves

The leaves are intended to be somewhat loose and without detail. Use very little paint so that they are transparent when blended, and build the values with layers of sheer color.

6. LEAVES. Side load a ½-inch (13mm) angular with very thin (transparent) Traditional Raw Umber and apply the paint along both sides of each leaf. When painting the sides of each leaf, drag the tip of the brush inward at an angle consistent with the side veins and at irregular intervals to create texture.

7. FLOAT COLOR. With the same color and brush, apply a tornado-shaped float (fat at the back end and narrowing as you approach the tip) along the outside curve of the center vein on each leaf.

8. FLOAT COLOR. Float a wide crescent stroke at the back (rounded end) of each leaf with the same color also on a side-loaded ½-inch (13mm) to ³/₈-inch (10mm) angular. Fill in the tip of each leaf with a wedge-shaped float of the same color.

9. STEMS. I typically establish the stems using the toe of the angular on its chisel edge. If this seems awkward to you, you may want to use a no. 0 script liner. The stems are painted with very thin (transparent) Traditional Raw Umber. Create variety among the leaves with tints and accents from the project palette along with mixtures of the same colors. Thin each color so that it is transparent and apply with a side-loaded ½-inch (13mm) angular. Tints and accents typically look the best when placed in areas of similar value.

10. FINISHING TOUCHES. Use colors from the project palette along with mixtures of the same colors to refine your rose. Add details such as dots in the throat of the rose with French Vanilla.

ART CONCRETE

DAVE AND PAM SCHMIDT

Mixing up a 5-gallon (19l) container of Flex-C-Ment Concrete may seem a little unusual for a decorative painter, but its popularity is growing, and although the effort is greater than a lot of other decorative treatments, the end result is really quite rewarding.

When we first introduced this at a local home show as something new we had to offer, the feedback was tremendous. The material we used, called Flex-C-Ment manufactured by Yoder and Son, is a lightweight concrete designed to be applied over drywall as well as other surfaces. When applied over a concrete primer, this material can be carved, sculpted, stamped and even sprayed with a hopper gun to create numerous effects. The stone and brick we created looked so realistic it fooled almost everyone at the home show in Indianapolis.

Combining the skills of a mason and the artistic skills of the decorative artist makes this new avenue a great way to get your work to stand out in the ever growing field of decorative painting.

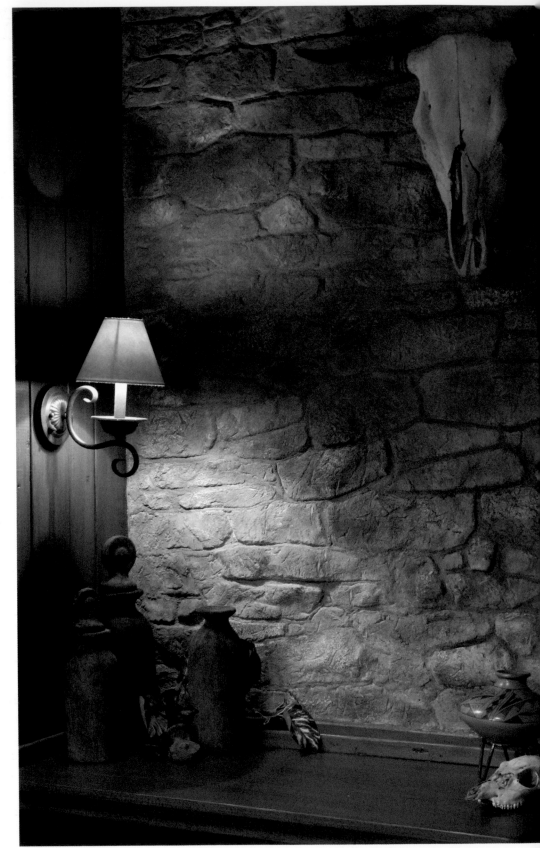

Photographs on pages 98–103 by Dave Schmidt

MATERIALS

Brushes

2-inch (51mm) and 4-inch (10cm)
 chip brushes
Coarse brush (old wallpaper brush)
Leon Neon

Benjamin Moore Flat Latex Paints

HC-99, HC-73, 2152-40,
 2163-10, HC-75, HC-95

Faux Effects AquaColors

Burnt Umber, Dark Brown, Earth
 Brown, Earth Green, White

Additional Materials

Assorted concrete trowels
5-gallon (19l) bucket
Bubble Gum Release Agent by
 Flex-C-Ment
Concrete carving tools
Concrete mixing blade
Drill, suitable to mix
 Flex-C-Ment Concrete
Fiberglass mesh
Flex-C-Ment Concrete Primer
Flex-C-Ment wall mix
Goggles
Grout bag
Grout blade
Hawk
Latex gloves
2-inch (51mm) painter's tape
 for walls
Paint tray
Plastic floor cover
Rag or sea sponge
Respirator
9-inch (23cm) roller with
 a ½-inch (13mm) nap
Stone texture stamps for walls
Water
Water Bottle

BEFORE THEY PAINTED

Husband-and-wife team Pam and Dave Schmidt have more than thirty years combined experience in the decorative painting and mural field. They have taught nationally and internationally as guest instructors with Prismatic Painting Studio. Dave was a partner with Gary Lord at Prismatic Painting Studios and co-authored *Marvelous Murals You Can Paint* with him before moving to the Indianapolis area.

Pam recently received her Certificate of Interior Decorating. This combined with her strong color sense, high energy and artistic abilities makes this duo very popular with the designers and builders in their market.

Both Pam and Dave attribute the success of their business to their varied backgrounds and interests, which allow a broader range of ideas and approaches to a project.

Preparation

Flex-C-Ment can be messy to work with. Cover the floor with heavy plastic taped to the edges of the room. If you are working with a baseboard, use a taping gun to cover and protect it.

Trace around the outlets and switch plate covers, remove the plates, then tape on the inside of your pencil marks. Before your second coat of concrete is dry, remove the tape. This will allow the plates to sit flush against the wall. Mix the Flex-C-Ment Concrete in a garage or outdoors to greatly reduce dust in the home, and wear a respirator when mixing the material. We mix about half a bag of the material in a 5-gallon (19l) container, making it easier to handle when carrying it from room to room. Wear gloves as the material will dry and crack your hands.

The drill you use to mix the Flex-C-Ment Concrete should have high torque and be capable of handling the concrete mixing blade. If in doubt, check with a hardware store. Prior to investing, you might want to try renting the supplies needed. This is a strong drill; make sure you have a firm grip before you start to mix your material.

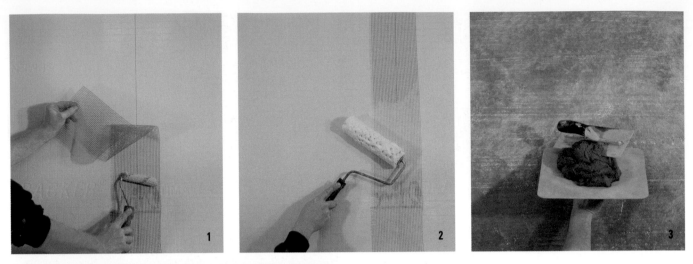

EXPERT ADVICE

Tip 1: Beginners should run sample boards before attempting to use this product on a wall. For the samples, mix small batches of Flex-C-Ment Concrete. Always add Flex-C-Ment Concrete to water, but keep in mind that with this product, a little water goes a long way. When mixing, test for proper consistency by running your finger through the material; the material should sag inward ever so slightly.

Tip 2: If Flex-C-Ment Concrete starts to set in the bucket while you are working, freshen it up by mixing in a little water. You can do this once, maybe twice at the most, after that you are weakening the mix by adding too much water.

Tip 3: Gather a few rocks for color reference and use flat latex paint for your rock colors. Always thin your paints by approximately 30–40 percent. Diluted paint color can change considerably as it dries on all porous surfaces. Always test your colors; you may need to add more or less water to achieve the desired color.

1. PRIMER. Apply Flex-C-Ment Concrete primer to all inside and outside corners as well as any exposed drywall seams. While the primer is still wet, apply fiberglass mesh allowing 3 inches (76mm) on both sides of the corners and seams, then roll back over the applied mesh so that the mesh is flat and adheres to the work surface. This helps reduce the possibility of small cracks later on. Allow to dry.

2. PRIME. Apply Flex-C-Ment Concrete primer using a 9-inch (23cm) roller with a ½-inch (13mm) nap to a 5' × 5' (1.5m × 1.5m) section of the wall.

3. FIRST LAYER. Mix Flex-C-Ment according to manufacturer's directions. After it is mixed, you might find it helpful to load a hawk with a small triangular trowel.

While the primer is still wet or tacky, apply a thin coat [about $^3/_8$-inches (10mm) thick] of Flex-C-Ment Concrete using your skimming trowel. Start at the bottom of your section with the skim trowel and pull up with one fluid motion.

Do not over work Flex-C-Ment Concrete with your trowel. Excessive troweling can create bubble pockets in the concrete and weaken the bond. Also do not trowel beyond the bounds of the concrete primer.

4. ADDING TOOTH. Using a coarse brush (here an old wallpaper brush was used), brush across the surface horizontally before the Flex-C-Ment Concrete hardens too much. This creates a tooth in the surface for the next layer of Flex-C-Ment Concrete. Continue until the entire work area is covered with the skim coat. Let dry overnight.

5. TEXTURE COAT. When laying up the texture coat to be carved on the job, keep in mind it can be several hours before you can start carving. Allow time! Before applying the texture coat, apply another coat of concrete primer as described in step 2. While the primer is still tacky, apply Flex-C-Ment Concrete with your hawk and trowel. Vary the thickness of the material anywhere from ¼- to ¾-inch (6mm–19mm) or even thicker. Troweling the Flex-C-Ment Concrete onto a vertical surface takes practice, but remember not to overwork the material.

6. TEXTURE COAT. You may choose to have some rocks stick out slightly further than others. To do this, build up the concrete material in the selected areas. Once the texture coat is applied and the material is still soft, you are ready to texture the surface.

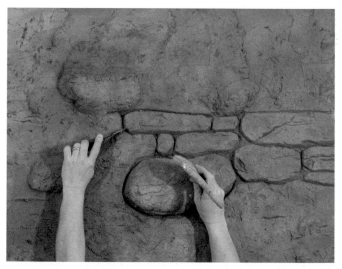

7. STAMPING. Apply Flex-C-Ment's Bubble Gum Release agent to both the Flex-C-Ment Concrete and the surface of the stone-texture stamps for walls, using a water bottle filled with the release. This prevents the Flex-C-Ment Concrete from sticking to the stamp.

Gently apply and then push the stamp into the surface of the Flex-C-Ment Concrete, and carefully remove it. Rotate the stamp so the pattern direction varies. Look for thin areas on your stamp's edges and gently cup the protruding rock to add texture. Too much pressure while stamping will flatten the highs and lows of the Flex-C-Ment Concrete and take away from the final look. Repeat the spray release when necessary. Continue working until the entire wall is complete.

8. CARVING. Let the Flex-C-Ment Concrete dry to a crumbly state (this may take several hours). Then, using the concrete carving tool or grout blade, begin carving into the Flex-C-Ment Concrete to create your stones. Try using your tools to detail some of the stone faces, or just knock out or dig out a few chunks on some stones. A 4-inch (10cm) chip brush makes a good dusting brush to clean out the grout lines.

As you carve, you can use an overhead projector to project a tracing of a stone or block pattern from a magazine or photo. Move the projector back and fourth for the desired size or scale of the pattern.

Let dry overnight.

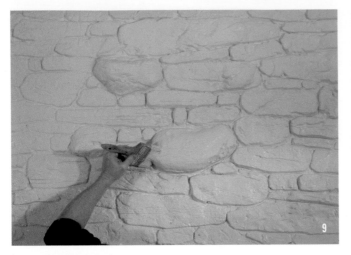

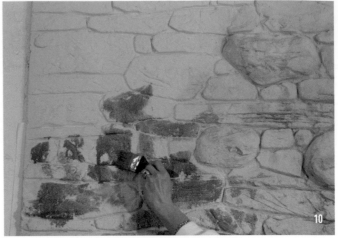

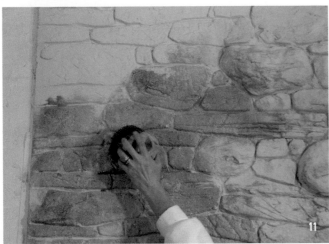

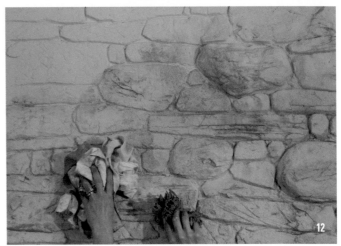

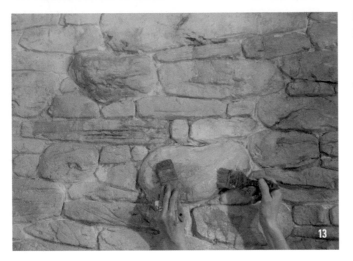

9. BASECOAT. Basecoat the wall with Benjamin Moore color HC-99. Let dry. Spraying on the base color will considerably speed up the process.

10. FIRST COLOR. Mist the surface lightly with water using a water bottle. Thin Benjamin Moore color HC-73 about 60 percent with water and quickly brush on a broken pattern of color working in small areas at a time using a 2-inch (51mm) or 4-inch (10cm) chip brush.

11. FIRST COLOR. Use a Leon Neon or large pounce brush to work the color into the stone.

12. SOFTEN COLOR. While your color is still wet, use a rag and a sea sponge to blot the surface and vary your highs and lows of color to create a soft and subtle pattern. Step back often and look at your colors making sure the colors come and go.

13. ADDITIONAL COLOR. Repeat the process described in steps 10–12, this time using two colors, Benjamin Moore 2152-40 and Benjamin Moore 2163-10, also thinned. Try not to overblend the two colors. Bounce around the surface varying the color on different stones. These steps should be done very quickly. Don't over think it, just run with it. Let dry.

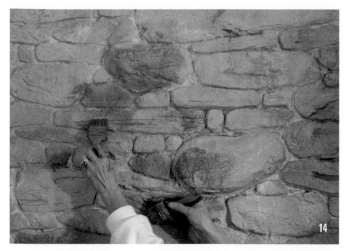

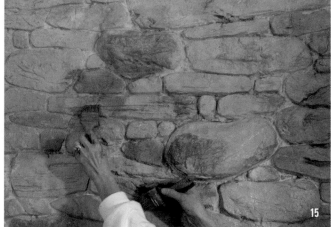

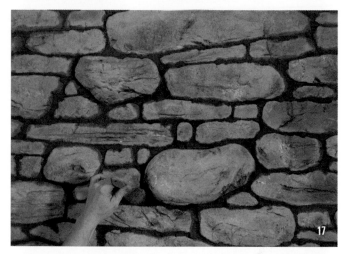

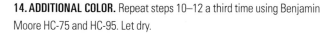

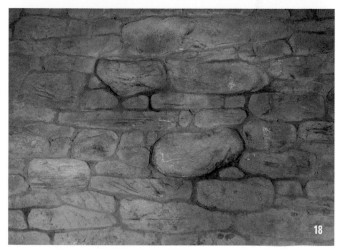

14. ADDITIONAL COLOR. Repeat steps 10–12 a third time using Benjamin Moore HC-75 and HC-95. Let dry.

15. AGING. To create a mossy, aged feel, brush or sponge on AquaColor Earth Brown and Earth Green thinned with water. Then soften the colors with a Leon Neon and let dry.

16. GROUT LINES. Mix a thinned batch of Flex-C-Ment by adding just enough water that it will flow through a grout bag. Fill the bag about halfway then twist the end to prevent the material from flowing out the back. Squeeze the Flex-C-Ment Concrete into the grout line areas.

17. GROUT LINES. Stop from time to time as you are grouting to lightly pounce the grout material into the lines using a chip brush. Do not overwork it and make it too perfect; give the wall some character. Let dry. (Notice how dark the grout appears when wet. This will dry much lighter.)

18. FINAL DETAILS. Mix AquaColor Burnt Umber, Dark Brown and White together then thin approximately 70–80 percent with water and brush onto the grout at random. This stains the grout color and warms it up a bit. It will appear dark at first, but then lighten considerably. Finish the surface by spraying a mix of Earth Brown and Dark Brown diluted approximately 70 percent with water around the ceiling lines, your corners and baseboard areas to create an aged, worn appearance. Soften using your Leon Neon.

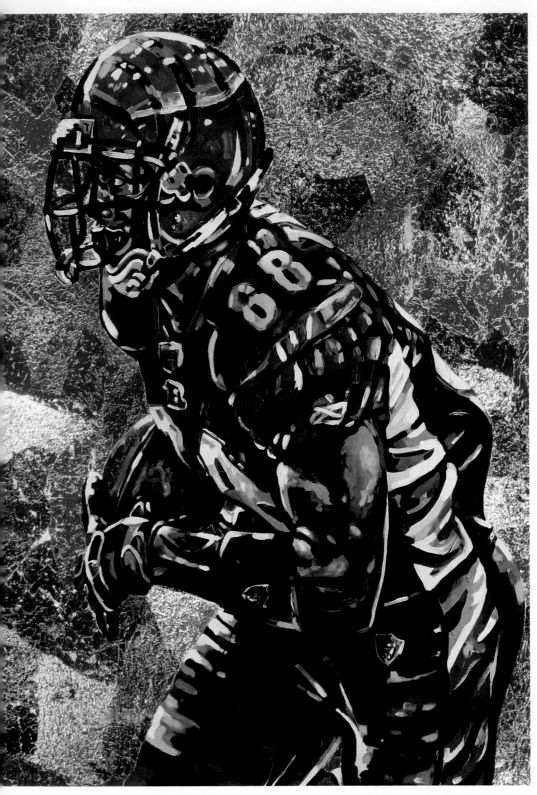

SHAWN VOELKER

This painting is embellished with metallic foil. The foil's official name is simply "Metallic Foil," which represents thirteen different types of foil. The subcategory for the foil in this project is "Silver Hologram Foil." The foil is not commonly sold at art/craft stores but may be found at local interior designer facilities or online.

The foil has enhanced innumerable end products such as picture frames, columns, crown moldings, furniture, wall finishes, mural embellishments, etc. Each foil is custom formulated for workability and is tested to assure the finest quality and best results.

MATERIALS

Surface
¼-inch (6mm) hardboard

Brushes
3-inch (76mm) Loew-Cornell
 Nylon
Various sizes and shapes of
 hard/soft bristles

Additional Materials
Acrylic paints by Liquitex
Charcoal pencil
Empty cups
Liquitex Acrylic Gesso
Metallic Foil–Silver
 Hologram Foil
Painting palette
Rolco Slow Set Gilding Size
 (Oil-Based)
Scissors
Tack cloth

BEFORE HE PAINTED

Shawn Voelker has a Bachelor of Arts in Graphic Design from Northern Kentucky University with the area of emphasis on Fine Arts. After college, he supported himself by selling his portraits and abstract landscape paintings. He took a part-time job as a parking attendant at an elite restaurant to get closer to his target client base. Shawn sometimes created pieces for direct sale to sports figures (similar to the painting in this demonstration), and would present it to them when they came into the restaurant to see if they were interested in the piece. At first, he was some-times forced to sell his work for very little. He asked different restaurants and busi-nesses to display his work for free to gain more exposure with a client base. It took Shawn about five to seven years of parking cars and displaying his work in restaurants before he was able to make a living solely on his painting. Shawn believes word of mouth is your best marketing tool.

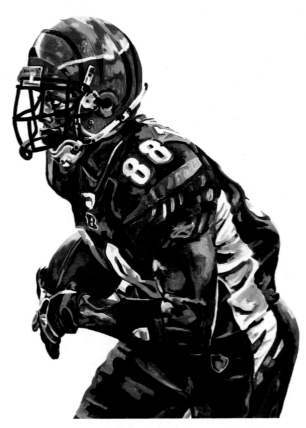

1. PREPARATION AND SKETCH. Cut your ¼-inch (6mm) hardboard to the desired format size and remove any dirt, sawdust, grease, etc. with a tack cloth. Apply three layers of Liquitex Acrylic Gesso using a 3-inch (76mm) Loew-Cornell nylon brush, letting each layer dry for forty minutes between coats. (Nylon bristles offer the smoothest finished surface, which will allow for more Metallic Foil coverage.)

Once the final layer of basecoat has completely dried, sketch your image onto the hardboard using a charcoal pencil. I often use reference photos to loosely sketch my images.

2. UNDERPAINTING. The underpainting serves as a guide for subsequent layers of paint and helps define color and color values. I prefer to use acrylic paints by Liquitex, and I keep at least twelve different colors on my palette at all times so I can provide a wide range of color values. Dilute your paints with cups of water to achieve a desired consistency.

Using a wide range of brush sizes, shapes and bristles will allow you to create different blends and "looks," which also allows the painting to be more appealing and dynamic as it relates to the foil when it's applied in steps 4 and 5.

Don't focus too much time and energy on detail at this point

3. OVERPAINTING. After the underpainting has completely dried (about four hours), you can place the overpainting. With the underpainting as a guide, begin to apply more permanent paint layers, which will appear much more resonant and powerful as compared to the first layer of paint.

Pay close attention to detail and make any necessary adjustments in color and color placement, as this layer will be seen in the final product. During this step, I constantly rework all areas of the painted image until I reach what I feel is a visually pleasing piece.

EXPERT ADVICE

Tip 1: When selecting and sketching an image for a foil painting, always remember to keep the image and foil balanced compositionally. In other words, you do not want the image or the foil to dominate the painting.

Tip 2: Timing is everything when transferring the foils and a little more or less drying time results in more or less foil coverage and can also provide smoother or more wrinkled appearances.

Tip 3: You can repeat the foiling installation process a third or even a fourth time by following step 5 to achieve even more foil coverage.

4. FIRST FOIL LAYER. Once the overpaint is dry, you can apply the first layer of Metallic Foils, or in this case Silver Hologram Foil. First, apply a base layer of Rolco Slow Set Gilding Size (I recommend oil-based) to all of the unpainted areas of your hardboard using a 3-inch (76mm) nylon brush. Let the Rolco Slow Set Gilding Size set up and become tacky (this takes one to two hours) before transferring any foils. Because the foils come in rolls, it's a good idea to pre-cut or tear it into smaller random shapes and sizes. These random sizes and shapes will help make the finished piece appear much more dynamic.

When applying the foil you must have the shiny side up and firmly press and rub the torn or cut foil into the tacky Rolco Slow Set Gilding Size. Keep a small corner of the foil between your fingers with your free hand so you have an area to pull when removing the backing.

After you have applied even pressure (removing all air bubbles) remove the backing with a swift, angled pull, starting in the small corner you kept in your free hand. This transfers the first layer of foil. Continue this process with your random pre-cut or torn pieces of foil until the entire Rolco Slow Set Gilding Size area has been covered.

About 70–90 percent of the foil will transfer on the first layer, but don't worry, the second layer will cover any spaces where the foil didn't transfer.

5. SECOND FOIL LAYER. After the first foil layer has dried for at least twenty-four hours, repeat the foil application process described in step 4. This second layer of foil should give you close to 95 percent coverage of the foiled areas with only small holes and hairline cracks visible upon close inspection.

6. TOUCH-UP WORK. After you have applied your final layer of Metallic Foil, you may need to return to some of the previous painted areas in your image for some touch-up work. It's very common for the foil to overlap or bleed onto the painting portion, so you simply need to examine which areas are affected and repaint them. It's also a great opportunity for you to step back and study how the painted image interacts with the Metallic Foil. Of course you should rework any areas that you think need it until you feel your entire painting is complete.

I often add many more highlights and darken the edges to create some contrast between the image and Metallic Foil.

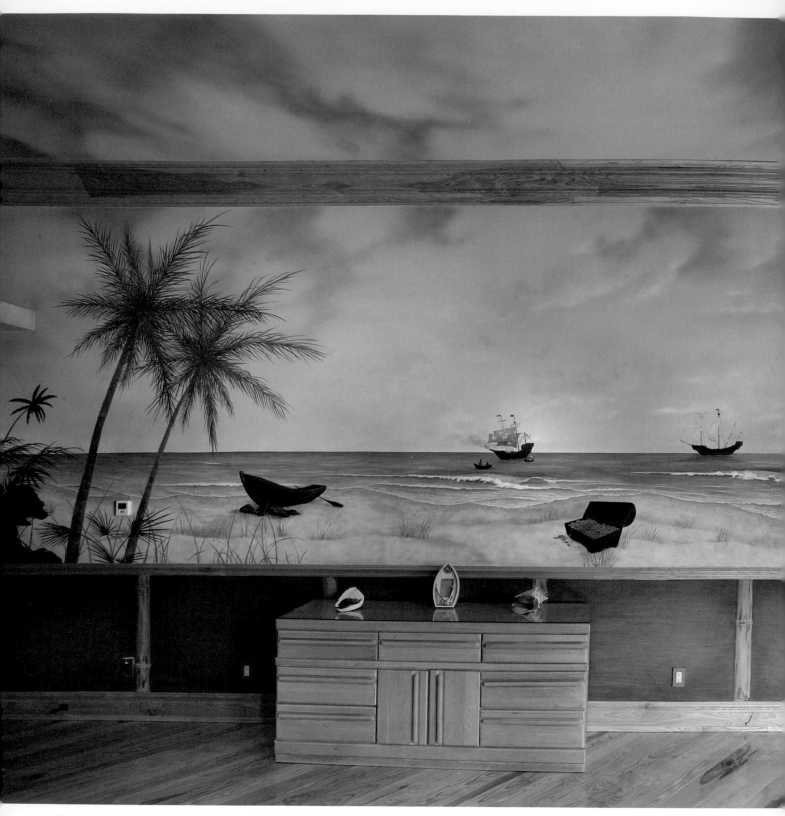

Photograph on page 108 by Robin Victor Goetz/www.gorvgp.com. Photographs on pages 110–111 by Gary Lord

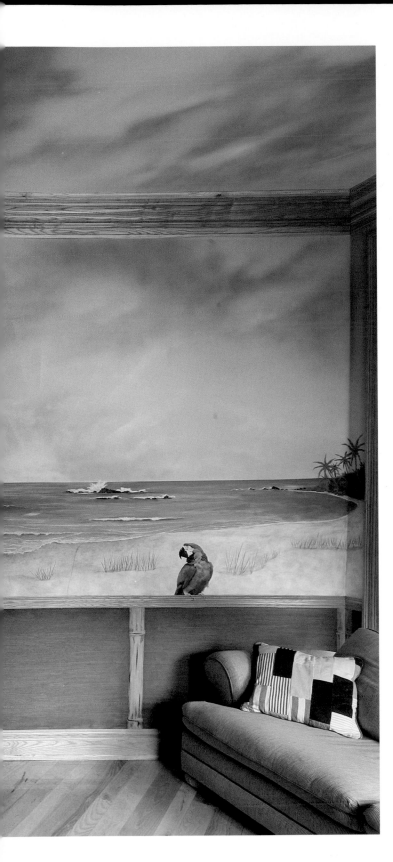

GARY LORD

When painting a daytime sky, you have the option of starting out with a variety of base colors. If the walls are a light, neutral color to start, you do not even need to basecoat them. Skies are darkest at the zenith and fade down into lighter blues at the horizon line. To achieve this fade on a ceiling, make the center of the ceiling the darkest area and fade out evenly to all edges. Or you can make the farthest part of the ceiling the darker color and fade to the other side of the room for the lighter color. Both systems work fine when fading backgrounds; it is more a matter of choice. You also could paint the background the lightest blue color, which will reduce the amount of paint needed to cover up the neutral white background.

MATERIALS

Porter Paint, Latex Flat
Dahlia Blue, Deep Blueberry, Flame Blue, White

Additional Materials
Air compressor
Auto touch-up spray gun
Conventional cup gun
HVLP spray gun
Paasche artist spray gun
Paint strainer
Water

▶ To read about how Gary Lord started his decorative painting career, see pages 10–11.

1. DARKEST COLOR. This ceiling had an existing neutral, white, flat basecoat. Start the sky fade with the darkest color, Deep Blueberry by Porter Paint, in flat latex. Decide how much space you want this color to occupy by thinking of the total composition and theme in the room. This large bedroom has a full pirate island scene associated with it. I wanted to create the effect of a twilight sky above the island mountains and fade over into the sunset on the ocean area. This demonstration focuses on the darkest blue of the sky, which is about 30 percent of the total composition.

Use water to dilute all of the latex paint by 20–30 percent or so until the mixture runs freely off a paint stir. Strain the diluted paint into the paint cup by using a paint strainer, cheesecloth or nylon stockings. Hold the gun 6 to 10 inches (15.2cm to 25.4cm) away from the surface, and begin to spray in slow, even movements that are parallel to the surface.

When using the HVLP, I used a 1.4 or a 2.4 tip with the air set around 6 to 7 on the turbine. I can adjust the air feed into the gun for fine-tuning by a nozzle on my air hose. This will start the "blocking in" process of your colors. Try for even, 100 percent coverage, but avoid drips and runs. It is better to build up your coverage in multiple passes than to have sags, drips or runs on your surface. When you come to your outside transition edge, hold the gun at a more oblique angle to the surface, only depressing the trigger of the gun halfway or so, and create a less opaque amount of color to fade back into. Then, working into your fade area, hold the gun farther away from the surface for a lighter amount of color.

2. MIDTONE BLUE. Dilute Flame Blue by Porter Paint in a flat latex as described in step 1. Spray this color into the first color with the soft transition process described in step 1 following the composition you have started. Then spray more solid into the main field area of the Flame Blue and finally start the transition for the next color toward the bottom.

3. LIGHTEST BLUE. Spray the lightest color, Dahlia Blue by Porter Paint in flat latex, over the lower third of the area. Also, spray a mist of Dahlia Blue in random areas into the top half of the Flame Blue applied in step 2. This helps soften the faded transition areas.

4. SOFTEN TRANSITIONS. If the transition between the midtone blue and lightest blue is softer than the transition between the darkest blue and the midtone blue, mix Deep Blueberry and Flame Blue in equal amounts to create a softer transition color. You can alter the colors by misting Dahlia Blue in random areas from the beginning to eliminate this step, as mentioned in step 3, but I like the additional color and pattern this step creates.

Change to a conventional cup gun because this creates a finer atomized spray than an HVLP does, and hold the gun back 12 to 18 inches (30cm to 46cm) from the surface to soften the transition colors. To "cut" in more of a pattern outline for the cloud areas, move the gun closer so it is only 3 to 6 inches (8cm to 15cm) from the surface. Use a compressor set at 35 psi to supply air to the gun. Keep the material feed at low and adjust as needed.

5. MOVEMENT. Begin to define areas of sky movement by spraying a combination of Deep Blueberry, Flame Blue and Dahlia Blue individually, plus the mixture of Deep Blueberry and Flame Blue to create a pleasing composition for the background of the clouds. Do this by adding and subtracting to the "cutting in process" with the conventional cup gun.

6. CLOUDS. Mix Dahlia Blue with pure White flat latex paint (1:4). Switch to the auto touch-up gun because it provides even finer detailing than the conventional cup gun. To create the whitest part of the cloud, have very little material feed to the gun and use a moderate amount of air. The closer you hold the gun [as close as 1 to 3 inches (3cm to 8cm)], the brighter and whiter that part of the cloud will be. To create a softer, broader, more even pattern, hold the gun farther back and allow more material to be sprayed. Use a combination of these techniques while keeping the air feed from the compression at 35 psi. If you need to fine-tune and adjust the air, you can do so on the gun.

The photo above shows this same scene under black lights. The demonstration on page 112 shows how to achieve these effects.

EXPERT ADVICE

Tip 1: I normally use an HVLP spray gun to base in my larger mass of faded backgrounds. This step requires the most spraying and the HVLP will create the least amount of overspray. I then use a conventional cup gun to re-fade and refine my background and let the clouds start to take shape. As the work gets finer and tighter, I switch to my auto touch-up spray gun and finally to my Paasche artist spray gun.

Tip 2: For a pretty, but faster and less refined sky, fade the sky and allow your negative space to be the clouds all in one movement. This negative space process is outlined in my book *Marvelous Murals You Can Paint.* It is my most popular method because it is very pretty and oftentimes is half the cost of the method demonstrated in this project.

Photograph by Robin Victor Goetz/www.gorvgp.com

GARY LORD

The client wanted to add to the mural on page 110 by creating a surprise element that can only be seen with special effects paint and lighting. Joseph Taylor and I painted this magical universe that shows only under black light and becomes three dimensional with special glasses. Invisible blacklight paints come in both water-based and oil-based colors. The water-based paints come in twelve different colors and the oil-based paints come in four different colors. You can layer the water-based colors on top of each other because they are a little more transparent than the almost opaque oil-based colors, and for this reason, I used the water-based colors.

The water-based paints are chalky on mid- to dark-value colors. This is noticeable in the moon that is visible in normal lighting in this mural. These same paints are not noticeable at all in other areas of the sky because they are within lighter cloud areas, which prevents their chalky appearance from showing. The oil-based paints are very pigmented and the colors are highly reactive to the black light, much more so than the water-based. I choose to use the oil-based paints for the small pinpoint star system around the planets. The planets can be painted in a large variety of ways. This demonstration shows four techniques as well as how to create the pinpoint stars.

MATERIALS

Brushes
¼-inch (6mm), ½-inch (13mm),
¾-inch (19mm), and 1-inch
(25mm) stencil brushes

Prismatic Painting Invisible
Water-Based Paints
Invisible Blue, Invisible Blue White,
Invisible Orange, Invisible Red,
Invisible Violet, Invisible Yellow

Prismatic Painting Clear Water-Based Paints
Clear Orange, Clear Yellow

Additional Materials
Acetate for stencils
Blacklight bulbs
Craft knife for cutting stencils
Emergency light lamps
Paasche artist spray gun

▶ To read about how Gary Lord started his decorative painting career, see pages 10–11.

Airbrushed Planets

SETUP. All invisible paint must be painted in a darkened space that is illuminated by ultraviolet black light so you can see what you are painting.

1. AIRBRUSH. With a 5-inch (13cm) circle stencil and an artist airbrush, spray Invisible Red along the edge of the stencil. Allow the paint to build up so it is fairly opaque in a crescent shape. Next, fade the same paint into the center of the circle. Do not allow the paint to travel to the opposite side of the circle.

2. AIRBRUSH. Next, spray Invisible Yellow along the edge of the stencil on the side opposite the red. Again, form a crescent shape that is opaque at the edge of the stencil and fades into the center. Create a second arch 1-inch (25mm) inside the circle and following the outside circumference. Now, in a full circular movement, complete the rest of the center circle with only a misting of paint.

This photo shows what the ceiling on page 112 looks like in regular lighting instead of ultraviolet black light lighting. See pages 108–111 to learn the technique used to create this spray sky.

Photo at left by Robin Victor Goetz/ www.gorvgp.com Step-by-step photographs on pages 113–117 by Gary Lord

1 2 3

Tip 1: These effects can only be created in a darkened room. I used cardboard taped to the window and then a drop cloth over the window to block the outside light. To light the room, I used three blacklight bulbs in three different emergency light lamps and that was more than adequate for lighting.

Tip 2: When painting the planets, I try to use colors that float roughly on the same plane as each other so the planets appear solid. I often paint a smaller object of a different spatial orientation next to the planet to exaggerate the three-dimensional effect. The step that helps create the most three-dimensional movement is the small pinpoint dots and small stars around the planets and off into the space area.

Tip 3: The invisible blacklight paints will only show once they are illuminated with true ultraviolet blacklight. The more black lights you have in the room, the stronger the invisible paints will show. These paints become even more unique when you use Prismatic Painting Studios patented 3-D glasses (at right). If you view the paints under black light with the 3-D glasses on, each color will float at a different spacial range creating a truly three-dimensional effect. Try it, it is truly amazing.

Eclipsed Planet

1. BASE. Using a 5-inch (13cm) circle stencil and a ¾-inch (19mm) stencil brush, paint 100 percent of the surface with a light to medium amount of Invisible Violet paint, varying the pressure slightly to create a slight mottled effect. Let dry.

2. GLOW. Place the circle created from making the stencil over the painted planet with tape on the back or mist the back of the plastic with water and it will adhere to a smooth surface. Stencil on Invisible Blue paint with the ¼-inch (6mm) stencil brush. Then use the Clear Yellow and Clear Orange paint. Apply the pressure hardest at the edge of the stencil and lighten it up considerably as you exceed the edge until there is almost no pressure at all. Keep the outline to within ½- to ¾-inch (13mm to 19mm) away from the stencil edge at most.

3. FINAL LOOK. Remove the circle for a total eclipse effect.

Ringed Planet

1. FIRST COLOR. Use a 1-inch (25mm) stencil brush for each color. With a soft, normal swirl stenciling application, completely paint the 12-inch (30cm) circle with a moderate amount of Invisible Violet. Vary the pressure as you move the brush to help create lights and darks inside the stencil. Also, concentrate a little more violet on one edge of the planet than the other.

2. SECOND COLOR. Next, stencil on Invisible Blue. Use the 1-inch (25mm) brush in the same manner as step 1. Concentrate more of this second color in the negative areas from the first color. Try to keep light and dark areas in a mottled effect, which helps give the illusion of craters.

3. THIRD COLOR. Use a ¾-inch (19mm) stencil brush and Invisible Blue White to highlight only one edge of the planet, where more of the Invisible Violet is. Use very little paint and light pressure on the brush.

4. RINGS. Cut a stencil for the ellipse out of clear acetate. Joe used an artist airbrush gun and sprayed the rings with the Invisible Orange paint. This step can also be done with a stencil brush.

Pinpoint Stars and Galaxies

1. FIRST COLOR. Use a 1-inch (25mm) stencil brush and paint the 9-inch (23cm) planet with light pressure and a moderate amount of Invisible Orange. Paint the entire surface with relatively even coverage.

2. SECOND COLOR. With a 1-inch (25mm) stencil brush, highlight three-fourths of the planet with Invisible Yellow, using light pressure with a little to moderate amount of paint on the brush. You're trying to create soft, mottled light and dark areas.

3. THIRD COLOR. Use a ½-inch (13mm) stencil brush with soft pressure and a small amount of Invisible Red paint to accent the side of the planet opposite from the yellow.

4. MOON. Use the 3-inch (8cm) circle and a stencil brush or artist airbrush with the Invisible Blue water-based paint to create the distant moon. Hug the edge of the stencil first and gradually allow the paint to build up in a crescent shape leaving the area blank by the larger planet so the moon appears to be behind it. I used blue paint on this because it appears the farthest away when using the 3-D glasses.

5. LARGER STARS. Using the back of an artist brush, pick up some of the other invisible colors (yellow, green and red) one at a time and tap them around the planet to create stars. These will appear to be the larger stars. The yellow and green colors will appear to float in the mid-range when viewed with the 3-D glasses.

6. PINPOINT STARS. Spatter a light spray of each color to create finer, more distant stars. You can do this by flicking the bristles of a small artist brush loaded with paint. The addition of the larger and pinpoint stars add a great deal of depth to the planets and the deep space feeling when viewed with the 3-D glasses.

7. AURAS AND GALAXIES. To add more depth and create the feel of deep space, you can use an artist airbrush gun and the invisible paints to place a glowing aura around a few of the larger stars. Do this by placing the tip of the airbrush very close to the star, and with a soft mist, gradually move back from the star.

To create the spiral constellation, use the airbrush in the same manner but create a spiral movement for your pattern. Also, kink the air hose as you paint, and the airbrush will spatter in little dots, then unkink the hose for a smooth spray.

8. FINAL DETAILS. Continue adding a glow around some stars, and use the back of the paintbrush to add red dots, which will appear closest of all the colors when viewed with 3-D glasses.

FORCED-PERSPECTIVE CEILING MURAL

MARC POTOCSKY

MATERIALS

Surface
Pre-stretched, pre-primed canvas

Brushes
½-inch (13mm), 1-inch (25mm)
 natural bristle flats
2½-inch (64mm) and
 3-inch (76mm) chip
½-inch (13mm) nylon filbert
½-inch (13mm) nylon flat
No. 3 or 4 nylon round

Golden Acrylics & Proceed Paint
Burnt Umber, Carbon Black, Raw
 Sienna, Raw Umber, Red, Titanium
 White, Ultramarine Blue, Yellow
 Ochre

Additional Materials
Good quality painter's tape
Long straightedge
Pencils or chalk
Rulers, yardstick or tape measure

▶ The original maquette for this demonstration can be found on page 25.

Photographs on pages 118–121 by Justin C. Maturo

The centerpiece of this mural, which includes the sky, trees, railings and the first grey tier, was painted as one piece on canvas in my studio and installed on the highest point of a tray ceiling. The lower white section was painted on site. This tray ceiling consists of a flat main ceiling that juts up at a 60-degree angle to another higher section of ceiling in the center. This project can be painted on a regular flat ceiling with the same results.

To create the illusion of height and the sense of upward movement, there needs to be a vanishing point. In this case, the vanishing point is located dead center. Forcing everything in the painting to that one vanishing point is known as forced perspective. Perspective is forced by drawing lines from the center to the outside of the painting so the trees, railings and lower panels will line up and recede into the upper distance. This receding

is called foreshortening. Foreshortening causes or allows objects to decrease in scale as they move away and upward (from wide to thin), so that the viewer experiences depth and height.

BEFORE HE PAINTED

Marc Potocsky is predominantly a self-taught artist. He has worked as a highly skilled decorative painter, muralist and designer contracting and practicing through his Connecticut studio, MJP Studios, for the past fifteen years. Marc is a member of the Society of Decorative Painters and an Industry Partner of the American Society of Interior Designers. Marc has also been invited to exhibit his work at the prestigious "Salon—A Gathering of International Decorative Painters."

Marc makes instructional DVDs and teaches decorative painting classes and workshops when he is not painting in the field. He has a passion to share his knowledge and experience and to learn and educate others in this age-old art form. His feeling is

"If you stop learning, you stop living!" Marc had taken a few workshops on trompe l'oeil, stenciling, wood graining and marbling early on in his career and for years continued to work on his craft, studying from books, photos and real life.

MJP Studios creates trompe l'oeil, murals and custom faux finishes for designers, architects, businesses, hotels, churches, public spaces and residential homes nationally, including in Connecticut, New York, New Jersey, Rhode Island, Pennsylvania, and Maryland.

1. PERSPECTIVE DRAWING. I've used a one-fourth section of the mural for this demonstration. On a pre-shrunk canvas, brush on a very light wash of Burnt Umber + Raw Sienna + water (1:1:2). Let dry.

On the job, your vanishing point will be in the center of the mural. For this demonstration, I will use the upper right-hand corner. Using a sharp pencil and your straightedge, draw a line from the right-hand corner to the bottom left.

Now measure and sketch out your upper (1) and lower (2) tiers. Measure and draw your railing (3), add the center post (4) and all the spindles (5). Your straightedge will always be lined up at the top right-hand corner (your vanishing point), and the left will be lined up with all your measured markings. Line up your trees using the same technique. You can add the molding (6) on the tiers now or later if you like. Step 1 is the most time consuming, but be patient. It will be worth it in the end.

2. SKY. Tape off the top of the railings. Using your chip brush, block in the sky using a mixture of Ultramarine Blue and Titanium White (1:1). Start at the top right-hand corner. As you work your way down to the top of the tree line, add some additional Titanium White, blending it into the darker value. Just before the horizon line, add more Titanium White, using a small, square natural bristle brush.

3. CLOUDS. Paint in the clouds using your large and small square natural bristle brushes with a palette of Titanium White, Ultramarine Blue and brush-mixed grey made of Carbon Black, Titanium White and Ultramarine Blue. You can add red to the grey mixture to create duller undertones.

4. TREES. Mix Ultramarine Blue + Yellow Ochre (1:1) to create an olive green for the trees. Use your small, natural bristle brush to block in the trees and the tree line. Use a small filbert and a yardstick to paint straight lines for the evergreen trees.

5. HIGHLIGHTS AND SHADOWS. Remember your light source. In this case, the light is coming from the left-hand side. (On the job, the light can follow where the natural light is coming from.) With your small pointed nylon, paint the left side of the trees, adding more Yellow Ochre to the olive green mix for the highlights. Paint the right side of the trees using more Ultramarine Blue in the olive green mix for the shadowing. Don't be too concerned if you get a little paint on the rails. You can clean and tighten the rails with a clean pointed nylon and some Titanium White.

Use two tones of grey for the shadows. Use the grey mixture from step 3 and create a second mixture of Carbon Black + Titanium White + Raw Umber (1:1: touch) to create a medium grey. Use the small filbert or pointed nylon to paint the right side of all the spindles with the greys. (You can use your ruler or yardstick as a guide.)

6. CAST SHADOW. To make a dramatic cast shadow, mark a spot on the left side of the mural, the same distance but opposite from your original vanishing point. Using your straightedge, draw some light lines on each side of the spindle (these lines are recreated on the photo). Paint where these lines hit the rail with a darker grey (created by adding more black to your medium grey mixture). You can add a little more shadow to the post and its top.

EXPERT ADVICE

Tip: For this mural I used a long, metal straightedge to draw my lines. For larger jobs, I use a chalk snap line. As you line up your straightedge with your marks, you will notice that the post and spindles will automatically be thinner at the top and wider on the bottom. But your makings need to be at the top of each element, not at the bottom. There is a bit of measuring involved in a project like this. It is up to you to decide the distance between each architectural element.

7. UPPER TIERS. Block in both upper tiers with a grey wash, the same value as the grey in step 5. Make the upper left-hand panel darker than the bottom panel by adding more black to the grey mix.

Redraw the molding on the tiers if necessary. Make sure the distance is greater between the molding at the top tier and the molding of the bottom tier. Tape off the left side of crown and panel molding. Using your square nylon, small filbert and a stripping stick or yardstick, paint the shadows for the first crown and molding on the right side using the same palette as step 5 + more black for darker shadows. Add lighter greys and Titanium White for the highlights. Let dry.

8. MOLDING. Paint the molding on the upper tier following the instruction in step 7. Progressively add more black for the darkest shadows.

9. BOTTOM TIER. Paint the crown and molding on the bottom tier using a lighter value of grey from step 5.

10. MOLDING. Now tape off the right side and repeat the process for the top and bottom tiers.

Add a few distant birds flying in the sky if you like.

JAPANESE CRANE MURALS

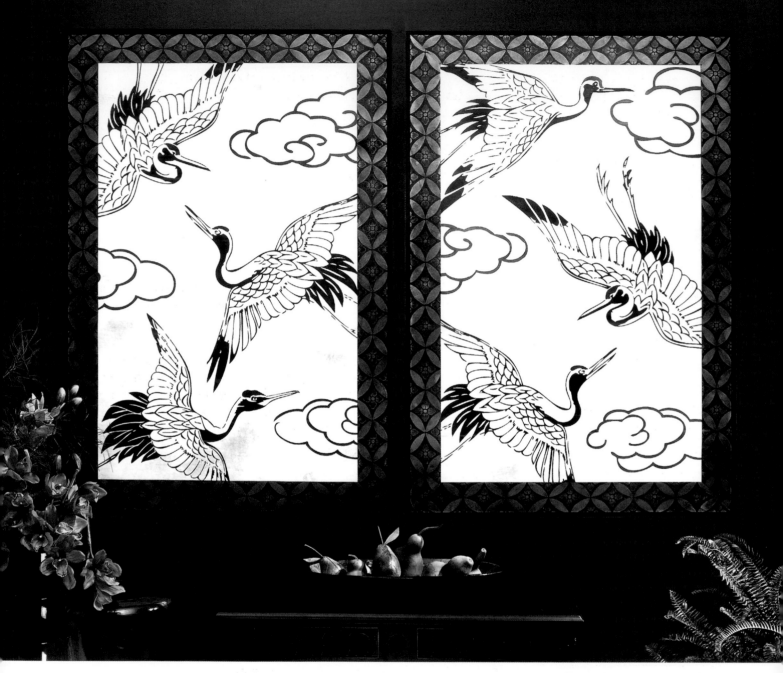

MELANIE ROYALS

Cranes are thought to be one of the oldest birds on earth, and they have a long history in Japanese traditions and legends. These majestic white birds mate for life and are devoted to their partners and their offspring, making them a popular motif for Japanese weddings. In fact, throughout all of Asia, the crane is a symbol of enduring love, peace, happiness and eternal youth.

BEFORE SHE PAINTED

Melanie Royals studied both art and fashion design in college while working as a waitress. Here's her story: "I got into the decorative painting business before there was such a thing. In 1984, while I was pregnant with my son, I picked up *The Art of Stenciling,* written by Adele Bishop and Cile Lord in the 1970s. I was hooked. With the book as a guide, I taught myself how to cut and apply stencil patterns to the walls of my new home.

"Shortly after my son was born, a friend from the restaurant I had waitressed at opened up a Victorian bed and breakfast. I talked myself into the job of designing and stenciling five of the rooms. Stenciling then was the latest new (formerly old) craft that was undergoing a resurgence in popularity. The designs included hearts, geese and roses. All of the walls were off-white. I worked for several weeks and earned the grand sum of $450.00. I was thrilled! The rest, as they say, is history."

MATERIALS

Surface

Roc-lon multi-purpose cloth (available from Royal Design Studio)

Brushes

3/8-inch (10mm) and 1-inch (25mm) stencil brushes

LusterStone by Faux Effects

Ebony Frost, Mandarin Red, Snowflake White

Modern Masters Metallic Paints

Olympic Gold, Sashay Red

Additional Materials

Blue painter's tape
Craft knife
Japan scrapers
Metal ruler
Modello® Decorative Masking Pattern:
Japanese Crane Panels
(www.modellodesigns.com)
Royal Design Studio stencil:
Floral Lattice Allover
(www.royaldesignstudio.com)
Venetian Trowel

SURFACE PREPARATION. Cut two pieces of Roc-lon multi-purpose cloth to a size of 35" × 51" (88.9cm × 129.5cm).

1. BASECOAT. Basecoat the Roc-lon multi-purpose cloth with two coats of Olympic Gold metallic paint following the paint manufacturer's instructions. Allow it to dry between coats and allow the final coat to dry for a minimum of two days.

2. BACKGROUND. Use a Venetian trowel to apply a skim coat of Snowflake White LusterStone to the surface using a thick-and-thin application and leaving about 50 percent of the metallic basecoat showing through. Allow the surface to dry thoroughly.

3. BACKGROUND. Apply a second coat of Snowflake White LusterStone to the surface, filling in some of the open areas and creating a soft, cloudy effect for your background. Allow it to dry thoroughly.

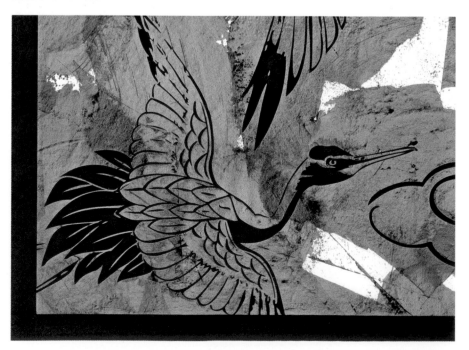

4. CRANE MODELLOS. Apply the Japanese Crane Panel Modello patterns according to manufacturer's installation instructions. Burnish the adhesive pattern well to the surface.

5. CRANES. Use a large Japan scraper to apply a thin coat of Ebony Frost LusterStone through all of the design areas, including the outer frame area that extends to the edge of the canvas. Allow the paint to dry and repeat for complete coverage.

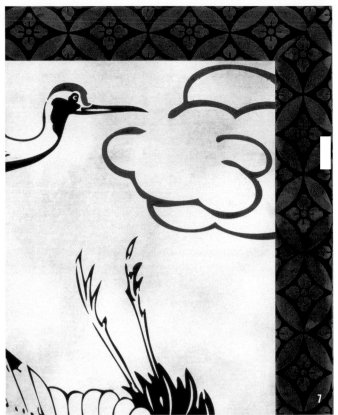

6. CLOUDS AND CRESTS. Tape around the areas that will receive the red paint—the clouds and the crests of the birds' heads. Apply one thin coat of Mandarin Red LusterStone using a Japan scraper. Apply this thinly so that some of the black shows through from underneath. Allow to dry and remove the Modello Decorative Masking Pattern.

7. BORDER STENCIL. Apply 2-inch (51mm) blue painter's tape inside the black band to protect the center of the panel. Use 1-inch (25mm) blue painter's tape to tape around the outer edge, leaving a 3-inch (76mm) solid black band in between. Center the Floral Lattice Allover design in this area and stencil it with Olympic Gold, using a swirling and stippling motion with a 1-inch (25mm) brush. Create a mitered corner with tape. To have the stencil design finish in the same way in each corner, begin with a floral element centered between each corner and stencil out to each edge from there.

8. FINISHING TOUCHES. Go back and replace the stencil over the design. Use a $^3/_8$-inch (10mm) stencil brush to color just the outer edges of the flower petals with Sashay Red. Lightly touch the areas where the lattice points come together with the red color. The photo shows this in progress.

TO FINISH: Use a metal ruler and sharp craft knife to trim ½-inch (13mm) from around each outer edge for a nice clean finish. Apply to the wall surface using wallpaper adhesive. To create a rod-pocket hanging panel, cut your Roc-lon canvas several inches longer to start, fold it down and glue or sew to create a panel to insert a dowel or drapery rod through.

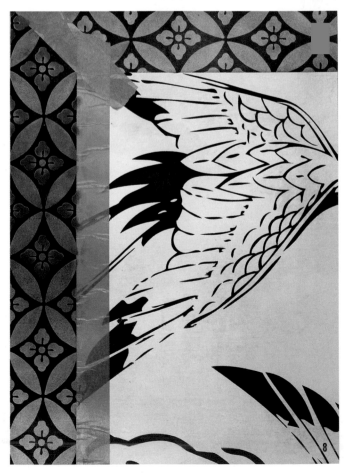

PIERRE FINKELSTEIN

A pediment is an architectural ornament that fits directly above a door casing. Pediments have been used for centuries to increase the grandiose effect of a door. There are many different types of pediments, from the hand-painted easel type of still life, to elaborate woodworking, carvings, low relief and others, all of which serve only as an embellishment to give height to a door opening.

Pediments can be painted directly on the wall above the door space, but creating one on a separate cutout has several advantages: One: You can work in the privacy and efficiency of your own shop; Two: scheduling the project is easier as the work can be done on your schedule (in-between jobs); Three: The overall visual effect will be more dramatic since the cutout casts its own shadow on the wall; Four: The thickness of the wood cutout will sit better on the casing of the door and thus look like an extension of the casing; Five: If there is water damage or the client moves, the pediment can also be moved to a new location. In the case of water damage, remove the pediment, repair the wall, and then replace with minor touch-ups.

This technique could easily be done on canvas instead of a wood cutout and then installed above the door when completed. Painting ornamentation on either a canvas or a cutout is a great opportunity to practice your trompe l'oeil skills in the comfort of your own studio while saving the client extra hassle.

This design and several others can be purchased at www.pfinkelstein.com.

Getting Started

Find your field of work by measuring the exact width of the door casing and the area above it. There are no standard

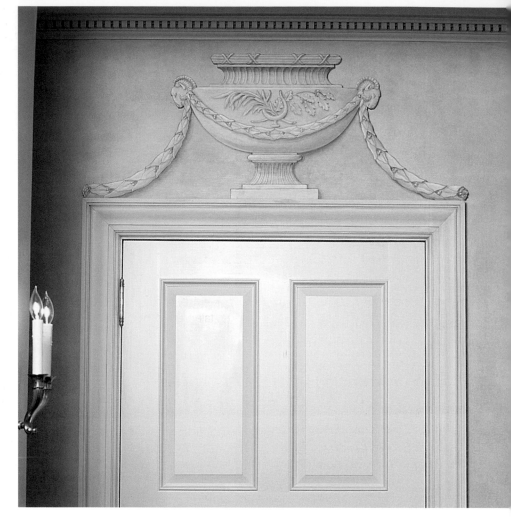

Photographs on pages 126–129 by Pierre Finkelstein

rules regarding the height of a pediment. Generally, it is best to leave a few inches of clearance so it doesn't touch the crown. Architectural books and reference material are excellent sources of inspiration for designs.

Use grid paper to draw your design at the exact scale. Create a pounce pattern (transfer method using tiny holes, outlining the important lines of a pattern) and tap a charcoal bag over it to transfer the pattern contour onto a clean piece of ¾-inch (19mm) MDO board (found in home stores). MDO is plywood coated with a paper-type material that gives you an extremely smooth and ready-to-paint surface. If MDO is not available, MDF or grade A birch plywood will

work well, but will require the added step of creating a smooth surface with compound paste.

Retrace the pounce pattern with a 2H pencil (the exact contour only). Cut out the contour with a jigsaw using a fine-tooth blade to avoid splintering the wood. Sand the edges smooth, and spackle any holes or unevenness created by the cutting. Apply two coats of oil primer over the entire surface including the edges and back of the cutout (to avoid warping of the wood). Let dry. Give the surface a light sanding, then dust it. Apply two coats of basecoat (a warm, grayish-white tonality of eggshell latex or oil).

MATERIALS

Surface

¾-inch (19mm) thick Medium
 Density Overlay (MDO) board

Pierre Finkelstein Brushes

Badger
Oval, synthetic varnish (GLZ:18 s40)
Synthetic round glazer (GLZ:1 s6,
 GLZ:2 s000)
Square, synthetic basecoat
 (GLZ:17 s40)
Sable blend filbert (TL:8 s10)
Sable fine-point detail (TL:4 s2)
Sable short-point detail (TL:5 s10)
Samina outliner (TL:15 s2, s4)

Paints

Oil Primer
Eggshell latex basecoat
Ultra Flat latex varnish

Decorative Palette

Products used: Golden Artist Colors
 and Proceed Slow-Dry Acrylic
 Decorative Paints.
B = Black,
BU =Burnt Umber,
RS = Raw Sienna,
RU =Raw Umber,
W = Titanium White,
UB = Ultramarine Blue
MM = Matte Medium

Additional Materials

Easel
Grid paper for sketching
Jigsaw with fine blade
Mylar (thick paper) for pounce pattern
Pounce wheel/pounce bag (filled with
 graphite) or carbon transfer paper
Spackle and wood glue
2H pencil
150/320 grit sandpaper

All of these brushes, acrylic paints, and stencil
patterns are available at www.pfinkelstein.com
or call 1 (888) FAUX-ART.

BEFORE HE PAINTED

Pierre Finkelstein discovered his interests as a graphic designer and sign painter in New York City at age 19. These interests were temporarily interrupted by a one and a half year service for the French military in the paratrooper division. Pierre saved money for two years to attend the prestigious Van Der Kellen Painting Institute in Brussels. Originally, he was enrolled for the sign painting training, but as fate had it, they just stopped that program which led him to enroll in the decorative painting program. In 1986, Pierre graduated with Gold Medal honor. This training in Europe gave Pierre the confidence to head back to New York City and build his craft, client by client. In 1990, his confidence won big when he was awarded the title of the "Best Craftsman in France," an honor given out every four years. Pierre has always stood by his motto of success: "It's five percent talent and 95 percent practice that makes a successful decorative painter."

1. TRANSFER THE DESIGN. Pounce the design over the cutout exactly (alternative to pouncing: use regular carbon transfer paper or graphite rubbed on back of design). Remove the excess charcoal with a badger brush. Now that the design is transferred, it is not necessary to retrace in pencil.

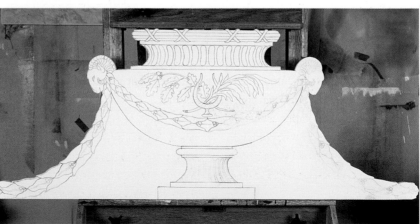

2. OUTLINING. When mixing all of the colors for this project, use a general formula of 1/3 Matte Medium (Matte Medium is best because it dries fast, but a low-viscosity slow-drying medium is OK), 1/3 colors, 1/3 water (this is a recipe that is meant to be modified when needed). First, mix a dark grey color (W+ B + UB + RU). Using a fine-pointed liner brush (TL:15), outline the entire pounced design. This outline will serve as a detailed sketch, but it also will read in the final trompe l'oeil effect. If you must, use a 4H pencil with a light touch.

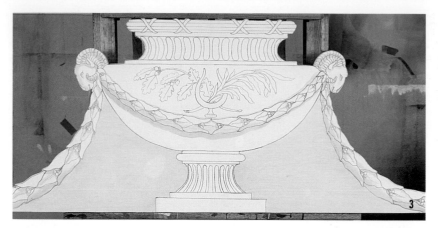

3. HALFTONE. The halftone is the lightest part of the shadow. This step will take the longest, but a successful halftone will make the rest of the painting much easier and more realistic. Mix the halftone by combining RU + UB with a dash of White. Establish a light source and start placing the halftone on the opposite side. Switch between the filbert, short-pointed, and fine-pointed sable brushes. It is important to understand the profile of your piece in order to place the shadow at the right location. Don't forget to paint the negative space between the garland and the urn base in a similar color to the wall itself.

4. MORE HALFTONES. Continue to add halftone where needed to complete the entire "basic shadow" of your piece. Note that the halftone color will be slightly warmer for the cast shadow on the negative shape around the base of the urn. In this case, add more RU + RS to your mix, but remember the overall tonality of any shadow is dictated by the color of the surface it falls on.

5. ACCENT. Create the accent color by adding more RU, UB and a little Black to the halftone. Keep some of the halftone color on your palette for touch-ups. The accent is the darkest part of the shadow. The accent follows exactly the shape of the halftone but is one-third smaller and placed in the inner edge of the shape.

6. MORE ACCENT. Complete all sections with the accent. Add a second coat in the most recessed areas to increase the depth. You'll see the design will really start to show dimension. Remember, the shadowing system (halftone + accent) creates 80 percent of the overall effect. The highlight is simply an extra bonus.

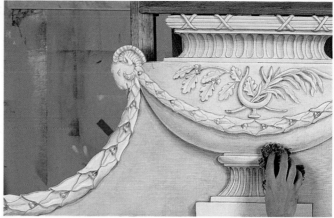

7. HIGHLIGHT. Create a semiopaque highlight color of White with a tiny dash of RS. Start applying highlights using a short, pointed sable detailing brush. Apply directly on the opposite side of shadow, facing your light source (be sure that the highlight does not touch the halftone). The highlight will be less visible than the shadowing. Finally, create the super highlight with pure White placed only at certain high points of your ornamentation.

8. AGING. This is an optional step, which adds a slight distress and element of classical realism so your painted trompe l'oeil will look more like a real bas-relief. Mix RU with a dash of UB and glaze the entire surface heavily with a glazing brush. Use a sponge and dab and displace the glaze to create a fine texture, then smooth and soften with a badger to remove any obvious sponge marks. Let dry.

9. VARNISHING AND INSTALLATION. Sand lightly with 320-grit paper to remove lint and specks. Dust off. Apply two coats of acrylic flat varnish. To install the pediment, sand down the area where the pediment will be installed. Put the cutout in place and very lightly trace the outline. Remove the board, apply heavy epoxy-type glue on both the wall and cutout. Let the glue set. Maintain pressure for a few minutes, and voila!

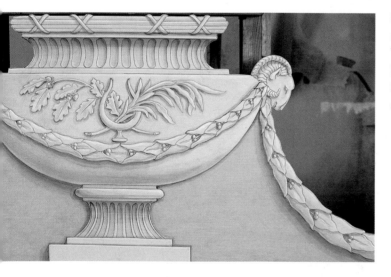

Pierre has owned and operated Grand Illusion Decorative Painting, Inc. since 1987, painting for many residences in Manhattan and beyond. He teaches a few times a year and specializes in painting efficient faux marble, wood, and trompe l'oeil effects. He is dedicated to offering the highest quality brushes and tools for the painter who believes in having the best tools for every job.

Photos on pages 130–133 courtesy of Studio William Cochran

WILLIAM COCHRAN

An exterior mural in an urban area can have a dramatic impact on the vitality of its neighborhood. In the best of cases, it can become a beloved landmark and a symbol of local pride, not to mention a most unexpected street-side encounter with art. It also represents a prominent achievement and a significant investment by the sponsors. Yet a mural outdoors faces many hazards, and it is imperative that these are intelligently addressed in the planning stages before the first brushwork begins. This is a case study of such a mural, commissioned by The Village of Great Neck Plaza on Long Island. Great Neck is

perhaps best known as the setting for *The Great Gatsby*, the classic American novel by F. Scott Fitzgerald.

The most unusual part of this mural's protective measures is the ventilated panel system on which it was painted. Installation is sometimes the contractual obligation of the artist. In these cases (and in all cases, for aesthetic reasons), it is critical that the artist supervise the installation and understand every aspect of the work. It is also important to have the benefit of a conscientious craftsman who is fully licensed and insured, and highly experienced as contractor.

BEFORE HE PAINTED

William Cochran did not become an artist until he was in his early thirties. He repaired boats in college, discovering that he loved to work with his hands, but he studied literature, philosophy and theater, not visual art. He spent several years traveling and several more designing large scale signs and graphics, which taught him to think in architectural scale. He learned from several artists whom he worked with on specific projects, including Mark Oatis, Paul Wilson and others. Many of his techniques were developed "in the field," working on large public art projects such as Community Bridge.

Today William creates public artworks in paint, glass, masonry, bronze, steel and light. These projects are carefully integrated in the historic downtowns of the East Coast. They frequently engage the community directly in the creative process, exploring local history and the meaning of place in ways that illuminate common ground. William often works on projects for three or four cities simultaneously, with a special focus on the Washington, D.C., and New York areas. A recent textbook has identified him as a prominent figure in the field of contemporary public art. He also loves teaching and teaches painting and mural-making workshops at The Faux School in Frederick, Maryland, Big Oak Arts near Sacramento, and in other cities nationwide including Santa Fa, New Mexico, and Cincinnati, Ohio. See his work at www.WilliamCochran.com.

1. PRE-INSTALLATION. Before painting began, craftsmen created the surface by cutting thin, tough cement panels to size and shape on site, pre-installing them in the same way they will be in the final configuration. The use of panels has multiple advantages: It isolates the mural surface from the existing wall, isolating the mural substrate from the wall and allowing air to flow behind the panels to prevent the build-up of moisture or condensation; it allows the mural to be painted in the studio, away from weather and spectator induced delay; and it allows the panels to be removed at some point in the future for conservation, if necessary.

The panels are durable but can crack if not handled correctly. Each arrived in its own wooden "cradle" made of 2' × 4's (61cm × 122cm) with additional 2' × 3's (61cm × 91cm) placed under the length of the panel to support it during transport.

2. FLASHING AND HAT CHANNELS. The mural is further protected by custom fabricated stainless steel flashing that blocks water from reaching the back of the mural. The flashing was designed and painted in advance of installation to blend inconspicuously into the design.

The heavy-duty galvanized steel hat channels that attach the panels to the wall remained on the wall after the pre-installation during the nine months of painting needed to create the mural. A slot was cut with a grinder directly into the brick facing of the building by installation contractor Louis Feldstein. The flashing is mortared with waterproof mortar into this slot so that it becomes a permanent part of the wall. The face of the flashing hangs down over the upper edge of the panels as a rain shield. An air gap between the flashing and the top panel edges and another at the bottom of the panels allows air to pass freely behind the mural, so that any water or condensation has an evaporation escape path.

After the flashing is installed, final adjustments are made in the hat channels, and additional short channels are installed between the primary support members for additional impact resistance.

3. GUSSET. Teresa Cochran installs EPT-type rubber strips with double-sided tape to the front of the hat channels. They will be permanently held in place by the panels and their screws, and are designed to isolate the mural panels from the hat channels to avoid a buildup of condensation where the sun-washed panels contact the metal channels behind the surface.

4. INSTALLATION. The panels slip under the flashing and are carefully repositioned and checked for level and plumb.

The panels are installed on the metal framing. They are very durable and can withstand abuse and weather for decades.

5. INSTALLATION. The panels are fastened through the face with stainless steel screws. In some panel systems, there are ways to blind fasten the panels so that the fasteners are invisible.

Utterly amazing! A & G we almost thought they were real! Absolutely fantastic – Awesome – I th were statues – can't believe it's a paint wonderful – we should have more art

A waste of money! Art is good – enjo

THOUGHTS FROM THE COMMUNITY. As the installation unfolded, curious passersby were directed to a mural information station where they found a detailed Frequently Asked Questions brochure about the project. There also was a guest book to register their comments and feedback. Art is subjective. In any public art project, you can expect comments of all kinds.

GALLERY

This gallery showcases the fantastic talent of the contributing artists. The murals are arranged by subject for easy reference.

I am humbled by the amazing wealth of talent showcased in this gallery and truly appreciate each artist and his or her respective contributions.

Ceilings

Nothing sparks the imagination more than being surrounded by art—literally. The ceiling, or "fifth wall," offers unlimited possibility for mural painters.

1. Ceiling Medallion, Sharon Leichsenring, 48" × 75" (1.2m × 1.9m), artist's acrylics on ceiling, photograph by Thomas Cain

2. Ceiling, Pascal Amblard, 8' × 8' (2.4m × 2.4m), acrylics, photograph by Pascal Amblard

3. The Fall of the Gigants originally rendered by Giulio Romano, Sean Crosby, 14' × 16' (4.3m × 4.9m), Faux Effects PlasterTex Base, Faux Effects FauxCrème Colors, photograph by Craig Walsh

4. Admirations—detail,
Randy Ingram and J. Brian
Townsend, 12' (3.7m) in
diameter, dome, oil on
plaster, photograph by
Randy Ingram and J. Brian
Townsend

5. Bamboo Ceiling,
Joseph Taylor, 12' × 16'
(3.7m × 4.9m), acrylics,
photograph by Exposures
Unlimited Ron Kolb

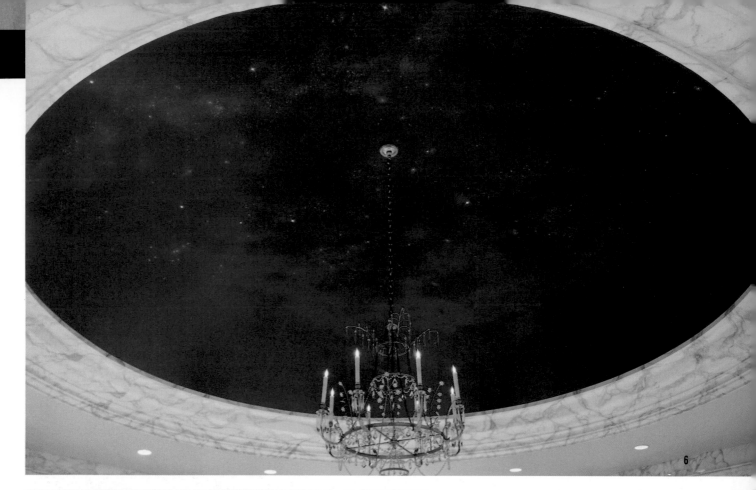

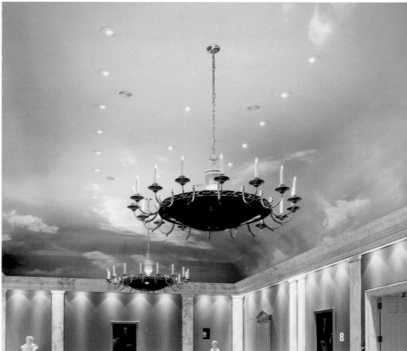

6. Night Sky, accurate to the northern hemisphere during the summer solstice, Gary Lord, 16' (4.9m) diameter, latex and acrylic paints, photograph by Ron Forth

7. The Triumph of Zephyr and Flora (originally rendered by Giovanni Battista Tipeolo in 1734-1735), Sean Crosby, 4' × 6' (1.2m × 1.8m), Faux Effects PlasterTex Base, Faux Effects FauxCrème Colors; Trompe L'oeil frame painted with Faux Effects Neutral White SetCoat, FauxCrème Colors and Activator II, photograph by Sean Crosby

8. Airbrushed Boardroom Daytime Sky, Gary Lord, 35' × 80' (10.7m × 24.4m), latex and acrylic paints, photograph by Ron Forth

Figures

There are almost as many ways to paint the human figure as there are humans. From classical to action to photo-realistic, these gallery pieces offers a variety of examples.

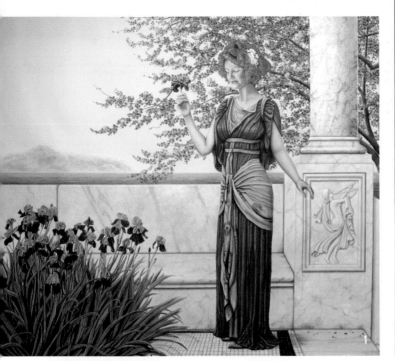

1. Reproduction of a scene by English painter John Godward (1861-1922) with artist's wife (Kate) as the subject, Marc Potocsky, 5'6" × 4'6" (1.7m × 1.4m), acrylics on canvas, photograph by Justin C. Maturo

2. Detail from 19th c. Pre-Raphaelite Reproduction (Stanhope), Lori Le Mare, 36" × 24" (91cm × 61cm), acrylics, photograph by Lori Le Mare

3. Surfacing, Lori Le Mare, 36" × 24" (91cm × 61cm), oil, photograph by Lori Le Mare

4. Zeus and Hera—detail, Jeff Raum (based on Rubens), 3' (91cm) diameter dome, oils

5. A Handful of Keys—detail, William Cochran, 17' × 8' (5.2m × 2.4m) (figures are life-sized), acrylic paint and antigraffiti coating on ventilated cement panel system, commissioned by the Village of Great Neck Plaza, photo courtesy Studio William Cochran

6. Reproduction of The Archangel Michael, Sean Crosby, 4' × 6' (1.2m × 1.8m), Faux Effects PlasterTex base, Faux Effects FauxCrème colors, photograph by Craig Walsh

7. A Handful of Keys—detail, William Cochran, 17' × 8' (5.2m × 2.4m) (figures are life-sized), acrylic paint and antigraffiti coating on ventilated cement panel system, commissioned by the Village of Great Neck Plaza, photo courtesy Studio William Cochran

8. Young Veronese—detail, Pascal Amblard, 7' × 4' (2.1m × 1.2m), acrylics, photograph by Pascal Amblard

9. Keiwan Ratliff/ Cincinnati Bengal, Shawn Voelker, 36" × 48" (91cm × 122cm), acrylic foil painting on artist board, photograph by Dale Voelker Photography

10. Sea Nymph Panel, Alison Woolley Bukhgalter, 35" × 24" (89cm × 61cm), casein paint on wood, photograph by Florenceart.net studio

Nature

A mural of a sweeping vista can create a "view" in any location and let one enjoy the splendor of the outdoors. Subjects can range from traditional, idyllic countrysides to exotic fantasy landscapes.

1. Detail from 16th c. French Romantic Reproduction (Boucher), Lori Le Mare, 24" × 65" (61 cm × 165 cm), acrylics, photograph by Lori Le Mare

2. Hudson River Hallway—detail, Randy Ingram and J. Brian Townsend, 24' × 8.5' (7.3m × 2.6m), oil on sheetrock, photograph by Randy Ingram and J. Brian Townsend

3. Novak Tropical Mural, Zebo, 10' × 10' (3m × 3m), acrylic, glaze and airbrush paint on wall plaster, photograph by Zebo Studio

4. India—detail, Jeff Raum, 8' × 8' (2.4m), acrylics, photograph by Jeff Raum

**5. Tropical Beach
Paradise,** Randy Ingram
and J. Brian Townsend,
40" × 84" (102cm ×
213cm), oil on canvas,
photograph by Randy
Ingram and J. Brian
Townsend

6. Ursini Project, Sharon
Leichsenring, 5.4' × 14'
(1.6m × 4.3m), Artist's
acrylics on wall, photo-
graph by Thomas Cain

Ornamental

Decorative scrolls and flourishes have charmed the eye for centuries.
An ornamental mural adds beauty and sophistication to any area.

1. 18th c. French Decorative Ornament Panel With Gold Trompe L'oeil Molding, Marc Potocsky, 3'2" × 2' (97cm × 61cm), acrylics, photograph by Justin C. Maturo

2. Ancient Pompeian Mural, Melanie Royals, 48" × 84" (122cm × 213cm), glazing and stenciling on various distressed plaster finishes, photograph by Gary Conaughton, www.GaryConaughtonPhotography.com

3. Ornamental Mural 2, Cynthia Davis, with Rena Paris, (left panel) 5' × 4' (152cm x 122cm), (right panel) 26" × 4' (66cm x 122cm), acrylics, photograph by Joshua Pestka

4. Ornamental Mural, Cynthia Davis, with Rena Paris, 7' × 6' (2.1m × 1.8m), acrylics, photograph by Joshua Pestka

Faux Finishes

Wood-graining, marble, patina—faux finishes showcase the versatility of paint as a medium and the skill of the artist.

1. Bookmatch Faux Cherry Grained Panel With Trompe L'oeil Molding and Ornament, Marc Potocsky 3'2" × 2'2" (97cm × 66cm), acrylics and oil, photograph by Justin C. Maturo

2. Faux Marble Columns and Starlite Walls, Jeannine Dostal, acrylics, photograph courtesy of Jeannine Dostal

3. Walnut Wood Grained With Inlaid Rosewood Burl and Egg-and-Dart Wood Inlaid Ornamentation, Pierre Finkelstein, 20' × 18' × 10' (6.1m × 5.5m × 3m), beer glaze undertone, oil glaze second and third steps, oil varnished, photograph courtesy of Pierre Finkelstein

Trompe L'oeil

A successful trompe l'oeil mural should make the viewers forget they are looking at a flat surface. An artist must master the concepts of perspective, texture, and lighting to truly fool the eye.

1. Pompeian-Style Hand Painted Ornament With Aged Texture and Portor Marble Baseboard, Pierre Finkelstein, 14' × 14' × 10' (4.3m × 4.3m × 3m), water-based glazing, matte fluid acrylic painting over oil basecoat, oil varnished, photograph courtesy of Pierre Finkelstein

2. Weeping Wall With Plaque, Dave and Pam Schmidt, panel: 4' × 8' (1.2m × 2.4m), plaque: 3' diameter (1m), concrete, plaster and acrylic paint, photograph by Cripe Photography

3. **Trompe L'oeil Classical Scene,** Dave Schmidt and Gary Lord 8' × 16' (2.4m × 4.9m), acrylics, photograph by Ron Forth

4. **Imitation Violet Breche, Rouge Royal and Portor Marble with trompe l'oeil molding**, Marc Potocsky, 2'8"× 6'4" (81cm × 193cm), acrylics, photograph by Marc Potocsky

5. **Mosaic Border and Stone Wall,** Jeannine Dostal, acrylics, Faux Effects Aqua Stone and Faux Effects color tints and glazes, photograph by Exposures Unlimited Ron Kolb

6. Stove Backsplash Niche, Cynthia Davis, with Cathie-Rose Michaud, 42" x 25" (107cm × 64cm), acrylic over Italian plaster, photograph by Joshua Pestka

7. Pietra Dura-Style Inlaid Marble, with onyx, breccias, and various semi-precious stones, Pierre Finkelstein, 30" × 40" (76cm × 102cm), matte-fluid acrylic, water-based varnish on draw-down card, photograph courtesy of Pierre Finkelstein

8. Italian Landscape Trompe L'oeil, Nicola Vigini, 5' × 6' (1.5m × 1.8m), oils, photograph by Nicola Vigini

9. Niche and Statue With Trompe L'oeil Shears and Architecture, Marc Potocsky, 4'5" × 8.5' (1.3m × 2.6m), acrylics on canvas, photograph by Justin C. Maturo

10. Niche With Parrots and Fruit, Pascal Amblard, 3' × 5' (91cm × 152cm), acrylics, photograph by Pascal Amblard

11. Faux Marble Inlay Tabletop, Alison Woolley Bukhgalter, 47" × 47" (119cm × 119cm), casein paint on wood, photograph by Florenceart.net studio

12. Striped Drapery, Sheri Hoeger, 8.5' × 11' (2.6m × 3.4m), airbrushed acrylics, photograph by Dave Adams Photography

13. Lion Fountain, Jeff Raum, 38" × 22" (97cm × 56cm), acrylics, photograph by Jeff Raum

14. The Forgotten Song From Community Bridge, William Cochran, 15' × 10' (4.6m × 3m), silicate paint on cement stucco, photograph by Edwin Remsberg

15. Niche with Vase, Joseph Taylor, 3' × 6' (91cm × 183cm), Latex and acrylic paints, photograph by Exposures Unlimited Ron Kolb

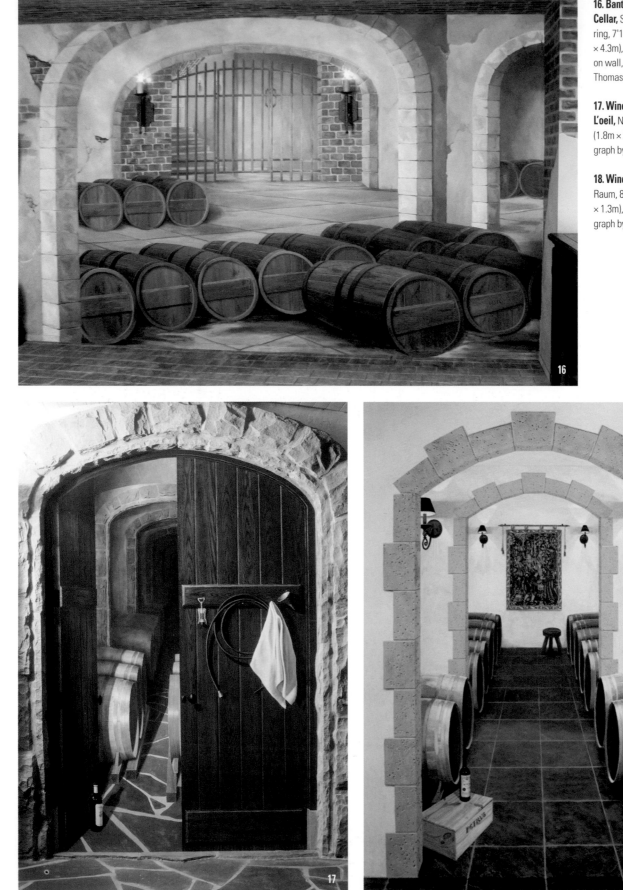

16. Bantam Lake Wine Cellar, Sharon Leichsenring, 7'10" × 14' (2.4m × 4.3m), artist's acrylics on wall, photograph by Thomas Cain

17. Wine Cellar Trompe L'oeil, Nicola Vigini, 6' × 9' (1.8m × 2.7m), oils, photograph by Nicola Vigini

18. Wine Cellar, Jeff Raum, 86" × 53" (2.2m × 1.3m), acrylics, photograph by Jeff Raum

Theme

Theme murals create a unique feel to reflect the client's personality and style. They can be inspired by a place, a pet, a time period or even a famous work of art.

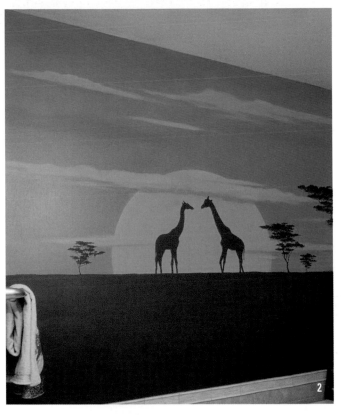

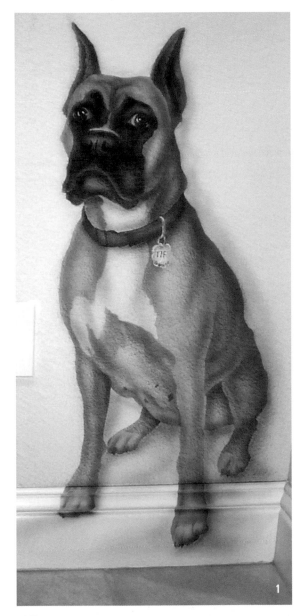

1. Tiffany, Sheri Hoeger, 32" × 16" (81cm × 41cm), airbrushed acrylics, photograph by Sheri Hoeger

2. Giraffe Silhouettes at Sunset, Joe Taylor, 6' × 12' (1.8m x 3.7m), latex and acrylic paints, photograph by Exposures Unlimited Ron Kolb

3. Laundry Overalls, Sheri Hoeger, 5.5' × 22" (165cm × 56cm), airbrushed acrylics, photograph by Hugh Hoeger

4. Nautical Mural, Cynthia Davis, with Rita Sellers, 15' × 5' (4.6m × 1.5m), acrylics, photograph by Joshua Pestka

5. Battle of the Fantastics, Randy Ingram and J. Brian Townsend, 48" × 74" (1.2m × 1.9m), oil on canvas, photograph by Randy Ingram and J. Brian Townsend

6. Peaceful Gardens, Jeannine Dostal, 6' × 11' (1.8m × 3.4m), multi-media waterbased products, photograph by Robin Victor Goetz/www.gorvgp.com

7. Specialty-Themed Game Room, Dave and Pam Schmidt, 24' x 8' (7.3m x 2.4m), acrylics, photograph by Dave and Pam Schmidt

8. Rose Parade, Rebecca Baer, 15.5" × 31.5" (39cm × 80cm), acrylics, photograph by Rebecca Baer

9. Replicas of Classic Movie Posters, Kris Hampton, 24" × 36" (61cm × 91cm) each, latex and acrylic paints, photograph by Kris Hampton

10. Schoeb Klimt Mural, Zebo, 14' × 18' (4.3m × 5.5m), Faux Effects Palette Deco AquaColors and Modern Masters metallic paints on wall plaster, photograph by Zebo Studio

11. Dancing Silhouettes,
Gary Lord, 8' × 16' (2.4m × 4.9m), latex paint, photograph by Gary Lord

12. Art Deco Dining Room,
Sharon Leichsenring, 8'4" × 12' (2.5m × 3.7m), satin finish latex paint and artist's acrylics, photograph by Thomas Cain

15

15. Schoeb Trees Mural, Zebo, 14' × 12' (4.3m × 3.7m), Airbrush paint and AquaColors on wall plaster, photograph by Zebo Studio

16. Wedding Kimono Wall Hanging, Melanie Royals, 47" × 64" (119cm × 163cm), glazing and stencil embossing with metallic plaster and paints on canvas, photograph by Gary Conaughton, www.GaryConaughtonPhotography.com

13. Touch of Golden Sun, Jeannine Dostal, Faux Effects Palette Deco and color tints, photograph by Jeannine Dostal

14. The Colony Beach and Tennis Resort Monkey Bar Mural, Zebo, 6' × 20' (1.8m × 6.1m), acrylic, glaze and airbrush paint on wall plaster, photograph by Tina Parkes, Portraits by Tina

16

CONTACT THE ARTISTS

Pascal Amblard
Atelier Pascal Amblard
www.pascalamblard.com

Rebecca Baer
Rebecca Baer Inc.
13316 Marsh Pike
Hagerstown, MD 21742
Phone: (301) 797-1300
painting@rebeccabaer.com
www.rebeccabaer.com

Alison Woolley Bukhgalter
Florence Art
Via di San Bartolo a Cintoia, 15/r
50142 Firenze
Italia
Telephone the studio:
+39 055 7332865
In North America call or fax:
1-800-420-5531
www.florenceart.net

William Cochran
Studio William Cochran
Phone: (301) 696-2839
wmcochran@comcast.net
www.WilliamCochran.com

Sean Crosby
The Mural School
168 Elkton Road
Suite 209
Newark, DE 19711
Phone: (302) 731-7752
Fax: (302) 731-7754
themuralschool@comcast.net
www.themuralschool.com

Cynthia Davis
Cynthia Designs
12 Sunbeam Dr.
Trumbull, CT 06611
Phone: (203) 268-8928
cynthia@cynthiadesigns.com
www.cynthiadesigns.com

Jeannine Dostal
kdostal@cinci.rr.com
www.jeanninedostal.com

Pierre Finkelstein
Pierre Finkelstein Institute
20 W. 20th St.
Suite 1009
New York, NY 10011
Phone: 1-888-faux-art
info@pfinkelstein.com
www.pfinkelstein.com

Kris Hampton
Gary Lord Wall Options, Inc.
11126 Deerfield Rd.
Cincinnati, OH 45242
Phone: (513) 931-5520
info@walloptions.com
www.walloptions.com

Sheri Hoeger
The Mad Stencilist
P.O. Box 219, Dept. N
Diamond Springs, CA 95619
Phone: (530) 344-0939
Fax: (530) 626-8618
sheri@madstencilist.com
www.madstencilist.com
www.bigoakarts.com

Randy Ingram and J. Brian Townsend
Classical Art Studios
Showroom location:
Gallery 51
919 Highway 33
Building 6, Unit 51
Freehold, NJ 07728
Phone: 1-800-766-8712
www.classicalartstudios.com

Sharon Leichsenring
Leichsenring Studios
9 Oxen Hill Rd.
Trumbull, CT 06611
Phone: (203) 452-7710
Fax: (203) 452-0373
Leichsenringstudios@charter.net
www.LeichsenringStudios.com

Lori Le Mare
Lori Le Mare Studio Inc.
251 Sorauren Ave. 4th floor, #405
Toronto, Ontario Canada
Phone: (416) 820-1407
info@lorilemarestudio.com
www.lorilemarestudio.com

Gary Lord
Gary Lord Wall Options, Inc.
11126 Deerfield Rd.
Cincinnati, OH 45242
Phone: (513) 931-5520
info@prismaticpainting.com
www.walloptions.com

Marc Potocsky
MJP Studios
241 Branford Rd. #254
North Branford, CT 06471
Phone: (203) 488-1265
Fax: (203) 488-7744
mjpfaux@aol.com
www.mjpfaux.com

Jeff Raum
Muracles
15006-D Varsity St.
Moorpark, CA 93021
Phone: (805) 523-0052
Fax: (805) 529-9231
muracles@aol.com
www.jeffraumart.com

Melanie Royals
Royal Design Studio/Modello Designs
3517 Main Street, #301
Chula Vista, CA 91910
Phone: 1-800-747-9767
melanie@royaldesignstudio.com
www.royaldesignstudio.com
www.modellodesigns.com
blog: www.designamour.com

Dave and Pam Schmidt
PJD Creations, Inc.
4953 Willow Ridge Court
Zionsville, IN 46077
Phone: (317) 873-8762

Joseph Taylor
Gary Lord Wall Options, Inc.
11126 Deerfield Rd.
Cincinnati, OH 45242
Phone: (513) 931-5520
info@walloptions.com
www.walloptions.com

Nicola Vigini
Vigini Studios, Inc.
2531 Boardwalk
San Antonio, Texas 78217
Phone: (210) 212-6177
Fax: (210) 212-6183
info@viginistudios.com
www.viginistudios.com

Shawn Voelker
19 Carneal St.
Ludlow, KY 41016
ssvoelks@fuse.net
www.shawnvoelker.com

Zebo
Zebo Studio
22259 Catherine Ave.
Port Charlotte, FL 33952
Phone: (941) 870-5696
Fax: (941) 870-5698
zebo@zebostudio.com
www.zebostudio.com

INDEX

The best in MURAL PAINTING
instruction and inspiration
is from North Light Books

Paint Effects for a Timeless Home

With a little paint and this easy-to-follow guide, you can transform even the most modest dwellings into warm, welcoming interiors. Thirty-five step-by-step demonstrations show you how to create popular decorating styles from Tuscany, England, France, Early America and rural Mexico. Stunning photo galleries provide further decorating ideas for infusing ordinary rooms with timeless beauty, traditional artisanship and plenty of old-world appeal.

ISBN 13: 978-1-58180-884-1; ISBN 10: 1-58180-884-4; paperback, 128 pages, #Z0558

Your Home: A Living Canvas

Adding décor elements can give your home a new life. This treasure trove of inspiration is filled with examples of added effects and stunning photography of finished rooms. Author and artist Curtis Heuser guides you room by room through his renovated Victorian home. Along the way you'll learn how to create unique paint effects, pick up tips on everything from colors to contractors, and be swept up to new inspirational levels.

ISBN 13: 978-1-58180-783-7; ISBN 10: 1-58180-783-X; hardcover, 144 pages, #33453.

Creative Kids' Murals You Can Paint

More than 50 whimsical wall paintings offer you a range of unique ideas, themes and color combinations, complete with 32 step-by-step demonstrations that make these murals easy and fun to recreate on your own walls. The fun and whimsical mural designs are adaptable for any child's room—everything from nursery and magical themes to animals, flowers and sports.

ISBN 13: 978-1-58180-805-6; ISBN 10: 1-58180-805-4; paperback, 128 pages, #33484.

Spectacular Walls

Do-it-yourself decorators everywhere can learn how to use the texturing techniques featured on such networks as HGTV thanks to *Spectacular Walls*. Thirty-eight illustrated, step-by-step projects offer expert instruction in a variety of techniques including Venetian plaster looks and easy wall glazing and ideas drawn from cake decorating that allow you to create effects ranging from subtle and refined to whimsical and colorful.

ISBN-13: 978-1-58180-727-1; ISBN-10: 1-58180-727-9; paperback, 128 pages, #33399.

These books and other fine North Light titles are available at your local arts & crafts retailer, bookstore, or from online suppliers. Discover imagination, innovation and inspiration at www.mycraftivity.com. Connect, Create, Explore.